OVERCOMING THE PROBLEMATICS

OF ART

THE WRITINGS OF YVES KLEIN

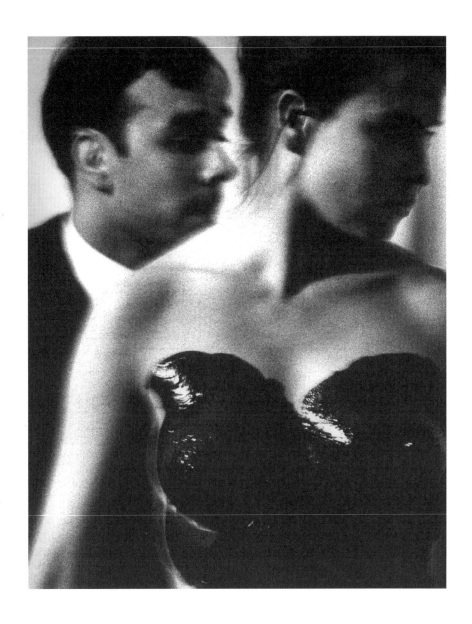

Anthropometry performance, Galerie International d'Art
Contemporain, Paris, 9 March 1960

OVERCOMING the PROBLEMATICS of ART

THE WRITINGS OF YVES KLEIN

TRANSLATED, WITH AN INTRODUCTION

BY KLAUS OTTMANN

SPRING PUBLICATIONS
PUTNAM, CONN.

Published by Spring Publications, Inc.
www.springpublications.com

First Edition 2007

Originally published in 2003 as *Le dépassement de la problématique
de l'art et autres écrits* by the École nationale supérieure
des beaux-arts, Paris.

Inquiries should be addressed to:
Spring Publications, Inc.
P.O. Box 230212
New York, N.Y. 10023

Designed by white.room productions, New York

Printed in Canada

Library of Congress Cataloging-in-Publication Data

Klein, Yves, 1928-1962.
 Overcoming the problematics of art : the writings of Yves Klein /
translated, with an introduction by Klaus Ottmann. - 1st ed.
 p. cm.
 Includes bibliographical references.
 ISBN 978-0-88214-568-6 (pbk. original : alk. paper)
 1. Klein, Yves, 1928-1962 - Aesthetics. 2. Klein, Yves, 1928-
1962 - Written works. I. Ottmann, Klaus. II. Title.

N6853.K5A35 2007
700 - dc22

 2007028911

∞ The paper used in this publication meets the minimum requirements
of the American National Standard for Information Sciences -
Permanence of Paper for Printed Library Materials, ANSI Z39.48-1992.

TABLE OF CONTENTS

"Regarding my ~~complete~~ ethics, 'Overcoming the Problematics
of Art,' on the principle of collaboration in the creative act:
~~by collective operation yet rigorously individual. The essential~~
~~idea at the outset was to try to show the public what was the~~
~~authentic state of mind of a whole historical generation, ours:~~
..." (Yves Klein Archives)

INTRODUCTION
BY KLAUS OTTMANN

> I am neither a literary man, nor am I a man of
> sophistication. I am an artist and I love my
> freedom, which is touched neither by vanity nor
> by stupid candor, even if I have, from time to
> time, a brush with idiocy.
> Yves Klein[1]

Theodor W. Adorno once said that in speaking about the nine-
teenth-century German poet Heinrich Heine one must think in
terms of a *wound*, about what in Heine and his relationship to the
German tradition causes pain. Similarly, to talk about Yves Klein
one must speak of the wound caused by the effects of his art and
ideas inflicted upon French artistic tradition.

Heine's wound was the fatal injury he inflicted on the German
Romantic soul:

> Heine the advocate of enlightenment unmasked Heine
> the Romantic, who had been living off the good for-
> tune of autonomy, and brought the commodity character
> of his art, previously latent, to the fore. He has
> not been forgiven for that. The ingratiating quality
> of his poems, which is overacted and hence becomes
> self-critical, makes it plain that the emancipation of
> the spirit was not the emancipation of human beings
> and hence was also not that of the spirit.[2]

1 "The Monochrome Adventure" (137).

2 Theodor W. Adorno, "Heine the Wound," in *Notes to Literature*,
vol. 1, trans. Shierry Weber Nicholsen (New York: Columbia University
Press, 1991), p. 82.

Heine accomplished his radical departure from the Romantic tradition of poetry with a satirical style that was previously unknown in German literature, aptly described by Lewis Browne as

> lifting the readers to the highest heavens of sentiment, and then suddenly letting them drop into the lowest pits of realism. [3]

Similarly, Yves Klein broke with tradition by combining artistic cunning, a philosophical sleight of hand was no less satirical and confusing to his peers than Heine's poetry was to his, with mystical, philosophical, and religious references into what one critic at the time described as a "symbolic sauce." [4]

Klein fought all his life against what his role model Eugène Delacroix called "the French defect" [*le défaut français*]: "that of having line everywhere." [5] For Klein, lines were prison bars from which painting needed to be liberated:

> Ordinary painting, painting as it is commonly understood, is a prison window whose lines, contours, forms, and composition are all determined by bars. The lines concretize our mortality, our emotional life, our reason, and even our spirituality. They are our psychological boundaries, our historic past, our skeletal framework; they are our weaknesses and our desires, our faculties, and our contrivances.
> Color, on the other hand, is the natural and human measure; it bathes in a cosmic sensibility. (19)

In 1959 Klein declared in his now-famous Sorbonne lecture: "My paintings are only the ashes of my art." [6] His wound was the ashes of *all* painting – the impossibility of painting forevermore. Klein's

3 Lewis Browne, *That Man Heine* (New York: The Macmillan Company, 1927), p. 142.

4 Christine Duparc, quoted by Pierre Restany in *Yves Klein*, exhibition catalog for the retrospective at the Musée National d'Art Moderne, Centre Pompidou, Paris, 1983, p. 70. See also Yve-Alain Bois, "Klein's Relevance for Today." *October* 119 (2007), pp. 75-93.

5 *The Journal of Eugène Delacroix*, 29 October 1857.

6 "Mes tableaux ne sont que les cendres de mon art." (83)

striving for emancipation from matter in order to overcome the *predicament* of French art in his time has proved as devastating to the state of art in France as Heine's subversive poetry to the fate of German Romanticism – and at times as overacted. Klein was at once a leading figure of a new French art and the self-appointed arbiter of its demise.

The son of two accomplished painters, Fred Klein and Marie Raymond,[7] Klein was originally influenced by his parents, but he soon abandoned both pictorial content *and* form in his art, immersing himself instead in the boundlessness of pure color:

> In 1946 I was painting or drawing either under the influence of my father, a figurative painter of horses in landscapes or of beach landscapes, or under the influence of my mother, an abstract painter of compositions of form and color. At the same time, "COLOR," the sensuous pure space, winked an eye at me irregularly, yet with stubborn persistence. This sense of the complete freedom of sensuous pure space exerted upon me such a power of attraction that I painted monochrome surfaces to see, with my own eyes to SEE, what was visible in the absolute. I would not consider at the time these attempts as having pictorial potential, until the day, around one year later, when I said to myself, "Why not." The "WHY NOT"[8] in the life of a man is what decides everything, it is destiny. It is the sign that conveys to the inexperienced artist that the archetype of a new state of things is ready, that it has ripened, that it can be brought forth into the world. (45-46)

This *Why not* signified a qualitative, postmodern leap, a decision to free himself from the *nostalgia* that, in the words of the philosopher Jean-François Lyotard, "allows [in Modern art] the unpresentable to be put forward only as the missing contents; but the form,

7 In 1949 Raymond won the prestigious Kandinsky prize and was praised by the art critic Charles Estienne for the "decisive clarity of [her] compositions."

8 See p. 45n29 below.

because of its recognizable consistency, continues to offer the reader or viewer matter for solace and pleasure."[9] Klein did not permit himself to be trapped in this modernist sentiment towards form, the *easy* abandoning of content that is free of failure. Instead, he denied himself "the solace of good forms"[10] by constantly revolting against his own style.

Adorno demanded that any adequate aesthetic theory must find a comprehensive resolution of the conflict between autonomy and sovereignty that is inherent in modern art – what he called "the antinomy of aesthetic semblance"[11] – without subordinating one to the other. The autonomy of art (and the aesthetic decision) has become a mainstay of Modernism and its concept of the avant-garde. It has risen out of the crisis of semblance. It claims autonomy by refusing aesthetic semblance and denying that in art "the Absolute is present."[12]

The postmodern artist makes an autonomous choice precisely by *abolishing autonomy*. He does so by deciding *after the choice has already been accomplished*. The paradox is that it is a *decision without intentionality*; yet it precludes the possibility of intervention by an outside power or predetermined fate. Thus the extraordinary in art is achieved neither passively (by birth or knowledge) nor actively (by intention), but by an *active-passive* decision to do what is impossible, i.e., to represent the Nonrepresentable. It is a decision that once the calling of the Nonpresentable is heard cannot be refused, and is made in *certain knowledge of failure*. To paraphrase Keat's famous notion of "negative capability":[13] the postmodern artist is

9 Jean-François Lyotard, *The Postmodern Condition: A Report on Knowledge*, Theory and History of Literature, Volume 10, trans. Geoff Bennington and Brian Massumi (Minneapolis: University of Minnesota Press, 1984), p. 81.

10 Ibid.

11 Theodor W. Adorno, *Aesthetic Theory*, Theory and History of Literature, Volume 88, trans. Robert Hullot-Kentor (Minneapolis: University of Minnesota Press, 1997), p. 103.

12 Ibid.

13 "... *Negative Capability*, that is when man is capable of being in uncertainties, Mysteries, doubts, without any irritable reach-

capable of being in the certainty of uncertainties, i.e., failure. *Only a decision unto failure is a postmodern decision,* as failure is immanent in the definition of the postmodern.[14] In this regard, Klein was the quintessential postmodern artist.

Like Heine, Klein unmasked the illusion of a pure and autonomous art. In retrospect, he was closer to the American Pop artists, especially Andy Warhol, than to contemporary artists such as Damien Hirst or Takashi Murakami who some forty years later are commercializing the autonomy of art itself. Klein overcame *the problematics of art* by overcoming commerce: in his philosophy of *communal* art, there is no distinction between artists, critics, and dealers.

Klein introduced his solution to the aesthetic antinomy of autonomy and sovereignty in his 1959 Sorbonne lecture. Artists are at once unified and apart:

> For those artists prepared to cooperate, imagining means withdrawing, leaping forward to a new life. In their combined élan, going out into all directions and dimensions, they are paradoxically at once unified and apart. Imagination for them is the audacity of sensibility ...
>
> I propose then the following to the communal artists who already know what I have just enunciated and perhaps even more, know to mock their possessive, selfish, and self-centered personality through a kind of exasperation of the Me in all their representative activities in the theatrical, tangible, physical, and ephemeral world in which, as they quite well know, they play a role. I propose to them that they continue to say "my work" for their separate parts, which nevertheless are produced in cooperation, when speaking to the living dead who surround us in the daily life of

ing after fact & reason." John Keats, *The Major Works* (Oxford: University Press, 1990), p. 370 (Letter to George and Tom Keats, December 1817).

14 On the postmodern notion of failure see my *The Genius Decision: The Extraordinary and the Postmodern Condition* (Putnam, Conn.: Spring Publications, 2004).

the communal work. I propose to them that they continue to say joyously "me, I, my, mine," etc. and not the hypocritical "we" and "our," but this only after having fully adhered spiritually to the conjugation of means in the creation of art. (76-77)

In 1957, on the occasion of his two-gallery exhibition of blue monochrome paintings, Klein introduced his economy of the immaterial:

I exhibited blue monochrome paintings, all identical in format and tone, at Iris Clert and Colette Allendy ... The most sensational observation was made of the collectors. They chose among the eleven exhibited paintings each their own and paid for each the asking price. And the prices, of course, were all different. This fact serves to demonstrate that the pictorial quality of each painting is perceptible by something other than its respective material and physical appearance. (83)

As Thierry de Duve writes,

After Beuys, after Warhol, the Klein case shows a third type of congruence between the aesthetic field and that of the political economy. With Beuys the congruence is forged by the identification of the artist with the proletariat and the assimilation of labor power to creativity. With Warhol it is forged through the artist's identification with the machine and the assimilation of the work of art to a commodity, but one without value. With Klein it is forged by the assimilation of artistic value to value plain and simple, that is, to exchange-value, and thus by means of the artist's identification with the capitalist, the dealer, with the owner of the means of production. In this equation of values, price is the middle term ... The price is only the expression of exchange-value. No one has succeeded, like Klein, under the names of pictorial quality (offering price) or pictorial sensibility (asking price), the pure exchange-value of a work of art as commodity.[15]

15 Thierry de Duve, "Yves Klein, or The Dead Dealer," trans. Rosalind Krauss, *October* 49 (1989), pp. 72-90.

Klein may arguably have been the most revolutionary artist since Duchamp. What he may have lacked in irony, he made up for in spiritual vision, political intellect, and humor, as often evinced in his writings. Klein embodied the neoplatonic belief that a person's happiness is found in intellectual activity. He had a natural aptitude for using words and ideas in a quick and witty way to create visions of remarkable intellectual depth.

More than forty years after his untimely death at the age of 34 in 1962, Klein's art has remained misunderstood to some extent. Commonly identified still today by his predilection for painting in a single color (in particular, International Klein Blue), he is often regarded as just another abstract painter. But Klein was anything but ... Despite the numerous paintings covered in thick crusts of blue or pink pigment, Klein was foremost a conceptual artist with a keen philosophical mind, yet he was also deeply spiritual, believing emphatically in the immateriality of art. In one of his notes he wrote,

> The less we leave to posterity, the less we become a ghost, the more we enter eternity. [16]

After his heuristic experience in 1957, Klein was no longer satisfied with painting – academic or otherwise. Painting became only *an interval*, the means to a higher end:

> My monochrome canvases are not my definitive works, but the preparation for my works; they are the remains of the creative process, the ashes. [17]

Painting, for Klein, became simply a mode of existence:

> I will be a "painter." People will say of me: that's the "painter." And I will feel myself to be a "painter," a true one, precisely because I won't paint, or at least not in appearance. The fact that I "exist" as a painter will be the most "formidable" pictorial work of the present age. (147)

16 "Moins on laisse à la postérité, moins on devient un fantôme, plus on rentre dans l'éternité." (Yves Klein Archives)

17 "Comment et pourquoi, en 1957 ..." (Yves Klein Archives)

Guided by his studies of the Japanese *Kata* (the abstract, purely spiritual lines of movement in judo), Rosicrucian cosmogony, and the phenomenological and psychological philosophies that emerged during his lifetime, Klein dared to take literal Delacroix's notion that art is about the "indefinable."[18] On the evening of April 28, 1958, at Galerie Iris Clert in Paris, Klein exhibited the "indefinable" as the "Void" in an exhibition entitled "The Refinement of Sensibility in the First Material State into Stabilized Pictorial Sensibility" by painting the entire gallery – except for the ceiling and the floor – white and presenting the seemingly empty space to the curious public waiting outside. The event was recounted in detail by Klein himself in "Overcoming the Problematics of Art."[19] The exhibition, today widely regarded one of the pivotal events of twentieth-century art, was followed two years later by the now famous photograph of the artist leaping out of a window.[20] It appeared on the front page of his mock Sunday edition of the Paris newspaper *France-Soir*, which was sold on newsstands throughout Paris on November 27, 1960.

<p style="text-align:center">*</p>

There are artists whose works are so completely their own that the established methodologies and interpretive approaches are inadequate to the task of the critic or art historian. In the postwar period, the roster of these few, highly autonomous artists would include, aside from Yves Klein, the American artist Andy Warhol and the German artist Joseph Beuys. What sets these artists apart is that they can be thought of not only as leading artists of their respective countries, but as public figures that represent the essence of their nationality. This representation is, of course, a complex one, char-

18 "The merit of painting is the indefinable." *The Journal of Eugène Delacroix*, Supplement, p. 711.

19 "Preparation and Presentation of the Exhibition on 28 April 1958 at Galerie Iris Clert, 3 rue des Beaux-Arts, Paris..." (48-56)

20 It was captioned: "The Painter of space launches himself into the void!"

acterized not by simply celebrating nationality, but by also making a nation's traumas and unhealed wounds manifest. In fact, they resemble the American philosopher and social activist John Dewey of whom it was said that until he spoke, America did not know what she thought. Few artists working today aspire to the visionary power, social activism, and nationalism that these artists in particular represented. In fact, Beuys still reigns today as the quintessential German artist, a title not even Gerhard Richter can yet claim.[21]

Yves Klein was a French artist. This seemingly self-evident statement implies certain interpretation of thought and arthistorical importance. Louis Pasteur once remarked that "science does not have a fatherland."[22] But even philosophy, which is directed at universalities, needs to be discussed within the characteristics that nationality produces, and this is true even more so for the discussion of an artist's work and thinking. All art is grounded in a sense of belonging or place. Klein not only became the embodiment of French art in the late 1950s and early 1960s but France's self-appointed ambassador, who in truly French fashion declared a social and economic revolution to be initiated by his Blue Period.

In the various manuscripts for his unrealized book project *Mon Livre*,[23] Klein (who was fully aware of the injustices in his country[24]) repeatedly declares his intention to turn all of France into

21 Richter came close to becoming the consciousness of the German soul when he painted his Baader-Meinhof cycle, *October 18, 1977*, which recalls the kidnapping and subsequent execution of a prominent German industrialist by the West German terrorist group Red Army Faction, but focused on one of the darkest moments of postwar Germany, the "Night of Stammheim," when three members of the group, including their leader Andreas Baader, were found dead in the Stuttgart-Stammheim high-security prison.

22 See John Alexander Gunn, *Modern French Philosophy: A Study of the Development since Comte* (London: T.F. Unwin, Ltd., 1922).

23 It appears that Klein may have ultimately abandoned it. Many of the texts contained in its various manuscripts are included in "The Monochrome Adventure." (137-73)

24 "Today every French citizen is inwardly ashamed, despite all their exterior assuredness of no longer being part of a legendary

one gigantic work of art, with its citizens as pigment, to be titled "France" or "The Blue Revolution":

> I want to take the surface of all of France as the canvas for my next painting. This painting will be titled: "The Blue Revolution."[25]

> How and why in 1957 I realized that to continue to make progress in my monochromatic and pneumatic works (pneumatic in the sense of abstract sensibility) I find myself obliged to take power in France (the country where an intense quality of sensibility in its natural material state reigns and constantly radiates). It is not the act of seizing power that interests me but the possibility of realizing a monochrome painting in my new style, "the refinement of sensibility," on the scale of ALL France and in France itself, on this extraordinary terrain, in this shrine of the world, this future support of the highest quality, using as pigments "the people and both the tangible and the intangible nature of a dynamic, explosive and pneumatic quality in the highest degree."[26]

> Each individual in my system will be considered by me during the creation of my painting "France" as grains of pigment ... In order to fix the independent individualities of the great dynamic multitude to the surface of "France," I want them to discover that they are artists; everyone is an artist, a creator, and a refiner of sensibility without knowing it.[27]

France and only France was his canvas:

> I have chosen FRANCE not so much because I live here and I am French, but because the French land is the richest in the world in spritual, sensuous, natural radiance ...

nation, but of a nation in decadence" ("Esquisse et grandes lignes du systeme economique de la revolution bleue ..." Yves Klein Archives). See also his letter to President Eisenhower (25-26).

25 "La grande force de ce mouvement ..." (Yves Klein Archives)
26 "Comment et pourquoi, en 1957 ..." (Yves Klein Archives)
27 "La grande force de ce mouvement..." (Yves Klein Archives)

The strength of France is art [*La force de la France,
c'est l'art!*][28]

La révolution Klein forever altered the face and the fate of French
art. When *Le Monde* famously declared in 1968, shortly before the
student revolution, that the country had become bored ("La France
s'ennuie"), France had also lost its most vital creative force.

<div align="center">*</div>

In his essay "Traditional and Individual Talent," T.S. Eliot writes,

> The more perfect the artist, the more completely sep-
> arate in him will be the man who suffers and the mind
> which creates; the more perfectly will the mind digest
> and transmute the passions which are its material.[29]

Eliot stipulated in his will that no biography of his life was
ever to be written. He believed that his life was in his poetry and
that books alone constituted the life of the poet. An artist's life
that has never been subjected to a biography is bound to over the
years become mythologized and spattered with misleading facts
and fallacies. This is even more true about Yves Klein. In recent
years, thanks to the publication of Klein's collected writings in
France and certain small, interdisciplinary exhibitions, such as
Yves Klein: Air Architecture, curated by the architect François Perrin
at the MAK Center in Los Angeles in 2005 (subsequently shown
at the Storefront for Art and Architecture in New York in 2005),
more facets of his visionary thinking have become known to a
broader public.

The general anglo-saxon prejudice towards French culture, epit-
omized by Henry James, is that the French mind is primarily con-
cerned with the senses at the expense of the intellect. It was Mat-
isse after all, who proclaimed that he worked *without theory,* finding
himself driven forward by an idea that can only be grasped bit by

28 Ibid.

29 T.S. Eliot, *Selected Essays 1917-1932* (New York: Harcourt, Brace
and Company, 1932), pp. 7-8.

bit as it grows with the picture. In contrary, Klein's art, in spite of its obvious sensuousness, was driven by his *intellect*. Like the American artist, poet, and philosopher James Lee Byars who had studied psychology, philosophy, and art, and lived in Japan for ten years, Klein was able to adapt the highly sensual, abstract, and symbolic practices found in Japanese rituals to Western science, art, and philosophy. Unlike Matisse, he rejected the traditional notion of the artist as someone who is guided towards the creation of his work by some unknown power or genius. As soon as Klein had emancipated himself from his parent's artistic ways, he began to make intellectual decisions based on philosophical ideas, which he developed over the years in collaboration with artists, architects, and writers into a large system that encompassed art, science, architecture, music, literature, and politics.

To let Klein's ideas come to the fore in his own writings is thus the main purpose of this book. However, this task is somewhat complicated by Klein's essential belief in artistic cooperation without distinction of individual ownership of ideas and works of art. He had a habit of freely quoting, in his writing, from books – notably Delacroix's journal, the philosophical writings of Gaston Bachelard, and the phenomenological writings of the art historian and curator René Huyghe – without giving proper credit to his sources, not because he was disrespectful of intellectual ownership or wanted to pass on someone else's ideas as his own, but because he felt unambiguously that ideas are to be owned and shared by all.

Despite claims to the contrary by Klein himself,[30] as well as by some of his contemporaries,[31] Klein constantly sought intellectual stimulation. He also was a ferocious reader of books on art, science, and philosophy. While Thomas McEvilley remains cautious as to

30 "I am neither a philosopher nor an economist, nor anything else, and I confine myself to expressing only *utopian* thoughts." (6)

31 Thomas McEvilley quotes Bernadette Allain, Klein's companion in the 1950s, as saying, "he was the least intellectual person I have ever known," in *Yves Klein 1928-1962: A Retrospective* (Houston: Rice University, 1982), p. 58.

the actual depth of Klein's reading,[32] it is quite evident from the following pages that Klein very much resembled his *sponge sculptures*, his portraits of the "readers"[33] of his art who, after having viewed his canvases, become impregnated with blue sensibility. Klein absorbed ideas like his sponges absorbed color. He borrowed indiscriminately – from books and from everyone he met. He had a thorough knowledge of Max Heindel's Rosicrucian writings. He also read several books by Bachelard and closely studied Huyghe's two popular works on the philosophy and psychology of art, *Dialogue avec le visible* and *L'Art et l'Homme*.[34] Through them he, in turn, became acquainted with the ideas of Goethe, Bergson, and Merleau-Ponty, among others.

According to the French philosophers Gilles Deleuze and Félix Guattari,[35] philosophy is a discipline that involves creating new concepts. Science, art, and philosophy are all equally creative, although only philosophy creates concepts in the strict sense. All true concepts require conceptual personalities (*personages conceptuels*), which play an essential role. Thus every philosophical concept is linked to its creator in much the same way as a work of art is linked to the personality of the artist, and all artists can be considered conceptual personalities.

32 Ibid. According to Restany, Klein once confided to him that he could only read the beginning of Bachelard's *The Dialectic of Duration* (arguably his most demanding book). See Pierre Restany, *Yves Klein: Fire at the Heart of the Void* (Putnam, Conn.: Spring Publications, 2005), p. 3.

33 Throughout his writing, Klein refers to the viewer or observer of art as "reader" (*lecteur*), perhaps in allusion to Marcel Duchamp's well-known declaration that "it is the observer [*regardeur*] who makes the piece of art." While for Duchamp the works becomes activated by the *regardeur*, the *lecteur* of Klein's paintings absorbs the sensibility of pure color literally like a sponge.

34 Published in English as *Ideas and Images in World Art: Dialogue with the Visible* and *Art and the Spirit of Man*, respectively.

35 Gilles Deleuze and Félix Guattari, *What Is Philosophy?* trans. Hugh Tomlinson and Graham Burchell (New York: Columbia University Press, 1994).

Yves Klein was an *agitateur d'idées*, an agitator of ideas who used his considerable charisma to propagate social change through art. He, of course, was first, last, and always an artist. He was not trained as a theorist nor did he teach art or philosophy. Like most artists, he was a "conceptual personality." When he theorized about his practice of art, he did so by speculating out of a general culture that includes philosophical, scientific, and political ideas. Yet Klein left two major bodies of writing in which he addressed the predicament of modern art quite explicitly in philosophical terms: "Overcoming the Problematics of Art" was to be his *ethics;* "The Monochrome Adventure," his *aesthetics.* Together with the other texts contained in this volume, they form the critical part of his artistic legacy.

With his writings and public talks, as with his artistic practice, Klein intended to promote his vision of a future of absolute artistic and social freedom and his belief in "great, absolute, and total Art (*le grand Art absolu et total*)."[36]

To paraphrase what Théophile Silvestre once wrote of Delacroix:[37] Yves Klein was a painter of a noble race who had a sky in his head and a fire in his heart.

<div align="center">*</div>

For the most part, the English translation of Yves Klein's writings follow the French edition prepared by Marie-Anne Sichère and Didier Semin. Capitalization, italics, and words in quotation marks follow those used by Klein. All footnotes are mine.

For Klein's frequent quotations of Delacroix, Van Gogh, and Bachelard I have used the following published translations:

> *The Journal of Eugène Delacroix*, trans. Walter Pach (New York: Covici, Friede, Inc., 1937).

36 "Comment et pourquoi, en 1957 ..." (Yves Klein Archives).

37 "Peintre de grand race, qui avait un soleil dans la tête et un orage dans le cœur" (Painter of a noble race who had a sun in his head and a tempest in his heart), *Histoire des artistes français* (Paris: G. Charpentier, 1878), p. 75.

The Complete Letters of Vincent van Gogh, 3 vols., trans. Johanna van Gogh-Bonger (Boston/New York/London: Bulfinch Press, 1958).

Gaston Bachelard, *Air and Dreams: An Essay on the Imagination of Movement*, trans. Edith R. Farrell and C. Frederick Farrell (Dallas: The Dallas Institute Publications, 2002).

_____, *Water and Dreams: An Essay on the Imagination of Matter*, trans. Edith R. Farrell and C. Frederick Farrell (Dallas: The Dallas Institute Publications, 1999).

_____, *The Poetics of Space*, trans. Maria Jolas (Boston: Beacon Press, 1969.

_____, *The Psychology of Fire*, trans. Alan C. M. Ross (Boston: Beacon Press, 1968).

In addition, references in the footnotes to the writings by Max Heindel are taken from the website of The Rosicrucian Fellowship in Oceanside, Calif.: http://www.rosicrucian.com.

*

I am indebted to the editorial work done by Marie-Anne Sichère and Didier Semin for the French edition of the writings of Yves Klein. This English edition could not have been realized without the assistance of Philippe Siauve and Emmanuelle Ollier at the Yves Klein Archives in Paris.

My deepest gratitude, however, goes to Rotraut Klein-Moquay and Daniel Moquay for their immeasurable support and friendship over the years.

—◇—

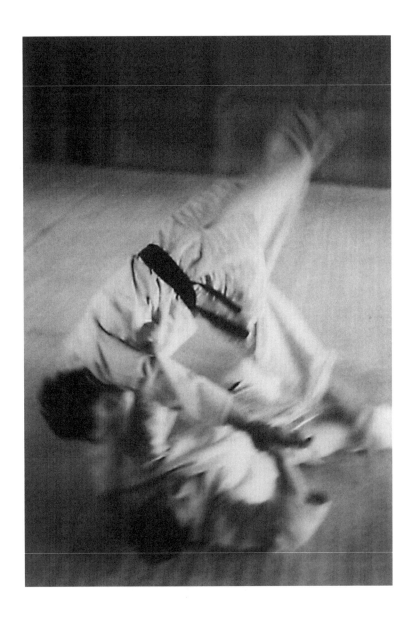

Yves Klein (top) demonstrating judo (Tokyo, 1953)

I. ON JUDO

Foreword to *The Fundamentals of Judo*

I have always thought that it is better to break down doors than to waste time searching for the keys and failing to find the keyholes due to a calm and passionless disposition.

Upon arriving in Japan, I had no respect for the *kata* [1] and for all the secrets that were supposed to be concealed within them.

The two *kata* that I had encountered in Europe beforehand, *nage-no* and *katame-no*, had made absolutely no impression upon me. I now believe that this was because they had never been correctly taught.

I thus thought only of knocking down doors with even more brute force, and to do it better and better, and more and more quickly, while I saw all around me innumerable quantities of keys that all seemed to function and open doors without damaging them, and without the unnecessary application of force.

It took me six long months of furious and sensational struggle in Japan, alongside the wise men and scholars of the *kata*, before I arrived one day – out of breath, exhausted, and worried – at the last door, a door that turned out to be too massive. I finally, in a rage, took the key that had been offered to me all along by one of the sweetly smiling old masters of the Kodokan. [2] And I opened the door by simply turning the key in the lock.

1 The choreographed movements practiced both in Japanese kabuki theater and the martial arts.

2 The Kodokan Institute in Tokyo was established by Jigoro Kano, the founder of judo in 1882. Klein arrived in Japan on September 23, 1952 and registered at the Kodokan Institute on October 9. He spent fifteen months in Japan, dividing his time between the Kodokan and teaching French. His book on judo, *Les Fondements du Judo* (published in Paris in 1954), was written during that time.

It is since that time that I began the study of the *kata,* which hold the keys to judo, "the keys to those celebrated doors, be they massive or not!"

And the young public sees nothing interesting in the fact that one may open a door with a key instead of knocking it down with brute force. One may say, "Why yes, evidently, it is too simple like that, anyone can do it." Knocking down a door always just seems more amusing!

<center>*</center>

Reflections on Judo, the *Kiai,* and constant Victory

I have often been asked if judo played a part in my pictorial conception. I have until now always answered that it did not. In fact, this is inaccurate: judo gave me much. I began it almost at the same time as my painting. One like the other has lived with me like I live with my physical body!

Here is in substance what I know of judo.

First of all, a great principle: "To have the spirit of victory." It is necessary to consider the defeats as important stages towards the final Victory. The small victories are like dangerous defeats for the final Victory. As soon as one is aware that the final victory has been won, the danger of the ultimate defeat looms over you. From the moment of the final Victory, one has gained definitively one more enemy: oneself. The defeated enemy knows it and counts on it thereupon for his revenge.

The *Kiai:*[3]

1. Our physical body consists of a skeleton and flesh. Inside the bones, the marrow circulates, a substance made of stuff nearly identical to that of the brain. The bones are the lines of the body. The line is intellect, reason, academicism, flesh, passion, all that was created by the intellect after man's Fall, the original sin, and it is what supports all, without which nothing would be living. Spirit, pure sensibility, life itself in man is apart from all that, although it is tied to the physical and emotional.

2. If one of the two adversaries during a judo competition is an ordinary judoka, he is seized by a feeling of anguish in the presence of his adversary. The other adversary is a true judoka; he can also have this feeling of anguish, and consequently in both adversaries blood is fired up and presses against the bones. Passion takes refuge at the very center of reason and thus paralyses the joints and impedes all movement of the skeleton. This is fear. A man who is afraid turns white because his blood no longer permeates his tissues all the way to the surface of the skin and because of that the skin appears white.

*

I came to judo ... completely by chance. I practiced French boxing (a kind of Karate) in a police club in Nice ... Certain police officers had installed in the same room a floor mat for judo ... and repeated movements of self-defense there that they called jiujitsu. As long as this small group was bent on practicing jiujitsu, my group, that of French boxing, regarded their efforts as not very effective and

3 *Kiai* literally means "concentrated spirit" and is used to describe the fighting spirit in Japanese martial arts. In a wider sense, it is also considered a universal force that governs human life and is the source of all energies. See chapter XIII of E.J. Harrison, *The Fighting Spirit of Japan* (Woodstock, N.Y.: The Overlook Press, 1982).

without value. We regarded savate[4] as a much more effective, beautiful, and interesting sport.

One day, however, two police inspectors returned from a special training course in Paris. They were taught judo and awarded a black belt, 1st dan. Starting the following day, the two new professors changed the crude method of training the small jiujitsu group and taught them judo instead ... It was no longer a brute force but a flexible art, a gentle way (the literal translation of the Japanese word *judo*).

I become a judoka, and French boxing no longer interested me. I dreamed of nothing but the fantastic movements of judo that, thanks to the technique of "yielding" to an adversary's force of attack, make it possible to overcome a more powerful adversary with a minimum of effort.

*

Judo has helped me to understand that pictorial space is, above all, the product of spiritual exercises. Judo is, in fact, the discovery of the human body in a spiritual space.

—◇—

4 French kickboxing or footfighting, a popular sport in France, which uses both the hands and feet as weapons and combines elements of Western boxing with Asian kicking techniques.

II. SOME (FALSE) FOUNDATIONS, PRINCIPLES, ETC. AND THE CONDEMNATION OF EVOLUTION

The law of exchange is a function of the comparative law of foundations.

From the beginning of the history of humanity, we have observed that the world evolves when it ought to have been created. By "evolve" I mean and describe the fact that we always construct the new on the foundations of the old, that we progress and that we improve thanks to past errors and "experience."

If we build a new house on the foundation of a "ruin," the house will unfailingly be one with its foundation; it, too, will crumble, for its foundation is but a ruin.

"All foundations are ruins."

Wisdom, philosophy, experience, science, power, etc., are all just an accumulation of errors, for this represents only endless strivings to improve, which, due to false foundations, can lead us very far and yet nowhere at all!

Man will never be able directly to achieve perfection as long as he limits himself to the infernal cycle of the infinite.

"To conceive is – expressed in a vulgar and yet precise manner – to castrate oneself, to transform oneself into a eunuch, to transmute oneself to a condition of sterility and powerlessness."

Errors! And new foundations! Advances towards and discovery of truth by "analogies." Nothing in the universe can be compared, nothing resembles anything else. Everything is unique, different, privileged. Two visually distinct and different beings are required to make a third. The system of evolution produces the phenomenon of development, blossoming, and degeneration.

To improve constantly is to expect to witness the dissolution of everything, of entire civilizations.

To improve constantly, to improve, and to rearrange is what caused, up to now, the cascade of crumbled civilizations, great and small.

Constructing and creating are exciting activities, but not on false and incomplete foundations. It is always necessary to destroy before rebuilding, but destruction does not mean "to destroy everything." We can build a new house beside an old house and in this manner destroy the old one with indifference.

We must be indifferent to the great examples of the elders (there are also young elders); we must shatter their powerless and desperate derision with overwhelming indifference. We must reject their destitute, unhealthy, and dusty experience.

If only youth, "the young," heard its own pure voice of enthusiasm – for, ultimately, youth's great error is making discoveries that, too sublime to be grasped, pass unnoticed. No one would ever have conceived of the "infinite," the source of despair, if they had not sensed the stupid necessity of "foundations" (without which, one suffers under the illusion, nothing can be built).

Youth is eternal, if we don't take evil into consideration – or errors; experience is the manifestation of evil – "it is the tree of science."

Evil = destruction.

Good = edification.

Evil + Evil = evil.

Destruction + edification = Creation.

What makes us grow old is the assimilation of errors instead of their expulsion and destruction; to know how to renew oneself is to know how to forget, "to know that to give up everything one has to chase shadows."

As to those who regard youth in action as "naive," they have no notion that to be naive is to live, and not to be naive is to commit suicide.

Another sad characteristic of the system of "evolution" is the desire for the solid, for resistance. Each of us in the current state of Society is guided by his or her education and surrounding community and is preoccupied only with material security, crystallized to the ultimate degree (I am neither a philosopher nor an economist, nor anything else, and I confine myself to expressing only *utopian* thoughts.).

All instants are created by the mind; accepting these instants, the intellect and the senses are created by the mind.

There are several kinds of beings in time – just as there are in humanity: there are those among them who are beyond the normal circuit: these are the externals of time; those are the instants.

We have, at times, relationships with the instants; these are beings like us, their unique characteristic is that they exist beyond the limits of dimension.

To make a small, intimate revolution is to question everything from a different angle or in one or more other dimensions; this is of no consequence.

It is the eternal return.

It is an improvement that advances nothing. Enthusiasm is the only means of true and direct investigation; enthusiasm leads always to the goal that is creation.

Enthusiasm lives and creates; the rest perishes.

Enthusiasm does not reflect, does not calculate, does not speak, and offers no explanations.

Remember then, those among you who are destined to scoff that he who smiles at the spectacle of enthusiasm is a desperate being who still retains his dignity; he who bursts into laughter at the spectacle of enthusiasm is a desperate being who loses his dignity; and he who mocks enthusiasm is a desperate being who has already lost his dignity – nothing remains of him but a corpse.

Those who cite specific cases, who give examples, are wrong, even when they have reason on their side. Only those who produce, present, and succeed in creating the fantastic, the monstrous, the repulsive, or the inconceivable are right, even when they are wrong.

Yesterday night, at 2 a.m., seated opposite François Dufrêne at the bar of La Rotonde, at the same spot where, I am certain of it, Lenin, thirty years earlier, pondered over the cataclysm of the Russian Revolution, I was finally able to speak, addressing Dufrêne, the exalted public educator, about his movies without "film":

"You must understand, this is a world without dimension, a world from which we cannot escape because we have forever been

searching within ourselves. That is why we never find the place of the true spirit within us.

"A person who succeeds in knowing himself will ultimately arrive at nothing, for he will have more and more delimited himself.

"In fact, those who wish to entertain themselves are forced to engage with the new, by inventing new dimensions. One can see no end to it; this is the trap.

"It is because of this that we have been obliged to recognize that a straight line curves in the universe, that the straight line could no longer move forward; it struck the interior face of the shell in which it was enclosed. Everyone then cried out: 'It must be flexible; it must bend upon itself.' And the straight line, thus becoming curved, evolved, turning and turning again, spiraling, inside the universe, the infinite, always returning to the same point.

"Thus, although with no future, it evolved into this curved line, without power to escape the infinite. You understand what I mean?

"Finally, frankly, what absurdity it is for the true mind to see the rationality in admitting that a straight line is curved, even while asserting that it is straight.

"You do understand, the more dimension, the more nothing, the more infinite, the more nothingness, the more divine, but, inconceivably, we refuse, foolish as we are, to see and contemplate it and to make use of it because it is too dazzling, because it burns reason."

YVES KLEIN

III. ART

To give real existence to things which have remained at the stage of intention in nature.
Goethe[5]

11 March 1952
A moment
is a pearl
it is round
flat or square
like the Earth
or like ourselves!
A moment
comes into the world
to love
with all its energies.
It wants to be loved.
All of the moments
around us
look at us ...
anxiously and they sigh ...
"Why do we not live
to love each other." We must
get married with
each other!

5 Cited in Pierre Huyghe, *Ideas and Images in World Art: Dialogue with the Visible,* trans. Norbert Guterman (New York: Harry N. Abrams, 1959), p. 209.

As to hate, it is bred
in mobs ...
How obscene is the orgy!
To live a moment is to die!

Wednesday, 12 March
The sun is out
but ...
out of me, for alas,
when it warms me
and I see it,
it is no longer
inside of me!

Thursday, 13 March
A day is space
and so is a year
an hour
a second
a life.
Must we live by the year?
Or the hour?
Or life?
Or the day?
Or the second?
... I love space
and I feel immense
when I dream
of the infinitely great
and the infinitely small.
Equilibrium doesn't exist in space,
and yet it isn't chaos!
This is it,
I feel it,
it is this
that I want: space.

Friday, 14 March
The day is blue
silence is green
life is yellow
light traces
lines that never end
And I linger,
transfixed by indifference!

Saturday, 15 March
If one becomes as a mirror
those who look at you
see themselves in you.
One then becomes invisible!

Sunday, 16 March
To instill discipline in oneself
is to take oneself as a disciple.
And to take oneself as a disciple is to recognize
that one is two
and yet, there are plenty of other solutions.

Monday, March 17
If I only succeeded … for just one day!
To love
each of the moments
of my life
with enthusiasm.
I truly wish to believe
that at the end of the day
I would be no more
than a small pile
of ashes.

IV. TEXT FOR THE EXHIBITION "YVES PEINTURES"
AT LACOSTE PUBLISHING HOUSE
PARIS, 15 OCTOBER 1955

After passing through several periods, my pursuits have led me to the creation of uniformly monochrome paintings.

Using multiple techniques, after appropriate preparation of the ground, each of my canvases is thus covered by one or more layers of a unique and uniform color. No drawing and no variation of hue appear: there is only UNIFORM color. In such manner the dominant force asserts itself upon the entire painting.

I thus seek to individualize color for I have reached the conclusion that each color expresses a living world and I express these worlds in my painting. My paintings affirm the idea of absolute unity in the context of perfect serenity, an abstract concept represented in an abstract manner, which causes me to be associated with abstract painters. I right away notice that abstract painters, for their part, do not share my point of view and reproach me for, among other things, refusing to juxtapose colors and provoke relationships among them.

I think, for example, that the color "yellow" is quite sufficient in and of itself to render an atmosphere and a climate beyond what can be apprehended by thought; moreover, the nuances of yellow are infinite, which makes it possible to interpret it in many ways.

For me, each nuance of a color is, in some way, an individual, a being that is of the same race as the basic color but clearly possesses a unique character and a distinct, personal soul.

There are nuances that are gentle, mad, violent, majestic, vulgar, calm, etc. In short, each color nuance is clearly a "presence," a living being, an active force that is born and that dies after living a kind of drama in the life of colors.

\diamond

V. SOME EXCERPTS FROM MY JOURNAL OF 1957

Friday, 23 August 1957 – Chamonix

My monochrome propositions are landscapes of freedom. I am an impressionist and a disciple of Delacroix.

Monday, 26 August

When Claude presented to me his most recent manuscript to read, I told him: "The day will come when you will present something to me that is true poetry; I believe that already by taking the manuscript in my hands I will feel it. Something will have changed everywhere!"

Saturday, 31 August – Venice

What above all inspired me in my most recent gouaches is the theme of the "dissolution of form by or in color." The apparent result is for me like a return to the soul "with infinite speed" that I consider to have surpassed already and which is, in any event, a stage already surpassed. This is the lyricism of displacement. It is the return to the romanticism of movement. While pure monochromy is truly of the present moment, it demonstrates the static freedom of universal sensibility, an absolute power of defying and dissolving every kind of movement; that which today no longer signifies "life" for anyone who "knows" but "death," whereas the true present-day manifestation, the veritable efficacy beyond picturesque agitation, is the "static."

Tuesday, 3 September

I am quite definitively opposed to those painters who neither know who they are nor what they do, who squeal, miserably safeguarding their impotence, that a painter should never speak of painting; otherwise (this in their eyes would be a rule), they would not be good painters.

I despise the obscurantism of false painters who proclaim themselves mystics and occultists. A painter should understand what he is and what he is doing and should be able to express himself in simple terms, perhaps, but must be able to do this through painting.

Venice, Friday, 6 September
A film is being shot in Saint Mark's Square; there are many extras attired in period costumes of the last two decades of the nineteenth century. A group of bishops and a sumptuously attired prelate makes me reflect that "the clothes do not make the man."

This is the very evidence: these ecclesiastics exist only by virtue of their exterior dress, and how many others are like them, even if *engaged* all the same. What thus makes an ecclesiastic [who he is] is what one does not see; it is abstract, but it is this that truly counts. It is same in painting: "the painting makes the painter"; it has nothing to do with his outward appearance but with what is not seen.

Saturday 7 [September]
Abstract painting is the picturesque literature of psychological states. It is impoverished. I am delighted that I am not an abstract painter.

"True painters and poets" neither paint nor write; they are simply painters and poets according to their legal status. Their presence and the sole fact that they exist as such is their great and unique work. And there, truly, one returns to, or rather, there one attains the masterpiece, and not as with today's painters who coin money with their canvases instead of painting them.

A painter must paint a single masterpiece, constantly: himself, and thus become a sort of atomic battery, a sort of constantly radiating generator that impregnates the atmosphere with his pictorial presence fixed in space after its passage. This is painting, the true painting of the twentieth century; the rest are exercises of the past, justified by pruning and by introspection.

Painting serves only to prolong for others the abstract pictorial "moment" in a tangible and visible manner.

Delacroix:

> I adore this little vegetable garden ... this gentle
> sunlight over the whole of it infuses me with a secret
> joy, with a well-being comparable with what one feels
> when the body is in perfect health. But all that is
> fugitive; any number of times I have found myself in
> this delightful condition during the twenty days that
> I am spending here. It seems as if one needed a mark,
> a special reminder for each one of these moments.[6]

Paintings are for painters usually the marks of these "moments," as poems are for poets.

For the painter, paintings serve only to take stock of these "moments", to ascertain their nature or rather what they are. Little by little, by trial and error, canvas after canvas, they succeed in living the "moment" continually.

Collectors and amateurs purchase paintings, unconsciously in search of the indefinable[7] because they sense (not so much because they see) the "moment" and because they, too, have experienced it in a manner even more vague than the painter and, in any case, without the creative power.

For each painter, the "moment" is generally always the same; only very rarely does it change.

It is the "quality" of the "moment" that determines the style of the painter.

There exist many "qualities" and "degrees" of the "moment," and the amateur quite quickly recognizes this moment in the style of a painter, what he experienced himself, and in pursuit of which he rushes headlong, for this moment has illuminated his life so filled with boredom.

All painters are good painters, each at his own level, just as everyone tastes beatitude in Paradise according to Dante, but each at his own level. There is no lack of amateurs for the painters whom we call bad painters. They are vulgar, crass, and ordinary – not a bad thing altogether. The principal ambition is to succeed in mak-

6 *The Journal of Eugène Delacroix* (25 October 1853).

7 See pp. 47n30.

ing ones mark in order to achieve the recognition of others. Bad paintings are no worse than good ones; they are for a greater majority of individuals. This majority offers greater material possibilities overall because they represent the majority and, almost always, material wealth at the same time.

This is what makes mediocre painters more successful than those who are not mediocre, but in the first round only (this first round can sometimes last for the entire life of the painter).

When the (general) public holds within itself, "en masse," the elevated sense of the great moment and when the painter who paints some moments of elevated quality, by whatever stroke of genius, touches on the public's sense of these great moments, then glory is justified at once.

Art collectors are of another breed altogether. They understand that behind the varying personal styles of artists there are moments to be found, each of a specific and different nature, and they buy and collect, cautiously, with regard to a certain unknown, which they pursue and which assures them of the future.

DELACROIX (*Journal*, 8 April 1854):

> The happy man is the one who has conquered his happiness or the moment of happiness that he feels at a given time. The thing they talk so much about and call progress tends to suppress the effort between desire and accomplishment; its effect would doubtless be to render man more unhappy, in reality. Man accustoms himself ... to a perspective of happiness easy to attain: suppression of distance, suppression of labor in every field.[8]

The composition, even the texture of my paintings, is the texture of the pictorial matter; it must be highly effaced, intensely worked, strong, and serious, in order to permit the display in all its splendor – color. DELACROIX says again correctly:

> I do not know whether I am mistaken, but I believe that the greatest artists have had great struggles

8 *The Journal of Eugène Delacroix* (8 April 1854).

> with that difficulty, the most serious one of all.
> Here one sees more than ever the drawback of giving
> to the details, through grace or coquetry in execu-
> tion, so much interest that later on one mortally
> regrets sacrificing them when they are injurious to
> the ensemble. [9]

Numerous are the painters and the refiners of space [*spécialisateurs d'espaces*] who know nothing of it.

Several months ago I was interviewed for the radio by an American woman who said to me, "If I understand you correctly, you have pulverized the barrier of form in your painting?" I replied to her, "Yes, I would even say that, in my paintings, I have succeeded in suppressing the space that exists in front of the painting, in the sense that the presence of the painting invades both the space and the viewer."

During a conference at the Institute of Contemporary Art in London[10] a man rose from his seat and furiously cried out, "This is all a gigantic joke; what is one to think, in effect, of a symphony consisting of one sustained note?" This is how I achieved victory right away: I had with me my tape recorder on which there were effectively recorded several long, sustained human screams. I descended from the stage for each response and lifted the tape recorder from the floor, placed it on a table, and turned it on. The room roared with joy.

The gesture had won the day, even though, ultimately, I was not able to play the sounds and the screams because there was no electrical outlet nearby. I was given full credit. The gesture alone was sufficient. The public had accepted the abstract intention. At that same conference in London, friends had done a poor job of standing up for me by repeating, "It is pure! It is pure purity ... etc." A young lady, having risen after the showing of a film on the Blue Period in Paris in which blond Bernadette appeared for a moment, protested in saying, "If it is so pure, what about that pretty blond

9 *The Journal of Eugène Delacroix* (23 April 1854).

10 This event took place on June 26, 1957 on the occasion of Klein's exhibition *Monochrome Propositions* at Gallery One in London.

in the film we have just seen?" I rose and looking straight into her eyes I answered, "I am crazy about pretty blond girls and I have many of them, and you, you please me very much, too. I would love to see you later, when all this is over, without any further talk of my paintings."

She added nothing more and sat down, blushing profusely!

VI. MY POSITION IN THE BATTLE BETWEEN LINE AND COLOR

Paris, 16 April 1958

For my part, the art of painting consists in liberating the first state of matter. Ordinary painting, painting as it is commonly understood, is a prison window whose lines, contours, forms, and composition are all determined by bars. The lines concretize our mortality, our emotional life, our reason, and even our spirituality. They are our psychological boundaries, our historic past, our education, our skeletal framework; they are our weaknesses and our desires, our faculties and our contrivances.

Color, on the other hand, is the natural and human measure; it bathes in a cosmic sensibility. The sensibility of a painter is not encumbered by mysterious nooks and crannies. Contrary to what the line tends to lead us to believe, it is like humidity in the air; color is sensibility become matter – matter in its first, primal state.

I can no longer approve of a "readable" painting; my eyes are made not to read a painting but, rather, to see it. Painting is COLOR, and Van Gogh proclaims, "I long to be freed from I know not what horrible cage."[11] I believe that he unconsciously suffered from seeing color cut into pieces by lines and its consequences.

Colors alone inhabit space, whereas the line only travels through it and furrows it. The line travels through infinity, whereas color *is* infinity. Through color I experience total identification with space; I am truly free.

In the course of my second Paris exhibition at the Colette Allendy gallery in 1956, I displayed a selection of PROPOSITIONS

11 The exact quotation is as follows: "And circumstances often prevent men from doing things, prisoners in I do not know what horrible, horrible, most horrible cage." *The Complete Letters of Vincent van Gogh,* vol. 1, p. 199 (Letter to Theo 133).

of colors in varying formats. What I expected from the general public was that "moment of truth" of which Pierre Restany [12] spoke in a text written for the exhibition. Taking the liberty of making a "clean slate" of any exterior impurity, I attempted to attain that degree of contemplation where color becomes full and pure sensibility. Unfortunately, this occasion made apparent that many spectators were slaves to their manner of seeing: they were much more sensitive to the relationships of the PROPOSITIONS to each other and tended to recreate decorative and architectural elements out of the colors.

This forced me to go much further in my experiments and to present in January 1957 at Galleria Apollinaire in Milan a show devoted to what I dared to call my "Blue Period" (it is true that for more than a year I devoted myself to the pursuit of the perfect expression of blue). This show included ten paintings in dark ultramarine,[13] all of them rigorously identical in tone, value, proportion, and size. The passionate controversies that resulted and the deep emotions provoked among persons of good will who were prepared to suspend the sclerosis of old conceptions and set rules testify to the importance of the event. Despite all the errors, the naiveté, and the utopian ideals in which I live, I am happy to be in pursuit of a problem of such great significance. We absolutely must realize – and this is no exaggeration – that we are living in the atomic age, where all physical matter can vanish from one day to the next to surrender its place to what we can envision as the most abstract. I believe that for the painter there exists a sensuous and colored matter that is intangible.

I thus believe that color itself, in its physicality, can limit and control my effort towards creating perceptible artistic states.

12 The critic Pierre Restany saw Klein's paintings for the first time in 1955 at the Club des Solitaires, in the private salons of the Parisian publishing house Lacoste. Encouraged by Restany, Colette Allendy offered Klein an exhibition in 1956 in her gallery, for which Restany wrote an introductory text he entitled "La Minute de vérité" (The Moment of Truth).

13 As well as one red monochrome, which was installed in a separate room.

In order to attain this "indefinable" of DELACROIX [14] that is the essence of painting, I devoted myself to the "refinement" of space, which is my ultimate way of treating color. It is no longer a question of seeing color but rather of "perceiving" it.

Lately, working with color has led me, in spite of myself, to pursuit, little by little, the creation of matter with a support structure (that of the observer, of the translator) and I have decided to bring an end to the conflict; at present, my paintings are invisible and it is these that I wish to display at my next Paris exhibition at Galerie Iris Clert in a clear and positive manner.

Yves Klein

VOWELS [15]

Black A, White E, Red I, Green U, Blue O: vowels.
Someday I'll explain your bourgeoning births:
A, a corset; black, hairy, buzzing with flies
Bumbling like bees around a merciless stench,

And shadowy gulfs; E, white vapors and tents, proud
Glacial peaks, white kings, shivering Queen Anne's lace;
I, purples, bloody spittle, lips' lovely laughter
In anger or drunken contrition;

U, cycles, divine vibrations of viridian seas;
Peace of pastures sown with beasts, wrinkles
Stamped on studious brows as if by alchemy;

O, that last Trumpet, overflowing with strange discord,
Silences bridged by Worlds and Angels:
- O the Omega, the violet beam from His Eyes!

ARTHUR RIMBAUD

14 See p. 47n30 below.

15 *Rimbaud Complete,* trans. Wyatt Mason (New York: Modern Library, 2002), p. 104.

VII. NOTES ON CERTAIN WORKS EXHIBITED
AT GALERIE COLETTE ALLENDY

The Folding Screens – The folding screens make it possible to be enveloped by the blue. Indeed, they may be arranged in a semicircle, so that the "reader"[16] of the work is placed at the focal point of its radius.

Pure Pigments – Pure pigment, exhibited on the floor, became in itself a painting, no longer to be hung on a wall; its fixative medium is the most immaterial possible, that is to say, it is a force of attraction that directed only towards itself. It does not alter the pigment grains, as inevitably does oil, glue, or even my own special fixative. The only trouble with it: one naturally stands upright and gazes towards the horizon.

Bengali Fires – One-minute painting of blue fire, mounted on a studio easel – a blue-painted wooden panel upon which were attached a number of combustible tubes of blue Bengali fires, which left in the "readers" the sensation of an enhanced visual memory after the painting had consumed itself. (The realization of blue fireworks is always extremely delicate and difficult to execute at night.)

Tapestry – Curious effect of this tapestry in relation to distance. It is the distance from the eye to the exposed surface that generates this effect. At a distance of one meter the tapestry (measuring 2 by 1.5 meters) is simply a very rich fabric; at three meters, it becomes a tapestry; at eight meters it becomes, in every pictorial aspect, a painting.

Tactile sculptures – These were not exhibited. I don't really know why any more. They were boxes, each pierced with two holes fitted with sleeves. The idea was to be able to put one's hands inside the box up to one's elbows and to touch and examine the sculpture in the in-

16 See p. XXI n33 above.

terior of the box without being able to see it. I now believe that I declined to exhibit these boxes because I very quickly had attained such an extreme perfection in these tactile sculptures that I believed it wise to hold them back for a little while. This extreme perfection was quite simply to have installed living sculptures in these boxes, living sculptures such as beautiful and evidently shapely nude models. At the time, this was a bit premature; the police would have been on my back right away. This is not to say that I may not present these hypersensitive sculptures to the public some day soon.

Sponge sculptures – It was also on this occasion that I discovered sponges. While working on my paintings in my studio I sometimes used sponges. Evidently, they very quickly turned blue! One day I perceived the beauty of the blue in the sponges; this working tool all of a sudden became a primary medium for me. The sponge has that extraordinary capacity to absorb and become impregnated with any fluid, which was naturally very seductive to me. Thanks to the natural and living matter of sponges I was able to make portraits of the "readers" of my monochromes, which, after having seen and traveled into the blue of my paintings, returned from them completely impregnated with sensibility, just as the sponges.

—◇—

VIII. THE BLUE CRIES OF CHARLES ESTIENNE [17]

In 1957 I made a short 16-mm color film about my exhibitions of the Blue Period.

I needed a commentary, preferably spoken by an art critic. So I asked Charles Estienne if he would willingly shout blue cries for the twenty-minute duration of the film.

The longest and most voluminous blue cries possible, drawing inspiration from the paintings in my studio at rue Campagne-Première.

This proved to be very successful and I must say that the film will retain the prestigious commentary that Charles courageously pronounced with such profound conviction at the time.

These are restrained cries, long enough and vigorously sustained (he requested two weeks for practice before the recording). To give an approximate idea of the cries alone: they are somewhat reminiscent of the cries that sailors shout out at regular intervals in order to avoid collisions in dense fog.

17 Charles Estienne was one of France's leading art critics in the 1950s, a proponent of a new postwar abstract art, author of the widely-read pamphlet *L'Art abstrait est-il un académisme?* (Is abstract art academic?), and an outspoken opponent of new American art. He was also a friend and supporter of Klein's mother, the abstract painter Marie Raymond. In his pamphlet Éstienne complained that artists no longer adhered to the Bauhaus vision of art that is both spiritual and social and warned of the danger of "sclerosis," the "monstrous solidification" of abstract art. Klein would later appropriate this notion in his writings.

IX. THE BLUE REVOLUTION
LETTER TO EISENHOWER, 20 MAY 1958 [18]

"THE BLUE REVOLUTION" –
Movement aiming at the transformation
of the French People's thinking and acting
in the sense of their duty to their Nation
and to all nations.
Address: GALERIE IRIS CLERT
 3, rue des Beaux-Arts
 Paris – Vme.

Mr. President EISENHOWER
White House
Washington, D.C. – U.S.A.

Dear President Eisenhower,

At this time when France is being torn by painful events, my party
has delegated me to transmit the following propositions:

To institute in France a Cabinet of French citizens (temporarily
appointed exclusively from members of our movement for 3 years),
under the political and moral control of an International House of
Representatives. This House will act uniquely as consulting body
conceived in the spirit of the U.N.O. and will be composed of a repre-
sentative of each nation recognized by the U.N.O.

The French National Assembly will be thus replaced by our par-
ticular U.N.O. The entire French government thus conceived will be
under the U.N.O. authority with its headquarters in New York.

This solution seems to us most likely to resolve most of the con-
tradictions of our domestic politics.

18 Original written in English.

By this transformation of the governmental structure my party and I believe to set an example to the entire world of the grandeur of the great French Revolution of 1789, which infused the universal ideal of "Liberty – Equality – Fraternity" necessitated in the past but still at this time as vital as ever. To these three virtues, along with the rights of man, must be added a fourth and final social imperative: "Duty."

We hope that, Mr. President, you will duly consider these propositions.

Awaiting your answer, which I hope will be prompt, I beg of you to keep in strict confidence the contents of this letter. Further, I implore you to communicate to me, before I contact officially the U.N.O. our position and our intention to act, if we can count on your effective help.

I remain, Mr. President,

<div align="center">Yours sincerely,</div>

<div align="center">Yves Klein</div>

X. THE BLUE SEA
LETTER TO THE SECRETARY GENERAL
OF THE INTERNATIONAL GEOPHYSICAL YEAR

Mr. Secretary General of the International Geophysical Year,
IGY - UWO, New York City, N.Y., USA

Mr. Secretary General,

Several luminaries have protested how various saltwater bodies were named: the Red Sea, the White Sea, the Black Sea, or the Yellow Sea, without one having been named the "Blue Sea." I propose that you employ to advantage my expertise in perfectly monochrome blue matter. By means of a remuneration that we can discuss (but one that must, of course, cover the cost of IKB (International Klein Blue) plankton – in my view the coloring agent best suited to this task – as well as my artistic contribution), I place myself entirely at the disposition of the I.G.Y. for the execution of this act of reparation.

Regards,

P.S. There is no danger to the red fish.[19]

cc: Mr. Kropotkine, Academy of Sciences of the U.S.S.R, National Geographical Institute; Commandant Cousteau; Mr. Paul E. Victor; Professor Picard; Mr. Alain Bombard; Mr. Robert J. Godet; Admiral Norry, Naval chief-of-staff (France); Admiral Furstord of the Sea, Admiral Commanding the 6th US Fleet (off Beirut); and *Geographical Magazine.*

—◇—

19 A word play: in French, *les poissons rouges* also means goldfish.

XI. BLUE EXPLOSIONS
LETTER TO THE INTERNATIONAL CONFERENCE FOR THE DETECTION
OF ATOMIC EXPLOSIONS

President of the International Conference for the
Detection of Nuclear Explosions

Honorable President, Distinguished Delegates,

I take upon myself in complete humility, but also in full conscience
of an artist, to present a proposition to the board of directors of your
Conference with regard to atomic and thermonuclear explosions.
This proposition is quite simple: to paint A- and H-bombs blue in
such a manner that their eventual explosions should not be recog-
nized by only those who have vested interests in concealing their
existence or (which amounts to the same thing) revealing it for
purely political purposes but by all who have the greatest interest
in being the first to be informed of this type of disturbance, which
I deem to say is all of my contemporaries. All I need is the position
and the number of A-bombs and H-bombs and a remuneration, to be
discussed, that ought, in any case, to cover:
 – The price of colorants.
 – My own artistic contribution (I will responsible for the color-
ing – in blue – of all future nuclear explosions).
 It is quite clear that we shall exclude cobalt blue as being notori-
ously radioactive and that we shall use only Klein Blue, which has
earned me the celebrity of which you are undoubtedly aware.
 Although I am fully occupied with my current work, notably
with creating the ambiance of the great Gelsenkirchen Opera
House, the humanitarian aspect of my proposal seems to me to
have priority over any other considerations. Do not think, how-
ever, that I am among those who place art after matter. Quite to the
contrary, its disintegration allows for the most spectacular mono-
chrome realizations that humanity, and I dare say, the cosmos itself
will have known.

In this double effect, I remain, distinguished sirs, your very devoted,

K.

cc: His Holiness the Dalai Lama; His Holiness the Pope Pius XII; President of the League of the Rights of Man; Director of the international Committee of Peace; Secretary General of the United Nations; Secretary General of UNESCO; President of the International Federation of Judo; Editor-in-Chief of the Christian Science Monitor; Bertrand Russell; Dr. Albert Schweitzer.

P.S. It is clear that not only the explosion but also the "fallouts" ought to be inalterably tinted in blue by my IKB procedure.

XII. "PURE VELOCITY AND MONOCHROME STABILITY"
AN ACCOUNT OF THE EXHIBITION IN COLLABORATION
WITH JEAN TINGUELY AT GALERIE IRIS CLERT

Following my exhibition *The Refinement of Sensibility in the First Material State into Stabilized Pictorial Sensibility*, also called my *Pneumatic Period*, in April of 1958, Jean Tinguely, whom this manifestation of my work had genuinely impressed, proposed that we collaborate on the creation of a large monochrome painting. In one corner of it he would bring to life elements of the same color to create, as he said, a phenomenon of metamorphosis in front of an apparent monochrome surface, which, however, was really pneumatic in the spiritual sense, that is to say, infinitely volumetrically abstract.

He promised to present this creation, signed by me as well as by him, to the *Salon des Réalités Nouvelles*, of which he has been one of the pillars since its foundation, and from which I had been excluded since 1955 when I first tried to present a strictly monochrome painting.

I enthusiastically accepted this proposition, and determined to go forward with it, we immediately purchased the particle board and the slats necessary for the fabrication of this collaborative work.

Alas, the secretary of the Salon and then its very president categorically refused acceptance of this work when Jean presented it to the Salon for registration – and Tinguely consequently resigned from the Salon without a moment's hesitation. This incident only strengthened our determination to set off for the human adventure of creative "collaboration," now more current than ever, which has been pursuit by some of the greatest contemporary artists and architects since the celebrated pre-Hitler Bauhaus.

Very excited by this rejection, we decided to provoke, over a period of time, a protest against the Salon by exhibiting this painting,

despite its rejection, in a Paris gallery during the Salon's opening. Pierre Restany obliged to write a delirious and aggressive introduction. Jean Tinguely and I ought to attend the Salon's opening reception and take possession of the event by projecting, with the help of blue flashlights, beams of blue on all the paintings and works exhibited while strolling among the crowd.

Nothing at all came of these plans, because, for my part, I was in full negotiations in Germany and could not take time off to take the train in the evening back to Paris only to return to Gelsenkirchen completely exhausted two days later. In short, the *Salon of False New Realities* narrowly escaped our protest.

Then came the holiday season, well deserved after a winter so charged with emotions and effort. We decided to take everything up again in September.

By September Jean and I had each deeply reflected upon the entire matter and our collaboration evolved towards a more intelligent, more dissolved manifestation.

I remarked to Jean that the means of meeting each other in the Absolute, in great art, was not to create work separately and then naively superimpose two works to lure them into a collaboration. Rather it was imperative that the work dissolve at the heart of the problem, "static velocity," which is to say, velocity in place, and that I let it take form, a circle, in order that, by the velocity of the rotation, the monochrome surface become iridescent and then visible again after the exhibition of my evolution towards the immaterial.

The color of immaterial blue, presented in April 1958 at Galerie Iris Clert, had rendered the sum of myself inhuman and excluded me from the world of tangible reality. I was outside of society, inhabiting space, and no longer capable of returning to earth. Jean Tinguely perceived me in space and signaled to me by way of velocity a volumetric route of return to the ephemera of material life. It is this that I have called my *rescue* by Tinguely. *Pure Velocity and Monochrome Stability* was a triumph of total and profound collaboration.

It was Solomon and Hiram Abiff who labored together on the construction of the temple.[20] The Queen of Sheba, Iris, came to see the result and could only state that the work was beautiful and grandiose, but it was also human by its faults, by its errors. What were these faults and errors? The temptation to materialize pure spirit! It is for this reason that Tinguely and I seek the means to continue after the exhibition of *Pure Velocity and Monochrome Stability*. Tinguely thus proposes to create a machine to produce monochromes. Being unenthusiastic about it, I propose instead to Tinguely – to whom *I had revealed* that he was pure velocity – a new manifestation, more vast in spirit than our first collaboration. I propose to him that, by way of his truly pure velocity, he should enter into space and materialize, in the wake of his continual passage, the immaterial blue of my territory that he has continually traversed since our alliance. The abstract image has no picturesque, and ultimately, rustic quality. Tinguely, the proprietor of velocity, enters my territory and launches himself into the air, which is presently the tangible aspect of all that belongs to me, and makes it circulate, and in the wake of this circulation, blue once again becomes visible.

Well, one day, I am holding a tube in my hand at Cassou's hardware store; I hold it out like a revolver and amuse myself in thinking of it as a weapon; it takes in energy at one end and sends it back out through the other. Tinguely understands that quite well, and I then say to him, "It would be great if air passes through it naturally for our exhibition."

This idea set forth, I take the problem up with him again that very evening, at La Coupole, I believe, and I draw a normal tube:

20 Yves Klein refers here to the Rosicrucian legend recounted in Max Heindel's *Freemasonry and Catholicism* (1931). See p. 34n21 below.

Tinguely draws a different tube:

I then draw this because I have always loved blunderbusses:

Then, I explain to him how to circulate air inside the tube, in a utopian manner perhaps, but logical in theory. Heat one end and cool the other, a neutral region in the middle. Later, Werner Ruhnau purports that it would suffice to heat one end only as that would create a temperature differential, which would make one end cooler in relation to the other. We go almost immediately to Hamburg with Ruhnau to study this with engineers at a large air-conditioner factory, and there everything takes precise shape.

Beforehand, Tinguely is dispirited and discouraged, I do not know why. Perhaps because I have not responded enthusiastically to his idea of a monochrome-producing machine, he declared to me one evening, repeating this several times, even in the presence of Iris, "No, this machine does not interest me; go ahead and produce it yourself. It's a fine idea, but my heart is not in it."

And then, voilà! I return from Germany and I say "my machine" and everything changes; suddenly he becomes quite possessive of the idea!

The law of consequence, arising from all human attempts to materialize pure spirit, is passion!

Alas, passion always strikes Hiram but never Solomon, for Solomon attaches no importance to matter. He plays with it, he loves luxury, the superficial good life for all that is human, he doesn't take the human condition seriously, whereas Hiram, on the contrary, is a prisoner of the fatality of transformation – he is first human, then spirit. The Queen of Sheba loves the spiritual; she only allows

for the necessity of temporary human condition – a psychological rivalry thus breaks out. Hiram withdraws into himself in anger (the wind of sensibility), "jealousy" is born, for the Queen of Sheba indicates her preference and honors passion over wisdom.[21]

I experienced this feeling in 1950 in Ireland, with Claude, when we collaborated in search of the truth. The situation was reversed then. I was the brain, the creator, the physical man, and he was the spirit, the aristocrat, the creature of luxury – everyone preferred him to me, although I, too, was highly regarded. All the same, after a certain time, I was struck with "jealousy." I was extremely unhappy and after months of suffering I quite understood that the point had to be made coldly, clearly, and dispassionately. Claude and I were at odds for six months because of that; now all is well – but what is certain is that once the point is made

21 Cf. Max Heindel, *Freemasonry and Catholicism:* "When Hiram Abiff appeared, and Solomon saw the love light kindle in the eyes of the Queen of Sheba, jealousy and hatred took root in his heart; he was, however, too wise to betray his feelings. But from that moment the plan of reconciliation and amalgamation of the Sons of Seth and the Sons of Cain which had been mapped out by the divine Hierarchies was doomed to failure, wrecked upon the rocks of jealousy and self-seeking."

The Rosicrucian Fellowship was founded in 1909 in Seattle by Heindel as an "International Association of Christian Mystics" and moved to Oceanside, Calif., in 1911. Klein obtained a copy of Heindel's *The Rosicrucian Cosmo-Conception* in late 1947 or early 1948 and continued to study his teachings for the next four to five years almost daily. Two of Heindel's leading ideas, Space and Evolution, became central notions in Klein's thinking. In the *Cosmo-Conception,* Heindel writes: "To the Rosicrucians, as to any occult school, there is no such thing as empty or void space. To them *space is Spirit* in its attenuated form; while matter is *crystallized space or Spirit.* Spirit in manifestation is dual, that which we see as Form is the negative manifestation of Spirit - crystallized and inert. The positive pole of Spirit manifests as Life, galvanizing the negative Form into action, but both Life and Form originated in Spirit, Space, Chaos!" (chapter XI). See also Thomas McEvilley, "Yves Klein and Rosicrucianism," in *Yves Klein 1928-1962: A Retrospective* (Houston: Rice University, 1982), pp. 239-54.

in me – from the moment I succeeded in brushing aside all the psychological justifications that I had built up within myself to strengthen my convictions against him, from the moment I recognized my jealousy – I uprooted it by a violent act of spiritual purity, and then a terrible strength entered me and threw me into spiritual realism, the assured conqueror of all, and everything became possible for me – all the magical arts had no more secrets for me. I read and continued to read the memory of nature past and future, and astonishing possibilities of endlessly renewed discovery were at my disposal.

I wish this same destiny for Jean Tinguely who is a brother to me and who holds within himself great and pure talent. He must conquer his psychological personality and become an individual and anonymous creator who says "me, I, my," for all belongs to him, even that which is another man's, for nothing belongs to him, not even his own life. All of this is just a game. One must live on earth in a man's skin and in society as a pure spirit who has donned a costume and who plays a theatrical role on a stage, sometimes one role, sometimes another, with the same ease – this is the luxury of the materialized pure spirit.

I had advised Tinguely, at the beginning of our collaboration, of the danger that he was running into. I foresaw very clearly that there would come a moment when this stage would have to be passed over, that there would be nothing to do but to let it go. As to myself, I have already crossed over; I know what it is, that it is hard.

It was on a Friday evening at La Coupole, in the presence of Iris [Clert], [Yoshiaki] Tono and his wife, a Japanese sculptor, and Giovanella, when the crisis broke out in Jean at the moment I said "my machine" to Tono, in speaking of our new creation in preparation. It was not the "my" for which he reproached me; it was his own suffering that he howled out, and I, stupidly, was so blind as to become angry and to be hard on him. I deeply regret this. When I had directed a similar tantrum against Claude (really against myself), he had been very generous and good to me. I know this now: he had said nothing; he had not become irritated and angry with me, where very easily he could have been, for at the time he was stronger

than me, both physically and spiritually (his judo was then better than mine).

When one is stronger, one should be more charitable (in the profound meaning of the word, not in the idiotic and miserably vulgar official meaning).

It is for this reason that I write these lines, to recapture my gesture of anger directed at a man of good will who was suffering, caught up in the trap of passion. I should to have been full of good humor that evening and replied to Jean Tinguely:

"Be outrageously selfish; be as much an egotist and as egotistical as I am and become spiritually superior to me, then all the world will love you more than me and Iris will no longer call on you in my absence to declare to you, 'Ha! If Yves were here!' – the genius, the only true genius.' Then it would be you who is the genius, the one-of-kind, the best, and then it would be me who would become jealous and envious and who would detest you – and it would be me who would find some futile reason to explode in anger and revolt against you.

"That evening, what you told me that it was you who had invented the machine, that you had forbidden me to proceed without you, etc., it was as if we were aviators and you had said to me 'Go ahead!' after having prepared everything and established all the rules for me, and then said 'Depart' to me, the test pilot – then I, at last having taken off and alone in flight high above, would then have taken full control of the machine, for safety in flight then depended more upon me than you! You, you remaining on the ground; I am the one who risks his neck if something does not work up there – which means that in flight, I think no longer of you; I think only of 'my machine.'

"You, below on the ground, you see that and you are very happy; everything is going well. When suddenly people come up to you and say, 'He's an ace! This is fantastic! He is the only one to do that! He is a genius!' – and you on the ground are sick to your stomach, for it is thanks to you that everything functions, just as much thanks to you than to me.

"Then, infuriated, you take a machine gun and shoot at me to bring me to down – and I, evidently at first astonished, come back to bomb and neutralize you – but a bombardment throws everyone down to the ground, and it is in this that I was so very wrong. I was not wrong to say 'my machine.' I was wrong to violently return fire.

"This machine, my dear friend, belongs to you and to me, although this may not be quite what you told everybody at La Coupole. It was not you who conceived it, it was *my idea*, the *tube*, my idea even in the majority of the technical details. My memory is very clear at present; I can describe everything, point by point, regarding how it came to be – but it would be infantile to have to do this – for I attach no importance to it. All that I can say as to your participation in the conception of this machine is that it was my contact with you that inspired me to create infernal and amazing machines; it was under your influence, and this is most important for you, it seems to me, for you to have influenced me rather than to dispute over something as inexact as the paternity of this machine.

"In any case, when you see me flying up there in a machine that we have created together and when you hear passers-by cover me with praise without acknowledging you – tell them that when I have returned and all is done, that I shall then declare that it is thanks to you that all of this has been possible. Which brings me back to my point, my dear Jean, which is to declare that one should not judge a collaboration during its realization, but afterwards, when all has been accomplished.

"Continuing with the example of aviation, if passers-by see you working on the machine that I have invented but you have produced, and I am not present, you should tell anyone who asks, 'This is *my machine*,' and thereby all the praise will fall to you and nothing to me. Afterward, aloft, it is *my machine* – but in the end, when all is done, it is *our machine*."

XIII. SPEECH TO THE GELSENKIRCHEN THEATER COMMISSION

Ladies and Gentlemen,

As I prepare for the commission that I am so honored to have received from you for the lobby of the new theater of Gelsenkirchen,[22] I wish to express to you some of my ideas and conceptions about painting, in order to explain to you, who have entrusted my art with your confidence, some of the reasons why I believe that the entire group of works that I am setting out to create should be in blue, uniformly in blue everywhere, and not consist of lateral panels in blue contrasted with white sponge reliefs. While the latter might be nice, it would lack the force and grandeur that a strictly monochrome grouping would produce.

Based upon sensory and tactile resources, I have pursued for several years now an adventure and pictorial experiment with pure color, i.e., color presented as a proposition of itself to the "readers."[23]

These monochrome propositions, so named by Pierre RESTANY because their material presentation makes them true supports of color (before I simply called them *paintings*), have preserved the objective aspect of traditional painting.

They are panels of wood or hardboard in varying formats (format and chromatic value being in general unconnected) whose surface has been covered with a very fine and tightly-stretched canvas. It is this canvas that is destined to receive the *color*, after meticulous preparation. A color whose tone, once fixed after

22 In 1958 Yves Klein was commissioned to decorate the lobby of new Opera House in Gelsenkirchen, Germany. The construction work lasted fourteen months and was overseen by the architect Werner Ruhnau.

23 See p. XXI n33 above.

diverse pigments are mixed together, is uniform. I speak of a kind of alchemy practiced by today's painters, *created* in the tension of each moment of the pictorial matter, suggestive of a bath in a space more vast than infinity. On the occasion of my second Paris exhibition, at Galerie Colette ALLENDY in 1956, I presented a selection of these propositions in various colors and formats. What I sought to inspire in the public was that "moment of truth,"[24] of which Pierre RESTANY spoke in his introduction to my exhibition, allowing for a blank slate devoid of all exterior contamination and attaining a degree of contemplation that turns color into full and pure sensibility.

Unfortunately, it became apparent from the responses to that occasion, and especially during a debate organized at Galerie Colette ALLENDY, that many of the spectators, being prisoners of a conditioned way of seeing the relationships between the different propositions (relationships of colors, of intensities, of dimensions and architectural integration), were recombing the canvases in their mind into one single polychrome installation. It is this that led me to push my attempt further still, this time in Italy at Galleria Apollinaire in Milan, in an exhibition dedicated to what I dared to call my Blue Period. (In fact, I had already dedicated myself for more than a year to the search for the most perfect expression of *Blue.*)

This exhibition included ten paintings in dark ultramarine blue, all of them rigorously similar in tone, intensity, proportions, and dimensions. The rather passionate controversy that arose from this manifestation proved to me the value of the phenomenon and the real profundity of the upheaval that comes in its wake to those unwilling to submit passively to the sclerosis of accepted ideas and set rules.

Allow me to add to this some reflections on the color blue:[25]

> The blue of the sky, if we were to examine its many image values would require a long study in which we

24 See p. 20n12 above.

25 Excerpted from G. Bachelard, *Air and Dreams*, pp. 161–70 (chapter 6: "The Blue Sky").

would see all the types of material imagination being determined according to the basic elements of water, fire, earth, and air. In other words, we could divide poets into four classifications by their response to the single theme of celestial blue:

Those who see in an immobile sky a flowing liquid that comes to life with the smallest cloud.

Those who experience the blue sky as though it were an enormous flame – "searing" blue, as the Comtesse de Noailles describes it.

Those who contemplate the sky as if it were a solidified blue, a painted vault – "compact and hard azure," as the Comtesse de Noailles again says.

Finally those who can truly participate in the aerial nature of celestial blue.

[...] The word *blue* designates but it does not render.

[...] First, a document taken from Mallarmé in which the poet, living in the "dear ennui" of the "Lethean ponds," suffers from "the irony" of the azure. He perceives an azure that is too offensive and that wants

To stop with untiring hand
The great blue holes that naughty birds make.

[...] It is through this activity of the image that the human psyche receives *future causality* through a kind of *immediate finality.*

Moreover, if we are truly willing to live, with Eluard, by imagination and for imagination, these hours of *pure vision* in front of the tender and delicate blue of a sky from which *all objects have been banished,* we will be able to understand that the aerial kind of imagination offers a domain in which the values of the dream and of the representation are interchangeable on the most basic level. Other matters harden objects. Also, in the realm of blue air more than elsewhere, we feel that the world may be permeated by the most indeterminate reverie. This is when reverie really has depth. The blue sky opens up in depth beneath the dream. Then dreams are not limited to one-dimensional images. Paradoxically, the aerial dream soon has only

a depth dimension. The other two dimensions, in which picturesque, colored reverie plays its games, lose all their oneiric interest. The world is then truly on the other side of the unsilvered mirror. There is an imaginary beyond, a pure beyond, one without a within. First is *nothing,* then there is a *deep* nothing, then there is a blue *depth.*

[...] Claudel, for example, seeks an immediate and passionate adherence. He will seize a blue sky in its raw material. For him, before this enormous mass where nothing stirs, this mass that is the blue sky or rather a sky overflowing with azure, the first question will be "What is blue?" The Claudelian hymn will answer: "Blue is obscurity become visible." To *feel* this image, I will take the liberty of changing the past participle, for, in the realm of the imagination, there are no past participles. I will say, then, "Blue is obscurity becoming visible." This is precisely why Claudel can write: "Azure, between day and night, shows a balance, as is proved by the subtle moment when, in the Eastern sky, a navigator sees the stars disappear all at once."

Blue has no dimensions. "It is" beyond dimensions, while the other colors have some. These are the psychological spaces. Red, for example, presupposes a hearth giving off heat. All colors bring forth associations of concrete, material, and tangible ideas, while blue evokes all the more the sea and the sky, which are what is most abstract in tangible and visible nature.

This all-too-brief presentation of my ideas on blue will perhaps not suffice to convince you of the fact that the other colors harden objects contrary to what one may normally think. In the case of the decoration of the lobby of this theater, a color other than blue or the noncolor of white would crystallize the sponge relief. The natural form of the sponge, which I will use as the foundation in my construction of the relief, would be rendered unnecessarily antipathetic and aggressive by the white, while the blue, on the contrary, will create a suggestion of the elementary state of the brutal budding of matter impregnated with spirit and sensibility that the color of the sky and the sea alone can produce.

The spectators, in passing time between acts in the presence of the blue and the white in the lobby of this magnificent building, would reconstitute the elements of a decorative polychromy, which would diminish the allure and general élan of the architecture; while, on the one hand, the architecture would be enhanced with a suggestion of unseen of grandeur in the presence of a great unity of blue. My works would produce a shock at once violent and gentle, which is, I do believe, the vainglorious spirit, sure of itself and the future, in the good sense that made you decide, one day, in Gelsenkirchen, upon the construction of such a cultural edifice at the pinnacle of progress and the avant-garde in the world!

My painting strives to be a representation of freedom in the first material state. Madame, Gentlemen, this is why I ask you today to agree with me in bringing about these works for you, in the spirit of my ideal conception of painting and in collaboration with the architect Werner Ruhnau.

Yves Klein

XIV. THE CONCEPT FOR GELSENKIRCHEN

I wanted to bring "a fresh eye before a new object" [26] to my work for GELSENKIRCHEN.

> The botanist's magnifying glass is youth recaptured. It gives him back the enlarging gaze of a child. With this glass in hand, he returns to the garden,
>
> *where children see enlarged.*
>
> Thus, the miniscule, a narrow gate, opens up an entire world. The details of a thing can be a sign of a new world which, like all worlds, contains the attributes of greatness.
> Miniature is one of the refuges of greatness. [27]

Although this may seem incredible, I have sought, in GELSENKIRCHEN, to create miniatures, measuring twenty by seven meters.

And this is why you see this structure move, titillate, excite the color, the blue.

I have always looked very closely, millimeter by millimeter, at my monochromes, which appear flat and uniform when they have the dimensions of easel paintings. In GELSENKIRCHEN, I hesitated to enlarge each detail proportionately. Had I done so, the relief would now be much more significant than it actually is. I was held back by remembering DELACROIX's words:

> I do not know whether I am mistaken, but I believe that the greatest artists have had great struggles with that difficulty, the most serious one of all. Here one sees more than ever the drawback of giving

26 G. Bachelard, *The Poetics of Space,* p. 155 (chapter 7: "Miniature").
27 Ibid.

to the details, through grace or coquetry in execu-
tion, so much interest that later on one mortally
regrets sacrificing them when they are injurious to
the ensemble.[28]

But the color is there. This is the essential point! In any event, whether there is more or less relief, I know that the blue kills the relief!

—◇—

28 *The Journal of Eugène Delacroix* (23 April 1854).

XV. OVERCOMING THE PROBLEMATICS OF ART

By Yves Klein
Artist and painter
Fourth dan black belt in judo
Graduate of Kodokan in Tokyo, Japan

It is inadequate to write or to say, "I have overcome the problematics of art." It is necessary to have done so. I have done so.
Painting today is no longer a function of the eye; it is the function of the one thing we may not possess within ourselves: our LIFE.

Here is how it came about:

In 1946 I was painting or drawing either under the influence of my father, a figurative painter of horses in landscapes or of beach landscapes, or under the influence of my mother, an abstract painter of compositions of form and color. At the same time, "COLOR," the sensuous pure space, winked an eye at me irregularly, yet with stubborn persistence. This sense of the complete freedom of sensuous pure space exerted upon me such a power of attraction that I painted monochrome surfaces to see, with my own eyes to SEE, what was visible in the absolute. I would not consider at the time these attempts as having pictorial potential, until the day, around one year later, when I said to myself, "Why not." The "WHY NOT"[29] in the life of a man is what decides everything, it is destiny. It is the sign that conveys to the inexperienced artist that the archetype of a

29 Cf. G. Bachelard, *The New Scientific Spirit,* trans. Arthur Goldhammer (Boston: Beacon Press, 1984), p. 7: "We shall uncover a kind of polemical generalization that shifts reason from the realm of the 'why?' to the realm of the 'why not?' We shall make room for paralogy alongside analogy and show how the ancient philosophy of the 'as if' is superseded, in the philosophy of science, by the philosophy of the 'why not?'"

new state of things is ready, that it has ripened, that it can be brought forth into the world.

However, I showed nothing to the world immediately. I waited. I "STABILIZED" it. I am opposed to the line and to all that result from it: outlines, forms, and compositions. All paintings, of whatever kind, abstract or representational, have on me the effect of the bars on a prison window. Freedom lies in the far away dominion of color! The "reader" of a painting of lines, forms, and composition remains a prisoner of his five senses.

Then I immersed myself in the monochrome space, in everything, in the boundless pictorial sensibility. I did not immerse myself in my own personality, not at all. I felt myself, volumetrically impregnating myself, beyond all proportions and dimensions, in EVERYTHING. I encountered or, rather, was caught up in the presence of many inhabitants of space, but none that were human in nature; none had arrived ahead of me.

There, space gave me the right to be "owner" or rather "co-owner" with others, but those had nothing to do with humans. And space graciously consented to manifest its presence in my paintings in order to establish them as titles of ownership, as my documents, my proofs, the diplomas of my conquests. I am not only the owner of Blue, as one would assume today, no, I am also the owner of "COLOR," for it is the terminology of space for legal titles. Certainly, my immeasurable property is not only "color," it *is*, in short. My paintings exist only as the visible title deeds proving my ownership.

If, very unexpectedly, someone else had already been there, in this world of total space, at the time of my arrival, I would not have felt that inexpressible sensation of absolute freedom, of which my predecessors could only dream, enclosed forever in poetic pictorialism: hence I have received the rights, which I have subsequently made use of.

During this period of concentration, I created, around 1947–1948, a "monotone" symphony whose theme expresses what I wished my life to be.

This symphony of forty minutes duration (although that is of no importance, as one will see) consisted of one unique continuous "sound," drawn out and deprived of its beginning and of its end, creating a feeling of vertigo and of aspiration outside of time. Thus, even in its presence, this symphony does not exist. It exists outside of the phenomenology of time because it is neither born nor will it die. However, in the world of our possibilities of conscious perception, it is silence – audible presence.

In 1955 I exhibited in Paris twenty monochrome paintings of different colors. On that occasion I immediately noted something significant: the public, in the presence of the picture rails on which were hung several canvases of different colors, reassembled them into a polychrome decoration. Imprisoned by their learned ways of seeing, this public, however select, could not comprehend the presence of "COLOR" in any one painting. This is what provoked my initiation into the Blue period.

Through Blue, the "great COLOR," I am closing in, more and more, on the "indefinable" of which DELACROIX spoke in his journal as being the one true "MERIT OF THE PICTURE."[30]

Presented in Paris in 1957 at Galerie [Iris] Clert and Galerie Colette Allendy, the Blue period was my initiation. I realized that the paintings are only the "ashes" of my art. The authentic quality of the canvas, its very "being," once created, is beyond what is visible, in the pictorial sensibility of the First Matter.

It was then that I decided to present, at Iris Clert, the "immaterial Blue."

30 "The merit of the picture is the indefinable." *The Journal of Eugène Delacroix* (Supplement), p. 711.

Preparation and Presentation of the Exhibition on 28 April 1958 at Galerie Iris Clert, 3 rue des Beaux-Arts, Paris
"The Refinement of Sensibility in the First Material State into Stabilized Pictorial Sensibility"
The Pneumatic Period (a number of details have been omitted)

The object of this attempt is to create, to establish, and to impress upon the viewing public a sensuous pictorial state within the confines of an art gallery; in other words, the creation of an environment, of a real pictorial climate, therefore one that is invisible. This invisible pictorial state within the space of the gallery must literally become what until now has been given as the best general definition of painting: "radiance."

For the creative act to succeed, the immaterialization of the invisible and intangible canvas must act upon the sensuous vehicles or bodies of the gallery visitors with much more efficiency than ordinary, physical, representational paintings. The latter, if they are of good quality, are also endowed with this special pictorial essence and affective presence, that is, with sensibility, but it is transmitted by the suggestion of every physical and psychological appearance of the painting, by its lines, contours, forms, composition, juxtaposition of colors, etc. These intermediaries are now no longer needed: one is literally impregnated with the pictorial sensibility, refined and stabilized beforehand by the painter in a given space. It is a direct and immediate perception and assimilation without other effects, without gadgets or hoaxes.

To this effect, then, we design with Iris Clert the invitation to the opening reception with a text by Pierre Restany. This brilliantly laconic text is very clear, and, considering the importance of this exhibition for the history of art, we decide to print the invitation in an informal yet stately "Anglaise" font, and, above all, engraved, so that the blind can read it (they are all blind!); this is said with no pejorative or aggressive intent. The ink used will, of course, be blue, imprinted on a white card.

This seemingly symbolist method is not actually symbolic, since, in fact, everything occurs in space. It is good to give a first impression of what the exhibition will be: a space of blue sensibility within the framework of the whitened walls of the gallery. We also decide to send the invitations in a stamped envelop with the formidable blue stamp of last year's Blue Period.

> Iris Clert invites you to honor with all your affective presence the lucid and positive advent of a certain reign of the sensuous. This manifestation of perceptive synthesis testifies to the pictorial quest for ecstatic and immediately communicable emotion in Yves Klein's work (Opening reception, 3, rue des Beaux- Arts, Monday, April 28 from nine p.m. to midnight).
> Pierre Restany

3,500 invitations were mailed, 3,000 in Paris alone. We also decided to add a kind of free admissions ticket, clearly noting that without that special little card the price of admission would be 1,500 francs per person.

M _____

> Invitation for
> TWO PERSONS
> from 28 April to May 5
> for anyone without this card
> the admissions price will be 1,500 Francs

This ploy is required because, although all the pictorial sensibility I display is for sale, piece by piece or as a whole, the spectators endowed with a body or vehicle receptive to sensibility would be able, despite all my effort and all my strength to keep the entire exhibition in place, to rob me, by impregnation, of some degree of intensity, whether consciously or not. And that, above all, must be paid for. After all, 1,500 francs is not really that much.

We then decide upon the preparation and material presentation of the exhibition. (For publicity, two large posters are planned for the Place St-Germain-des-Prés, for five days only, blue letters engraved on a white background, text: Galerie IRIS CLERT, 3, rue des Beaux-Arts, YVES THE MONOCHROME, from the April 28 to May 5. After this we announce the exhibition with small ads in the Paris editions of "ARTS" and "COMBAT" as well as in the American edition of "ARTS.")

IRIS CLERT's gallery is quite small, twenty square meters, with one door and one store window to the street. We will close the street entrance and provide access for the public through a small door off the entrance corridor of the building, which leads into the back of the gallery. From the street it will be impossible to see anything other than the color blue, for I shall paint the windows in the blue of last year's blue period. In front of the building entrance, through which the public will have access to the gallery by way of the corridor, I will place a monumental dais draped in fabric of the same dark ultramarine shade of blue.

On the evening of the opening, beneath this dais on each side of the entrance, Republican Guards in formal presidential dress uniforms will be stationed. (This will be required to bestow upon the exhibition the official character I aspire and also because the true principle of the Republic, were it applied, pleases me, even though I find it incomplete nowadays).

We shall receive the public in the corridor, which measures approximately 32 square meters, where a blue cocktail will be served (prepared by the bar of La Coupole in MONTPARNASSE: gin, Cointreau, methylene blue).

Once in the corridor, the visitors will see on the left-hand wall a large blue tapestry that conceals the small access door into the gallery.

We are also planning to have four private guards prepared to handle any developments in dealing with up to 3,000 people. This is quite urgent and necessary, especially since I anticipate acts of vandalism. They are trained in riot control and will be instructed to treat the public with the utmost courtesy as long as it conducts itself decently and does not behave too disagreeably.

Two of these "bodyguards" will be stationed outside at the entrance of the building, together with the Republican Guards, to verify the invitations, while the other two, standing on each side of the tapestry at the corridor gallery entrance, will admit the public in groups of ten at a time into the gallery. As for myself, I shall hold court inside, asking people to remain no longer than two or three minutes in order to allow everyone to enter.

Preparation of the gallery: in order to refine the ambiance of this gallery – its pictorial sensibility in the first material state – to an individual, autonomous, and stabilized pictorial climate, I must, on one hand, bleach the gallery to wash away the impregnations with the numerous preceding exhibitions. In painting the walls white I wish not only to purify the space but, above all, to transform it, through this action and gesture temporarily into my work space, my studio.

I believe I shall reach my goal if I work conscious of my act and filled with enthusiasm over the principle of the demonstration by applying one or several coats of paint to the gallery walls with my usual technique, like a great painting, with the best of myself and all the good intention possible, using pure white lithopone [zinc sulfide] mixed with my special varnish consisting of alcohol, acetone, and vinyl resin (which does not kill the pure pigment when it is fixed onto the supporting surface), and applying enamel lacquer with a roller.

While not playing the role of a house painter, which is to say, allowing myself to proceed at my own pace and in my own manner of painting, free and perhaps slightly distorted by my sensual nature, I believe that the pictorial space that I had succeeded to stabilize previously in front of and around my monochrome paintings will thenceforth be well established in the space of the gallery. My active presence during the execution in the gallery space will create the climate and the radiating pictorial environment that habitually permeates the studio of the artist endowed with a true power; a sensuous density that is abstract yet real, existing and living, by itself and for itself.

For that reason nothing must disturb the view in the gallery, which however should not be too deliberately bare. Thus, no furniture; we will leave the built-in display case at the rear left wall. I will simply paint it white like everything else, except for its metal fixtures. I will leave the cupboard under the gallery window facing the street, paint its wood surfaces white in the same way, and cover its base with white fabric.

The glass of the display case and the locked door opening onto the street will also be painted white. Everything will be painted white to receive the pictorial climate of the sensibility of dematerialized blue. I will paint neither the ceiling nor the floor; I will leave the new charcoal-gray floor carpeting in place, which Iris had installed a few days ago.

To make it extremely clear that I have abandoned the material and physical aspects of the color blue, waste and coagulated blood issued from the first matter and sensibility of space, I wish to obtain from the Préfecture of the Seine and from Électricité de France (EDF) the authorization to illuminate the Obelisk at the Place de la Concorde in Blue. By placing blue filters over the light projectors already installed, the entire obelisk can be illuminated while leaving its plinth dark. This will restore to the monument all the mystical brilliance of ancient antiquity and contribute, at the same time, a solution to the perennial problem that the plinth has always posed as sculpture. In effect, thus illuminated, the obelisk will soar into space, immutable and static, in a monumental movement of the affective imagination, over the entire expanse of the Place de la Concorde, above the prehistoric gas-lit streetlamps into the night, like an enormous unpunctuated exclamation mark!

In this way, the tangible and visible blue will be outside, outdoors, in the street, and indoors will be the dematerialization of blue: the colored space, which is not seen, but with which one is impregnated. On Wednesday, April 23rd, at 11:00 p.m., IRIS CLERT and I will meet with the technicians from the EDF on the Place de la Concorde, assuming that the authorization to illuminate the obelisk in blue for the evening of our opening reception will have been granted by the prefecture. On our arrival we will be exalted with

enthusiasm, already from afar, by this extraordinary vision of such rare and exceptional quality. The surfaces covered by hieroglyphs will become the pictorial material of a profound and mysterious richness that is unheard of and bewildering.

It is grandiose.

The tests are conclusive on all counts.

Saturday morning, at 8:00 a.m., I set myself to work in the gallery. I have forty-eight hours to paint the entire space, all by myself. By Sunday everything must be done in order to air it out properly before the opening reception. The dais will be installed on Monday morning. At 2:00 p.m. on Monday afternoon, I will prepare my inaugural speech on the movement of sensibility, which I will deliver after the reception, at around 1:00 a.m., at La Coupole, among friends, during the final round of drinks.

Everything is ready; around 7:00 p.m., I am in the gallery. Suddenly, the telephone rings (during the exhibition the telephone is placed in the corridor outside). It is the police department. A laconic voice announces to me that a decision has been made to suppress the illumination of the Obelisk on the grounds that it is too personal in character and would attract too much publicity on the radio and in the newspapers. I am crushed ...

I attempt to contact IRIS who has left to prepare the opening reception scheduled to begin at 9:00 p.m. I find her; she desperately rushes off to the police department, but it is too late, all the world has left, and there is nothing left to be done. The next day we learn that this brusque and unexpected decision on the part of the authorities had been brought about by offensive and abominable telephone calls of jealous individuals who had calumniously objected to this official favor that had been granted me.

At 8:00 p.m. I went to La Coupole to have a "blue cocktail" specially prepared for the exhibition.

At 8:45 p.m. I am at the gallery. Last preparations.

At 9:00 p.m. the arrival of the Republican Guard in formal dress uniform. As soon as they arrive I offer them an honorary blue cocktail before they assume their position to stand attention beneath the dais at the entrance.

They arrive almost simultaneously with the four private security guards. I explain their duties to each of them; they recited them back to me and already the first visitors arrive ...

9:30 p.m. The place is packed; the corridor is full, as well as the gallery. Outside the crowd piles up, barely managing to get inside

9:45 p.m. It is delirious. The crowd is so tightly packed that no one can make the slightest movement. I am staying inside the gallery. Every three minutes I shout out and repeat in a loud voice to those piled up in the gallery (the private security guards can no longer contain them or control the gallery entrances and exits: "Ladies and gentlemen, please have the extreme kindness not to stay too long in the gallery so that other visitors waiting outside can enter in turn."

9:45 p.m. RESTANY arrives, in a car driven by BRUNING from DÜSSELDORF to PARIS, exact at the same time as KRICKE and his wife.

9:50 p.m. I suddenly notice, in the gallery, a young man about to draw on one of the walls. I rush towards him, make him stop and ask him politely but very firmly to leave. As I accompany him to the small exit door, the crowd inside the gallery has fallen silent and is now watching to see what is going to happen. I shout to the guards who are in the corridor: "Seize this man and throw him out!" He is literally extirpated, snatched by my guards.

10:00 p.m. The police arrive in force (three full patrol cars) by way of the rue de Seine; firemen also arrive in force, just as numerously, by way of the rue Bonaparte, but they cannot move any closer through the crowd in the rue des Beaux-Arts than to Galerie Claude Bernard ...

10:10 p.m. There are between 2,500 and 3,000 spectators in the street; The police by way of the rue de Seine, the firemen by way of the rue Bonaparte try to push the crowd towards the embankments of the Seine. When a police patrol reaches the entrance of the gallery to demand an explanation of what is going on (some people, furious at having paid 1,500 francs admission but unable to see anything at all, start to complain), my body guards laconically but firmly inform them: "We have our own private security

to maintain order here; we have no need of you." The police patrol, having no legal right to enter, withdraws.

10:20 p.m. the representative of the Order of Saint Sebastian arrrives in full dress (a bicorne hat with a cape emblazoned with the red cross of Malta). Many painters find themselves in the room at the same time. Camille Bryen exclaims: "All in all, what we have here is an exhibition of painters!"

For the most part, the crowd enters the gallery in anger and exits from it fully satisfied. It is what the Great Press will be forced to notice officially in writing that 40% of the visitors react positively, grasped by the pictorial sensuous state and seized by the intense atmosphere that reigns, terrifyingly, in the apparent void of the exhibition space.

10:30 p.m. The Republican Guards leave, feeling nauseated; for the last hour art students have slapped them familiarly on the shoulders demanding to know where they have rented their costumes and if they are movie extras!

10:50 p.m. We are out of blue cocktails. Someone runs to La Coupole looking for more. Two pretty Japanese women in extraordinary kimonos arrive.

11:00 p.m. The crowd outside, which had been dispersed by the police and the firemen, returns in small, exasperated groups. Inside, the place is teeming as ever.

12:30 a.m. We close up and leave for La Coupole,

At La Coupole, a huge table for forty in the back.

1:00 a.m. Trembling with exhaustion I pronounce my revolutionary discourse.

1:15 a.m. IRIS passes out!

The next morning. IRIS is summoned urgently to the Republican Guards. There she is submitted to a two-hour-long interrogation and is charged with an affront to the dignity of the Republic. Everything is fixed the next day when the Chief Commander of the Guards himself visits the scene (of the so-called crime according to the slanderers).

The exhibition, scheduled to be open for eight days, has to be extended for an additional week. More than two hundred visitors rush each day into the interior of the century.

The human experience has considerable range, almost inde-scribable. Certain people are not able to enter, as if deterred by an invisible wall. One of the visitors shouts to me one day from the door: "I shall return when this void is full ..." I answer him: "When it is full, you will no longer be able to enter."

Some stay inside for hours without saying a word, others trem-ble or start to cry.

I have sold two immaterial paintings out of this exhibition. Belief me, one is not robbed when purchasing such paintings. It is I who is always robbed because I accept money. This is why, at the Hessenhuis in Anvers, in a group show with BREER, BURY, MACK, MUNARI, UECKER, PIENE, ROT, SOTO, SPOERRI, and TINGUELY, I did not even want to paint one or several walls nor make any kind of figurative gesture, sweep or brush the walls with even a dry, paintless brush. NO, I simply restrained myself to presenting my-self at the exhibition space on the day of the opening, announcing to everyone in the space that was reserved for me:

"*FIRST THERE IS NOTHING, THEN THERE IS A DEEP NOTH-ING, THEN THERE IS A BLUE DEPTH*" (after G. BACHELARD). [31]

At present I no longer wish that anyone purchase my work for money. I have asked, for my three pictorial states exhibited, a quan-tity of pure GOLD. One kilo of GOLD for each work. There it is, cut and dried at last ... at last for the moment; afterwards we shall see what follows, which will not be long in coming.

Because, for me, there are no more problems. As I said at the be-ginning of this text: "I have overcome the problematics of art."

31 G. Bachelard, *Air and Dreams*, p. 168.

Speech Delivered after the Opening Reception
for the Pneumatic Period

Ladies, Gentlemen,

All of you this evening have conscientiously attended a historic moment in the history of universal art. Even beyond my modest person, this is the abrupt extrapolation of four millennia of civilization that has just found its exhaustive coronation. At a time when the advance of technology relates the first part of the twentieth century back to the innermost depth of the Middle Ages or the Lower [Byzantine] Empire, the message that I carry within myself is one of life and of nature, and I make you take part in it to the same degree that my companions will know my thoughts better than I myself should know it, for if they number in the thousands they will reflect it thousands of times, whereas I myself am alone.

I have reserved a surprise for you and I have thus decided to fulfill to your expectations. At the intersection of light where I have arrived, there are only two possible paths: the path of darkness, of retreat, of maceration, of meditation and renouncement; and that more arduous and more glorious path of sacrifice to the community. "Beforehand, people, I think that when one speaks of something one should speak in good faith," as Socrates says. And, I know that I have thus accomplished a just deed!

The justification of my work resides in the universal and motivated projection of its pictorial essence. When Paderewski[32] decided to seize power in a Poland on the edge of an abyss in order to turn it into a symphony or rather, alas, a funereal march, he had fewer reasons than I who wishes to turn France into an immediate and radiant vision. The detection of a new significant human state within the framework of my pictorial evolution prohibits to me to give up increasing my physical canvases; they are like the

32 Ignacy Jan Paderewski, Polish musician and diplomat.

Nestlé box of the Virgin[33] of which I say with Goethe, "Ich liebe dich, mich reizt deine schöne Gestalt; / Und bist du nicht willig, so brauch ich Gewalt."[34]

I have grasped, I say, the very essence of the human condition in relation to the universe for which I am not responsible and "to speak strictly and truly, this dismays me."

The indefinable of Delacroix is not to paint walls in blue but rather to refine the natural atmosphere.

The provisional government of rehabilitation will be a chivalric order in which artists, religious figures, and scientists will present France with a suitable color, Blue or white, even amaranth, and it will eradicate the miasmas of a horrible green, red, and gray France, of a leprous France; this government will reclothe its soldiers in the gaudy uniforms of Napoleon III or the lead soldiers of our childhood and rid us, like Holy water does away with the devil, of those to whom we can say with Cicero: "Quousque tandem Catilina abutere patientia nostra?"[35] Our pure and scandalous government will wipe out the hypocrits, the Françoise Sagans, the cheaters, the Genets, the Georges Duhamels, the Einsteins, the Roosevelts, the Pandit Nehrus, the rats and the trash, etc.

It is said and done.

33 Most likely, Klein refers here to the 1935 parody of a Madonna and Child painting by Raphael created by the Swiss artist Louis Rivier. It depicts the Virgin Mary feeding the infant Jesus from a modern nursing bottle while the infant St. John looks on yearningly. Captioned "Maternity as seen by Raphael," it was used, however, by Nestlé only once, as an advertisement in the magazine L'Illustration.

34 "I love you, your beauty has wakened my lust; I'll take you by force if I must" (from Goethe's poem Der Erlkönig, trans. David Luke).

35 "How long, Catilina, will you abuse our patience?"

Sketch for the Technical Manifesto of the Blue Revolution

"The Blue Revolution," a movement leading to the transformation of modes of thought and action of a people in the sense of individual "duty," in artistry, vis-à-vis the national collective, still in artistry, vis-à-vis the collective of nations.

Institute a council of ministers, under the political and moral control of an international chamber. This chamber of reflection would be an obligatory advisory board, modeled after the United Nations and composed of one representative from each nation.

The National Assembly would thus be replaced by a French U.N. The entire governmental power thus constituted would rest entirely under the authority of the United Nations.

Through this transformation of governmental structure, it is possible to make an example to the world on the order and greatness of the French Revolution of 1789, which upheld the universal ideals of "Liberty, Equality, and Brotherhood," then a necessity but still enduring with the Declaration of the Rights of Man and of the Citizen, which should be augmented today with a new law in the democratic sense, that of "virtue." Patriotism must thus become the patriotism of the world. Just as it is already the patriotism of art.

N.B. Duty = Imaginative action with a sense of responsibility.

Sketch and Broad Outlines for the Economic System of the Blue Revolution

The economy is the elective domain of vain illusions and of constructions in which the suppositions denote the insufficiencies of the prior analysis. Certain schools believed to perceive a good number of realities, but this approach to economic matters has too often remained only an approximation. Some down-to-earth physiocrats did not known, while exhausting the gangue of the sensuous universe, to break up the materiality of the cosmos in order finally to reach the definition of the unknowable by the sudden awareness of the marginal unity of space. A new effort came to light in the 1930s with the Keynesian school and its Full Employment Policy; but if the vocation of employment was able to lead to a valuable therapeutic amount, the complete failure of the general public to recognize spatial intensity could only lead once more to a quantitative approximation. We see therefore that everything is analyzed in terms of failure, and the balance sheet of composite economies today reveals only a large deficit.

A new era must thus appear in which a qualitative perception of the energetic field of the economy can at last orient the fundamental inertia of the "living" towards a dynamic conception of creation. For me this concept finds its foundation in the wealth, each day more elaborated, of spatial patrimony. It stretches out like a great fresco that awaits its monetary label. In fact, I challenge reserves and currencies: riches accumulated from the glories of the past but perilous mortgages of the structures of the present. No need henceforth for these wasteful intermediaries whose facticity hollows out a past between the intellectual prehension and the very quality of the values seized. Adhere therefore to the real, and, beyond a pure system of representation, let us then turn more simply towards the acceptance of the intrinsic value of matter, residing essentially in the notion of quality.

Upon this structurally qualitative foundation, each corporation will be made to deposit in the vaults of the Central Bank, previously emptied of all deposits of metals, their masterpiece of the

profession. Said masterpieces, thus gathered, will materialize the basic spiritual direction of the country, providing free access to any and all evolutionary potentiality – the sole source of progress. This permanent example, a catalyst of latent power, in maintaining in the spirit a stable sampling – but one that remains open – will finally allow to cast the foundations of a system of barter that is fundamentally healthy and sheltered from economic quantitative variations.

In fact, the suppression of fiduciary circulation eliminates also the slightest possibility of a cyclical evolution of the classic inflationary spiral. Overproduction, instead of presenting useless growth of qualitatively enumerable riches, will no longer be a pure and simple loss of strength but a general emulation whose constructive quest will contribute to the splendors of the future. In the international arena, the creation of a standard representative only of a quasi-spiritual value will prevent the development of any form of commercial Malthusianism, and will end, on the contrary, conflicts over customs duties, the motion of quality becoming a multiplier of past antagonistic national economies.

These brief opening comments on a possible economy of tomorrow, should we desire it, already provide glimpses into the enormous possibilities of a system that, at last, reconciles universal moral and intellectual aspirations with the most peremptory economic imperatives. Tomorrow, to be sure, the economic world will greet a new era and I shall at least have had the satisfaction to have known its awakening.

In such a system, the wealthy man would necessarily be an authentic genius in his specialty. Which, at last, will be only just.

Speech Delivered on the Occasion of the Tinguely Exhibition in Düsseldorf (January 1959)

Ladies, Gentlemen,

This evening, on the occasion of Jean Tinguely's formidable exhibition, which I consider to be the very fixative medium of the century! ... I would like to put forth to all those who willingly hear me: COLLABORATION! But pay attention to the etymology of the word. To collaborate means precisely to work together on the same project. The project upon which I propose collaboration is Art itself!

The source of inexhaustible LIFE through which as true artists we are liberated from the dreamy and picturesque imagination of the psychological realm, which is the anti-space, the space of the PAST, is found in Art. In an art without problematics we shall attain eternal life and immortality. Immortality is conquered collaboratively. This is one of the laws of man's nature with respect to the universe!

In order to create, it is never required to turn back on oneself to consider one's work, for this would be to come to a halt, which is death. The work must be like a volumetric wake; like a penetration by impregnation with sensibility in the immaterial space of LIFE itself. In collaboration we shall then individually practice "pure imagination."

This imagination of which I speak is not a perception, not a memory of a perception, the familiar, habitual memory of colors and forms ... It has nothing to do with the five senses, with the domain of sentiment and emotion, or even the purely and fundamentally emotional. That is the imagination of artists who are incapable of collaborating! For, out of a desire at any cost to save their individual personalities, they kill off their spiritual individualism and thereby lose their Life!

Artists who are unable to collaborate work with the gut, the plexus, the intestines! Artists who collaborate work with their hearts and their minds!

These are the artists who know of the RESPONSIBILITY of being HUMAN vis-à-vis the UNIVERSE!

For those artists, the imagination is in the psychic life, the continual experience of the "opening," the very experience of newness (according to G. BACHELARD).[36]

For the artists ready for collaboration, TO IMAGINE is to absent oneself, it is to leap towards a new life. In catapulting themselves in all directions and in all dimensions of their constantly new lives, they are paradoxically both united and separated at this same time. The imagination, for them, is the "audacity" of sensibility.

What is sensibility?

It is what exists beyond our being, yet is forever a part of us. Even Life itself does not belong to us; it is with our sensibility that we are able to purchase Life. Sensibility is the currency of the universe, of space, of Nature. It allows us to the purchase LIFE in the first material state! Imagination is the vehicle of sensibility! Transported upon imagination, we attain "Life" – life itself, which is absolute art.

In the wake of such volumetric motion in place, through vertiginous static speed, Absolute Art (which mortals vertiginously call GREAT ART!) soon materializes and appears to the tangible world.

This evening, I propose collaboration to artists who, already, are aware of all I have just pronounced and perhaps of even more ... to mock their possessive and egocentric personality, to exasperatedly cast aside the ME in all their representative activities in the theatrical, physical, and ephemeral tangible world in which they well know themselves to play roles ... I propose to them that they each continue to say "my work," separately, in speaking to the living dead who surround us in the daily life of common work that is moreover created in collaboration. I propose to them that they joyously

36 In *The Poetics of Space*, Bachelard writes: "The minuscule, a narrow gate, opes up an entire world. The details of a thing can be the sign of a new world, which, like all worlds, contains the attributes of greatness" (p. 155).

continue to say ME, I, MY, MINE ..., etc. and not the hypocritical WE, OUR ... But that, only after having solemnly signed the pact of COLLABORATION this evening!

I shall then find quite natural and normal to learn some day that the members of the famous pact have somewhere in the world suddenly and spontaneously signed one of my paintings, without even speaking of me nor even of COLLABORATION. Likewise, any the works that please me among the works of other members of the pact, I shall rush to sign without in the least feeling any need to indicate that, in fact, the work is not done by me.

I push towards this somewhat eccentric extreme perhaps in order to clearly show how, in the collaboration that I propose, it will be a matter of playfully flaunting the psychological world in order to free ourselves of its confines.

I am not speaking this evening in a utopian spirit in proposing this new form of collaboration in order to attempt to reinitiate on different foundations a perfected "BAUHAUS" in 1959. I speak on good grounds. For more than a year already, I have successfully collaborated with the architect Werner Ruhnau. Together we created the architecture of air and many other things are still in preparation. With the sculptor Norbert Kricke I conceived water, wind, fire, and light sculptures, without however having yet produced them. For the past months, Jean Tinguely, here present, and I have together excavated a mine of constantly renewing wonders, that of the perplexing "fundamental static motion in the universe."

In conclusion: in proposing Collaboration in art to those artists with mind and heart, I am, in fact, proposing to them to overcome art itself and to work individually on returning to real life where the thinking man is no longer the center of the universe but the universe the center of man. We will then know "prestige" in relation to the "vertigo" of the past.

We shall thus become aerial men. We shall know the forces that pull us upwards to the heavens, to space, to what is both nowhere and everywhere. The terrestrial force of attraction thus mastered, we shall literally escape into a complete physical and spiritual freedom!

Example of a Realized Collaboration
The General Evolution of Today's Art Towards Immaterial-
ization (not Dematerialization), by Yves Klein, artist-painter
and Werner Ruhnau, certified engineer, architect

Void		Blue light
Stratosphere		Energy
Atmosphere:	Optical fires	Heavy air
	Magnetism	Other gases
	Water	heavier
	Light	and denser
	Sound	than air
	Sound opposing sound	
	Odors	
Earth		Mortar
		Cement
		Stone
		Clays
		Iron

The architectures of air are here presented only as examples. What is ultimately important is the spiritual principle itself to utilize new materials for a dynamic and truly immaterial architecture.

Air, gases, fire, water, sound, odors, magnetic forces, electricity, electronics, etc. and again, and above all, air are such materials; they should have two known purposes: protection against rain, wind, and, in general, the mechanical conditions of the atmosphere; and thermal air conditioning, to heat and to cool. It is possible to envision the separation of the two functions. It has been shown that to each natural state, such as earth, water, air, etc., there are corresponding elements of construction. These elements of construction must always be denser and heavier than the original state in which one employs them (see the table above): on the left side are shown the original primary states of our world, and on the right side, the proposed corresponding construction materials.

The architectures of air should adapt themselves to given natural environmental conditions such as mountains, valleys, monsoons, etc., if possible without requiring the operation of large artificial modification.

For example, in places where the wind changes direction every six months, the roof of air may be created with very minimal artificial means.

In the end, it is an old dream of mankind and of the imagination to play with the elements of nature, to direct and control their phenomena and manifestations.

The evolution of Yves Klein had to arrive at an architecture of air because only in it can his pictorial sensibility in the first material state finally be produced and stabilized. Until the present time, in a space still architectonically very precise, he has been painting unified monochrome canvases in an enlightened and sane manner. The sensibility of color, still highly material, ought to be reduced to a more pneumatic immaterial sensibility.

Ruhnau is certain that today's architecture is on the path towards the immaterialization of the cities of tomorrow.

The suspended roofs and the tent construction of Frei Otto and others are important steps taken in this direction.

In utilizing air and heavy gases, sound, etc. as elements of architecture, this development can be further advanced.

Yves Klein's walls of fire and water are, along with the roofs of air, the materials for the construction of a new architecture.

With the three classic elements – fire, air, and water – the classic city of tomorrow will be constructed and will finally be flexible, spiritual, and immaterial.

The idea in space, of using pure energy as a material for construction for mankind, no longer seems absurd in this order of thinking.

GELSENKIRCHEN, 15 December 1958

My System of Evolution

1. – Composition
2. – Judo
3. – Music
4. – Painting
5. – Sculpture my current areas of activity
6. – Architecture
7. – Politics

Yves Klein (called the Monochrome)
Born 28 April 1928 in Nice
French Nationality
Artist-Painter
14, rue Campagne Première - Paris (14e)

Personal History

After having studyied at the National Merchant Marine Academy (*L'École nationale de la marine marchande*) and at the National School of Eastern Languages (*L'École nationale des langues orientales*), worked successively as a bookseller in Nice and as a racehorse trainer in Ireland. After traveling extensively throughout Europe, left in 1952 for Japan. After obtaining a 4th dan black belt at Kodokan in Tokyo, became technical director of the National Federation of Judo in Spain, 1954. During this time published *The Fundamentals of Judo* (*Les fondements du Judo*, Éditions Bernard Grasset, Paris) and a collection of reproductions of works (Fernando Franco, Sarabia, Madrid). He has lived in Paris since 1955.

N. B.
Under no circumstance do I consider myself an artist of the avant-garde. I insist on making it clear that, on the contrary, I think and believe myself to be a classical artist, perhaps even one of the rare classics of this century!

Creation of a Center of Sensibility[37]

The mission of this center of sensibility is to reawaken the potential of creative imagination as forces of personal responsibility. A new conception, the true notion of quality should replace that of quantity, which today overworked and overvalued.

It is possible to succeed in this through the immaterialization of sensibility.

At present, this is a question of recognizing the decayed state of the problematics of art, religion, and science. The problematics will no longer exist at the center of sensibility. The goal here is the nonproblematic existence of man in this world.

The idea of freedom becomes a new grace thanks to the unrestrained imagination and the forms of spiritual realizations. "The universe is infinite yet measurable." The imagination is realizable. It is viable. It should be lived at the School of Sensibility. This will be its radiating nucleus.

Immaterial architecture will be the face of this school. It will be flooded with light. Twenty masters and three hundred students will work there with neither program of instruction nor examination jury.

The action of the "Bauhaus Dessau" did not rest upon a interval of time but upon the concentration of ideas. After ten years, the School of Sensibility can be dissolved.

In order to infuse this school with the spirit of sensibility and immaterialization, the masters – with no exceptions – must participate in the construction of the school. The entire student body constitutes a collaborative play in the continual beginnings of this construction.

Materialism – all that is quantitative in spirit – has been recognized as being the enemy of freedom. Since long ago, a battle has been engaged with this spirit. The true enemies are psychology, sentimentality, and composition.

37 Original written in German.

Sentimental heroism engenders totalitarian worlds, wars, spaces defined by terror, residues for the ventriloquists of the Occident.

The School of Sensibility desires imagination and immaterialization. The school desires freedom for the heart and for the mind.

Dipl.- Ing. Werner Ruhnau, *architect*
Yves Klein, *artist-painter*
Gelsenkirchen, 27 March 1959

In addition to the creation of a School of Sensibility, this program may well influence the spirit of existing schools.

CHAIRS Provisional list of professors:

1. SCULPTURE Tinguely
2. PAINTING Yves
 Fontana
 Piene
3. ARCHITECTURE Frei Otto
 Ruhnau
4. THEATER Claude Pascal
 Pierre Henry
 Bussotti
 Polieri
 Kagel

In addition:

PHOTOGRAPH Wilp
CRITICISM
HISTORY
ECONOMY Péan
RELIGION
PRESS Restany
FILM
TELEVISION
POLITICS
PHILOSOPHY

PHYSICS
BIOCHEMISTRY
MILITARY SCHOOL General Dayan
MARTIAL ARTS

The construction costs
of the school are fixed
(for 1959) at: DM 10,000,000
Land DM 2.000,000
 ─────────────────
 DM 12,000,000

Annual cost for
20 professors
12 x DM 2,500 DM 600,000

Annual cost for
teaching materials DM 600,000
200 students:
12 x 500 DM per year DM 1,200,000
 ─────────────────
Total annual costs DM 2,400,000

Estimated misc. costs
(per year) DM 600,000

– All estimates are calculated in 1959 German Marks –

—◇—

Ladies and Gentleman,

[...] To best introduce you to the issues that Werner Ruhnau and I are going to present to you in our two presentations tonight and this Friday evening, I should perhaps first devote myself to a retrospective discussion of my evolution, taking its origins as my point of departure, without losing sight of its ultimate and consciously attained end: that of the immaterialization of art in order to rebound, in one prodigious leap, from the brink of the problems of art into an authentic immaterial reality. This is what we refer to as sensibility, of which we believe, already for some time, to have comprehended its intelligent existence, while remaining, despite our imprisonment in the psychological vertigo of composition, at the edge of the immeasurable marvel of life itself, of life in itself, on which personality at no time can inscribe its name. For his part, the architect Werner Ruhnau will guide you to the immaterial through the historical evolution of architecture across the ages. I for my part, as a painter, shall attempt to lead you to this same immaterial through my personal experiences, interspersed with reflections on successive operations that we shall review backwards through time.

Why this retrospective in time? Precisely because I have no desire to allow neither you nor myself to be seized, even for an instant, by the phenomenon of sentimental and picturesque reverie that inevitably results in an abrupt landing somewhere in the past, in the psychological past, to be exact, which is the counterspace, the space I have attempted to leave through my work of the past ten years. A thankless and painful work, oftentimes scattered with cruel doubts, which nevertheless has ended with the engendering of the architecture of air, almost already realized by

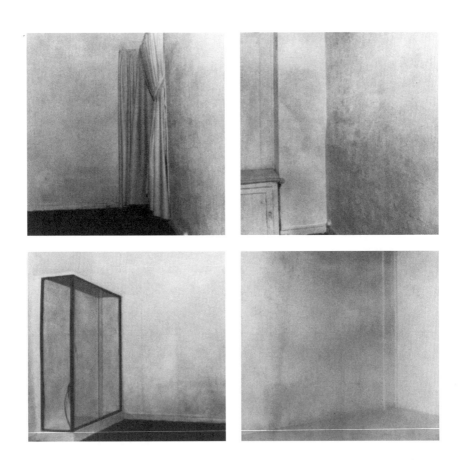

*The Refinement of Sensibility in the First Material State into
Stabilized Pictorial Sensibility,*
Galerie Iris Clert, Paris, 28 April 1958

Werner Ruhnau and myself. It promises, I hope, total physical comfort befitting to us in atmospheric phenomena and thermal conditions of Nature on the surface of our planet in the near future.

I begin, therefore, quite without emotion by seizing Ariadne's thread,[38] which for me is impalpable sensibility, new matter, and new dimension, before entering into the labyrinth of sentimentality, promising myself firmly to never let go of it until I return. And here is how it all happened.

First, hardly two months ago, at Anvers, I was invited to exhibit with a group of artists made up of [Pol] Bury, [Jean] Tinguely, [Dieter] Rot, [Robert] Breer, [Heinz] Mack, [Bruno] Munari, [Daniel] Spoerri, [Otto] Piene, and [Rafael] Soto. I traveled to Anvers and instead of installing a painting or whatever tangible and visible object in the space reserved for me in the Hessenhuis exhibit hall, I loudly pronounced to the public these words borrowed from Gaston Bachelard during the opening reception:

> First there is *nothing,* then there is a *deep* nothing,
> then there is a blue *depth.*[39]

The Belgian organizer of this exhibition then asks me where my work could be found. I reply, "Right here, where I am speaking" – And what is the price of this work? – "One kilo of gold, one kilo of pure gold will be acceptable for me."

38 Ariadne's thread, named after the red fleece which, in Greek mythology, Ariadne gave to Theseus to find his way out of Minotaur's labyrinth, is a logical term used to describe the solving of a problem with multiple solutions such as a logic puzzle or an ethical dilemma by arbitrary decisions. It is also mentioned in Heindel's *The Rosicrucian Cosmo-Conception* (chapter VII): "The 'Ariadne's thread' which will guide us through the maze of Globes, Worlds, Revolutions and Periods will be found when it is remembered and kept steadily in mind that the virgin spirits which constitute the evolving life wave became entirely unconscious when they commenced their evolutionary pilgrimage through the five Worlds of substance denser than the World of Virgin Spirits. The purpose of evolution is to make them fully conscious and able to master the matter of all the Worlds."

39 G. Bachelard, *Air and Dreams,* p. 168.

Why these extravagant conditions instead of a normal price represented simply by a sum of money? Because, for the pictorial sensibility of the first matter, adapted and stabilized by me and pronounced in these few words upon my arrival, which made the blood of this spatial sensibility flow, one cannot demand money. "The blood of sensibility is blue," says Shelley, and this is precisely what I think. The price of blue blood can never be silver. It must be gold. And then, as we shall see later, in Dr. Robert Desoille's[40] analysis of the waking dream, blue, gold, and pink are of the same nature. Only between these three states can there be fair exchange.

The public is highly receptive. Taken with the new, and full of good will, it remains perplexed and awaits something, for it sees neither a painting nor any other visual phenomenon. I am resolved to comment upon my act and declare:

"Perhaps it seems to you that I am attempting the impossible, that I am throwing myself towards something that is inhuman ... Truth be told, I would almost wish this for myself, that is, to begin my pictorial career today through this act, but alas! All of this is indeed human in the most authentic and constructive sense, which may be the most traditional, for it is the result of a long evolution, of a continual and persevering personal quest, often difficult over the years, a quest for liberation, for a forever truer comfort, a comfort more just, more airy than the material and tangible existence that we live in, an existence smothered and obscured by technology, which is the false and illusory perspective of science. The true science is pure art. "

For that exhibition I took my pictorial action precisely to the most extreme point of reduction. I could have made symbolic gestures, such as sweeping the space that had been reserved for me in that hall; I could even have painted the walls with a dry brush, without paint. No! The few words that I pronounced were already

40 Cf. G. Bachelard, *Air and Dreams*, pp. 111-25 (chap. 4). Desoille's studies were published in *Exploration de l'affectivité subconsciente par la méthode du rêve-éveillé: sublimation et acquisitions psychologiques* (Paris: J.L. d'Artrey, 1938). See Klein's extensive quotations from Bachelard's chapter below.

too much. I should not have come at all, nor should my name have appeared in the catalogue. [*Applause*]

"Where science fails, technology begins," says Herschel.[41] And I believe that I can say with good reason this evening that it will not be with rockets, sputniks, or missiles that mankind will achieve the conquest of space, for he will then always remain just a tourist in space. Rather it is achieved by inhabiting its sensibility, which is to say, not by joining up but by impregnating oneself, by becoming one with life itself, this space where the tranquil and tremendous force of pure imagination and of a feudal world reigns that, like mankind, has never known neither beginning nor end!

One must not take this to mean that I condemn technology, no, but let us leave it in its place. The more one lives in the immaterial, the more one loves matter. Technology is but the means; science, like art, is the end. Technology can never become a complete and autonomous entity, unlike the scientific fact or the work of art. "Woe to the picture which shows to a man gifted with imagination nothing more than finish. The merit of the picture is the indefinable: it is just the thing which goes beyond precision," Delacroix writes in his diary.[42]

On the occasion of an exhibition opening last January for one of my artist friends, I spoke briefly about one of the problems that Werner Ruhnau and I believe to be since always among the most important and most human of problems: cooperation in art.

The substance of this short speech was this: cooperation means to join ones action with that of others in order to reach a common goal. The goal for which I propose this cooperation is art. In art without problems can be found the source of inexhaustible life through which true artists, those whose are liberated from the dreamy and picturesque imagination of the psychological realm – the counterspace, the space of the past – shall attain eternal life, and immortality. Immortality is conquered jointly, this is one of the natural laws of mankind with respect to the universe: in order

41 Sir John Frederick William Herschel, English mathematician, astronomer, chemist, and experimental photographer.

42 *The Journal of Eugène Delacroix* (Supplement), p. 711.

to create, one must never turn back to consider ones work, for this would mean to stop, and to stop is to die. The work must be like a volumetric wake of penetration caused by the impregnation in sensibility, in the immaterial space of life itself.

Within this association of efforts, we must then individually practice pure imagination. This imagination of which I am speaking is neither a perception, nor the memory of a perception, nor a famil-iar memory, nor a habitual sense of colors and form. It has nothing to do with the five senses, with the domain of feeling or even with the purely and fundamentally emotional. That would be the imagina-tion of artists who will never be able to participate, for in their desire to preserve their individuality at all cost, they kill their fundamental spiritual selves and lose their lives.

Those artists who are unable to cooperate work with their stom-ach, their plexus, and their guts. Artists who are able to create communally work with their hearts and with their heads. Those are the artists who understand the responsibility of being human vis-à-vis the universe. The imagination of those artists lies in their psychism. The continuous experience of a beginning, the experi-ence even of newness, of which Gaston Bachelard speaks. For those artists prepared to cooperate, imagining means withdrawing, leap-ing forward to a new life. In their combined élan, going out into all directions and dimensions, they are paradoxically at once unified and apart. Imagination for them is the "audacity of sensibility."

What is sensibility? It is what exists beyond our being yet be-longs to us always. Life itself does not belong to us. It is with our own sensibility that we can purchase life. Sensibility is the curren-cy of the universe, of space, of Nature. It allows us to purchase life in the first material state.

The imagination is the vehicle of sensibility. Transported by the imagination, we attain life, life itself, which is absolute art. In the wake of such volumetric motion in place, such vertiginous static speed, absolute art soon materializes and appears in the tangible world. It is what mortals call, with a sensation of vertigo, "great art."

I propose then the following to the communal artists who already know what I have just enunciated and perhaps even more, know to mock their possessive, selfish, and self-centered personality through a kind of exasperation of the Me in all their representative activities in the theatrical, tangible, physical, and ephemeral world in which, as they quite well know, they play a role: I propose to them that they continue to say "my work" for their separate parts, which nevertheless are produced in cooperation, when speaking to the living dead who surround us in the daily life of the communal work. I propose to them that they continue to say joyously "me, I, my, mine," etc. and not the hypocritical "we" and "our," but this only after having fully adhered spiritually to the conjugation of means in the creation of art.

I shall then find it completely natural and normal to learn one day that one of the members of the celebrated pact has suddenly and spontaneously signed on of my paintings somewhere in the world without even mentioning me or of our enterprise. Similarly, I shall hasten to sign the works of other adherents of this kind of pact without preoccupying myself in the least with the fact these works are not, in fact, mine. [*Applause*] I put forth this apparently somewhat primitive, perhaps naive and eccentric extreme to clearly show how, this cooperation that I am proposing will be a matter of playing with this conventional psychological world to successfully free ourselves from it.

I do not speak in a utopian manner in proposing such a program in an attempt to bring back, on different foundations, another Bauhaus in 1959. I speak with full knowledge of the facts. For more than a year now I have successfully practiced this kind of cooperation with the architect Werner Ruhnau. Together we have created the architecture of air and other things are in preparation. With the sculptor Norbert Kricke we have created, but not yet realized, sculptural representations of water, wind, fire, and light. With Jean Tinguely we have been excavating marvels together constantly for ten months and upsetting the static movement of the universe.

Finally, I want to especially pay homage to Iris Clert, in the name of all her "foals," as she calls us, for the elevated and enthu-

siast spirit that she brings to the communal work, for her magnetic genius as an organizer who, in barely two years, has succeeded to gather in her gallery, as I have already said, the most dedicated and authentic seekers in the world of contemporary art.

In conclusion, by proposing a communal enterprise in art for artists of the heart and the mind, I am in fact proposing that they bypass art itself and work individually for the return of the real life, where the thinking man is no longer the center of the universe but the universe is the center of man. We shall then know distinction in relation to the vertigo of former times, and shall thus become aerial men. We shall know the force of attraction towards heights, towards space, towards that which is at once nowhere and everywhere. Thus having mastered the force of attraction, we shall literally levitate in complete physical and spiritual freedom.

I will take advantage of this moment to respond to the many kinds of contemporary pictorial attempts called "gesture," "sign," "speed." I know an artist who has created machines to produce paintings of that kind. These machines and their works have been presented quite recently here in Paris. The works are to certain abstract or nonfigurative art as the innovation of photography was to the realism of the nineteenth century. Just as the academic exasperation of realism was halted by photography, which allowed, in my opinion, painting to return on the path of wonder – that which it must always do to be truly painting, truly art. That path was Impressionism, and the same is true also for these extraordinary machines, which produce paintings of unprecedented and indisputable quality, improvisation, and variety. In this technical spirit of the "sign" and of "speed" will happily in time bring to a halt this class of abstract art, which has dangerously for several years rushed an entire generation into an emptiness that has no fullness, precisely into that which is the scourge of the Western world: the hypertrophy of the Me, of the personality.

I am specifically addressing those artists who have so often attacked my style of painting. I don't need any sign to orient myself in navigating the sea of sensibility. According to Poincaré, our feelings cannot give us the concept of space. Our mind construct

this concept out of elements that preexist within it. Feelings themselves have no spatial character. "It is not by going fast that one attains speed."

Descartes, whom all the fanatics of that art of the gesture and of the sign condemn and mistrust, foresaw the technical device that becomes a scientific objcct. These painting machines will be soon available to whoever desires to create an abstract canvas of quality, at whatever speed and in whatever lapse of time, limited or unlimited, with or without fervor, anger, delicacy, gentleness, brutality, charged with extraordinary signs, executed with gestures no less extraordinary than these machines themselves, even more so, the height of the spectacular. [*Applause*]

Having said that, I return to the attempts to coordinate with artists who work cooperatively on an absolute art, attempts that today are not yet easily realized. Here is first a summary of what this research has yielded. It is in form of a manifesto published by Werner Ruhnau and me: "The Creation of a Center for Sensibility." This Center for Sensibility has the mission to reveal the possibilities of creative imagination as a force of personal responsibility. A new concept, the true notion of quality, needs to be substituted for quantity, today overused and overvalued. It is possible to reach that point through immaterialization and sensibility.

Presently, it is a matter of recognizing the decayed state of the problems of art, religion, and science. These problems will no longer exist at the Center for Sensibility. The idea of freedom will become a new notion thanks to the unrestrained imagination and its forms of spiritual realization. The universe is infinite yet measurable. The pure imagination is realizable. It is viable. It must be lived at the Center for Sensibility. This will be the very heart of its radiance. Immaterial architecture, of which we shall soon speak this evening, will be the face of this center. It will be flooded with light. Twenty professors and three hundred students will work there without programs or exams. [*Applause*] The action of the Bauhaus Dessau did not rest upon an interval of time but rather upon the concentration of ideas. After ten years, the Center for Sensibility can be dissolved.

In order to breathe the spirit of sensibility and immaterialization into this center, the professors, with no exceptions, must participate in its construction. The body of students and interns constitute an unceasingly nascent play of cooperation in this construction. Materialism, all that quantitative spirit, has been recognized as being the enemy of freedom. For a long time a battle has been engaged against this spirit. The veritable enemies are psychology, the learned ways of seeing, sentimentality, composition, and the heroism. They engender totalitarian worlds, spaces defined by terror, the residuals for the ventriloquists of the Western world. [*Applause*]

This Center for Sensibility desires imagination and immaterialization. It desires freedom of the heart and the mind. In addition to the creation of this center, this program, in our opinion, may be able to influence already existing schools.

Following is a list, which I shall give to you even in its imperfect state, of department chairs corresponding to a very incomplete list of several professors already named:

– Sculpture: [Jean] Tinguely
– Painting: [Lucio] Fontana, [Otto] Piene, and myself
– Architecture: Frei Otto and [Werner] Ruhnau
– Theater: [Jacques] Polieri
– Music: Pierre Henry, [Sylvano] Bussotti
– Photography: [Charles] Wilp
– Criticism and History: no one named yet
– Economy: [Leslie] Péan
– Public Relations: Iris Clert [*Applause*]
– Religion, Press, Film, Television, Politics, Philosophy,
 Physics, Biochemistry: no one named yet
– Martial Arts and War College: General [Moshe] Dayan
[*Applause*]

The construction cost of this center is estimated in 1959 at one billion:

– Land 200 million,
– Annual cost for twenty professors 600 million

– Annual cost for teaching materials........60 million
– 200 students per year, total upkeep......120 million
– more than 600 million in costs for supplies, and unforeseen
 contingencies to be spread over the ten years

A total sum of 4 billion 200 million is required for the ten-year life of the center, which is small compared to what is spent on attempts to travel into space in the spirit of nineteenth-century fiction. [*Applause*]

We now reach April 1958 as we prudently and progressively move forward in time. I was preparing for *The Refinement of Sensibility in the First Material State into Stabilized Pictorial Sensibility*. It was later referred to as my "pneumatic" period. [*Laughter*] It followed the ethical rules that I had developed in the course of ten years. That ethics is the source of the immaterialism that will accomplish the rediscovery of a true love for matter as opposed to the quantitative, mummifying materialism that renders us slaves – to matter – and transforms matter into a tyrant.

With this attempt I wished to create, establish, and present to the public a sensuous pictorial state within the confines of an picture gallery. In other words, I sought to create an ambience, a pictorial climate that is invisible but present, in the spirit of what Delacroix referred to in his journal as "the indefinable,"[43] which he considered to be the very essence of painting.

This pictorial state, invisible within the gallery space, should provide the best general definition of painting to this day, which is to say, radiance. If the creative process is successful, this invisible and intangible immaterialization of painting should act upon the sensuous vehicles or bodies of the visitors to the exhibition much more effectively than ordinary, visible paintings, whether they are figurative, nonfigurative, or even monochrome. [*Laughter*] In case they are evidently good paintings, they are also endowed with this unique pictorial essence, with this affective presence, in a word, with sensibility, but transmitted by the suggestion of every physical and psychological attribute of the painting: lines, forms, composition, opposition of colors, etc.

43 See p. 47n30 below.

Presently there ought to be no more intermediaries. One should literally find oneself impregnated by that pictorial atmosphere, which the painter has beforehand refined and stabilized in the given space. It should act then as a perception – as immediate and direct assimilation without additional effects, gadgets, or hoaxes beyond the five senses – in the shared domain of man and space: sensibility.

How does one achieve that? I spent forty-eight hours alone in the gallery before the opening reception to entirely repaint the walls white, on the one hand, to clean away the impregnations of numerous preceding exhibitions [*laughter*], and on the other, by painting the walls the noncolor white to temporarily make the gallery my place of work and creation, in a word, to make the gallery my studio.

Thus I think that the pictorial space, which I already succeeded to stabilize before and around my monochrome paintings of the preceding years, will henceforth be well established in the gallery space. My active presence in the given space will create the climate and the radiant pictorial ambience that usually reigns in the studio of any artist endowed with real power. A sensuous density that is abstract yet real will exist and will live by and for itself in places that are empty only in appearance.

I have no wish to extend myself further on the subject of this exhibition. I should simply say that the experience was conclusive; it made me profoundly understand that painting is not a function of the eye. It was a complete success and the press was forced to acknowledge this phenomenon by noting that it had observed that 40% of the contacted public were captivated in this apparently empty room by something certainly highly effective, for many people who entered in a state of fury emerged satisfied [*laughter*], commenting upon and discussing in a serious and positive manner the real possibilities of such a demonstration. I should also say that I even saw numerous individuals enter and, after several seconds, burst into tears for no apparent reason, begin to tremble, or sit down on the floor and remain there for hours without moving or speaking. [*Laughter, applause*]

All of these reactions astonished me and, I must admit, they still very much astonish me today. [*Laughter*] Why have I arrived at that point? Because it is always quite simply agreeable whenever one undertakes to do something to go right to the conclusion. [*Laughter*] And one will see later, in the conclusion, with the architecture of air, that I was not wrong to act this way, although for a long time everyone believed that I was venturing towards a dead end. Phantoms and strange characters that belong to no one have emerged from this void filled with sensibility, such as these pictorial sponge-sculptures and these portraits of the "readers" of my monochromes.

Let us now go back in time to the blue period of 1957. It led me to the discovery that my paintings are only the ashes of my art. I exhibited blue monochrome paintings, all identical in format and tone, at Iris Clert and Colette Allendy. The considerably heated controversies raised by this manifestation proved to me the value of the phenomenon and the real depth of the upheaval that men of good will became embroiled in, with no concern to submit passively to the sclerosis of recognized concepts and established rules.

The public received each of these blue monochrome propositions, completely similar in appearance, in quite different ways. The art lover went from one to the other as is fitting and penetrated, in an immediate state of contemplation, into the world of blue. [*Laughter*] The most sensational observation was made of the collectors. They chose among the eleven exhibited paintings each their own and paid for each the asking price. And the prices, of course, were all different. [*Laughter*] This fact serves to demonstrate that the pictorial quality of each painting is perceptible by something other than its respective material and physical appearance. Those who chose recognized that state I refer to as pictorial sensibility.

How did I happen to enter this blue period? Between 1955 and 1956 I exhibited at Colette Allendy some twenty monochrome canvases, all in different colors: green, red, yellow, violet blue, orange. Thus I found myself at the beginning, or at least the first public showing, of this style. I was attempting to show "color," and I realized at the opening of the exhibition that the public, imprisoned by their learned ways of seeing, when presented with all those can-

vases of different colors hanging on the walls, recombined them in their minds into a single polychrome installation. The public could not enter into the contemplation of the color of a single canvas at a time, and that was very disappointing to me because I precisely and categorically refuse to create on one surface an interplay of even two colors.

In my view two, two colors juxtaposed on one canvas compel the observer to see the spectacle of this juxtaposition of two colors, or even of their perfect accord rather than entering into the sensibility, the dominant color, the pictorial intention. This is a situation of the psyche, of the senses, of the emotions, which perpetuates a sort of reign of cruelty. [*Laughter*] One can no longer plunge into the sensibility of pure color, without any outside contamination.

Some will undoubtedly raise the objection that this entire evolution has taken place quite rapidly, in barely four years, and that nothing can occur in such a short time, that ... [*hesitation*] it reveals too great an ease and thus a lack of any real, profound value. I reply that, although I did, in fact, begin to show my painting only in 1954 in Paris, I had already been working for a long time in that style, since 1946. This lengthy abeyance demonstrates precisely that I knew to wait. [*Laughter*]

I had waited for it to become stable within me before I could show or demonstrate what it *was*. The few friends during that time who encouraged me were aware of it. I had begun to paint monochromatically alongside my usual painting, which was influenced by my parents, both of them artists, because it seemed that color winked an eye at me. Besides, it filled me with wonder because in front of any painting, figurative or nonfigurative I felt more and more that the lines and all that results from its – the contours, the forms, the perspectives, the compositions – became exactly like prison bars. Far away, I felt amidst color, life, and freedom. In front of the painting I felt imprisoned. I believe it is that same feeling of imprisonment that made Van Gogh exclaim, "I long to be freed from I know not what horrible cage."[44] And then, "The painter of

44 See p. 19n11 above.

the future will be a colorist such as has never yet been."[45] This will come in a later generation.

It is through color that I have, little by little, become acquainted with the immaterial. The external influences that have made me pursue this monochromatic path to the immaterial are manifold: first, the reading of the journal of Delacroix, the champion of color, whose work lies at the source of contemporary lyrical painting; then a study of Delacroix in relation to Ingres, the champion of an academic art, who, in my view, by engendering the line and all its consequences, brought today's art to a crisis of form, as is expressed in the beautiful and grandiose, dramatic adventure of Malevich or in Mondrian's insoluble problem of spatial organization that has inspired the polychrome architecture from which our contemporary urban developments suffer so atrociously.

Finally, and above all, I received a profound shock when I discovered in the Basilica of Saint Francis of Assisi frescoes that are scrupulously monochromatic, uniform, and blue, which I believe may be attributed to Giotto but which might be by one of his pupils, or else by some follower of Cimabué or even by one of the artists of the Sienna school. The blue of which I speak should certainly be of the same nature and the same quality as the blue in the skies of Giotto, which may be admired in the same basilica on the floor above. Even if Giotto had only the figurative intention of representing a clear, cloudless sky, that intention is monochromatic all the same.

Regrettably, I had the pleasure of discovering the writings of Gaston Bachelard only very late, last year, in April of 1958. To the question I am often asked, why I choose blue, I will reply by citing again that marvelous passage concerning blue from Bachelard's book *Air and Dreams:*

> First, a document taken from Mallarmé in which the poet, living in the "dear ennui" of the "Lethean ponds" suffers from "the irony" of the azure. He perceives an azure that is too offensive and that wants

45 Ibid., p. 26.

> To stop up with untiring hand
> The great blue holes that naughty birds make.
>
> [...] It is through this activity of the image that
> the human psyche receives future causality through a
> kind of immediate finality [...] Other matters harden
> objects. Also, in the realm of blue air more than
> elsewhere, we feel that the world may be permeated by
> the most indeterminate reverie. This is when reverie
> really has depth. The blue sky opens up in depth be-
> neath the dream. Then dreams are not limited to one-
> dimensional images. Paradoxically, the aerial dream
> soon has only a depth dimension. The other two dimen-
> sions, in which picturesque, colored reverie plays its
> games, lose all their oneiric interest. The world is
> then truly on the other side of the unsilvered mir-
> ror. There is an imaginary beyond, a pure beyond, one
> without a within. First there is *nothing*, then there
> is a *deep* nothing, then there is a blue *depth*.[46]

It is from the above [paragraph] that I drew the sentence for
Anvers.[47] For Claudel, [as Bachelard writes,]

> "Blue is obscurity becoming visible." This is precisely
> why Claudel can write, "Azure, between day and night,
> shows a balance, as is proved by the subtle moment
> when, in the Eastern sky, a the navigator sees the
> stars disappear all at once."[48]

Blue has no dimensions, it is beyond dimensions, whereas the
other colors are not. They are psychological spaces; red, for example,
presupposing a hearth releasing heat. All colors bring forth specif-
ic associative ideas, tangible or psychological, while blue suggests,
at most, the sea and sky, and they, after all, are in actual nature
what is most abstract.

Regarding these commentaries on the color blue, I wish to speak
for a moment of the waking dream of Dr. Desoille, which can pro-
vide testimony of the immaterializing value of pure imagination:

46 G. Bachelard, *Air and Dreams,* pp. 163-68.
47 See p. 73 above.
48 *Air and Dreams,* p. 170.

Imagination and Will are two aspects of a single pro-
found force. Anyone who can imagine can will. To the
imagination that informs our will is coupled a will to
imagine, a will to live what is imagined.[49]

And then let us follow Robert Desoille's method in its apparent
simplicity:

Desoille counsels the subject who is bothered by a
specific concern to put it with all the others in the
ragpicker's bag, in the sack that he carries *behind his
back.* This is in keeping with the very expressive an d
effective gesture of the hand that throws everything
it scorns behind the back.[50]

It must not be forgotten:

that we are dealing with psyches that cannot decide to
make up their minds and who do not listen to rational
rebukes.[51]
 [...] When the spirit has thus been somewhat pre-
pared for freedom, when it has been unburdened of
terrestrial cares, then its training in imaginary as-
cension can begin.
 Desoille then suggests to his patient that he imag-
ine himself walking up a *gently sloping path,* an un-
broken path, with no abysses, no vertigo. Perhaps he
could be helped gently here by the rhythm of his gait,
feeling the dialectics of the past and future that
Crevel pointed out so well in *My Body and I:* "One of
my feet is called past, the other future."[52]

One must then return to:

the characteristic of the *directed ascensional dream*
upon which I would like to focus now.
 In fact, Desoille's method takes into account an
ascension in color ... It seems that an azure, or
sometimes a golden color, appears on the heights to

49 Ibid., pp. 111-12.
50 Ibid., p. 115.
51 Ibid.
52 Ibid., p. 116.

which we ascend in dreams. Often without any sug-
gestion, the dreamer, as he is living this imaginary
ascent, will reach a luminous place where he perceives
light in a substantial form. Luminous air and aerial
light, in a reversal from substantive to adjective,
are joined in one matter. The dreamer has the im-
pression of bathing in a light that carries him. He
actualizes the synthesis of lightness and clarity.
He is conscious of being freed both from the weight
and the darkness of his flesh. In certain dreams,
there is a possibility of classifying ascents as being
ascents into either azure or golden air. More pre-
cisely, there should be a distinction between ascents
in gold and blue and those in blue and gold, accord-
ing to the dream's color of transformation. In all
cases the color is volumetric; happiness pervades the
whole being.

[...] This universal light engulfs and blurs ob-
jects little by little; it makes contours loose their
sharp lines. It obliterates the picturesque in favor
of the radiant. At the same time, it rids dreams of
all those "psychological what-nots" that the poet men-
tions. Thus it gives a feeling of serene unity to the
contemplative person.

[...] Desoille's method, then, is an integrating of
sublimation into normal psychic life. This integration
is facilitated by images of aerial imagination ... An
initial calm is replaced by a conscious calm, *the calm
of the heights,* the calm from which one sees from "on
high" the turmoil down below. Then a pride is born
in our sense of morality, in our sublimation, and in
our life's story. That is when a subject can allow his
memories to rise up spontaneously. Memories have a
better chance at this stage of being more meaning-
ful, of revealing their causality, since the conscious
dreamer is, in a certain sense, at a high point in his
life. His past life can be judged from a new point of
view, one that we might almost say is absolute: the
person can judge himself. The subject often realizes
that he has just acquired new knowledge, has just
become psychologically lucid. [53]

53 Ibid., pp. 118-19, 123.

And although I am thinking that it may now be necessary to begin to return to today, to present to you the architecture of air, I still should speak to you first of the fire and of the water that I wish to integrate into this architecture to become a nonarchitecture.

Fire, for me, is the future without forgetting the past. It is the memory of nature. The project of a public fountain upon which would dance jets of fire rather that jets of water and the construction of walls of fire in the architecture of air is an idea that dates back to 1951. I became ecstatic at the sight of fountains and the jets of water at La Granja, the summer palace of the old Spanish monarchy, some eighty kilometers from Madrid, in every regard similar to Versailles. It is there that I imagined substituting brilliant jets of fire for the elegant jets of water above the tranquil water in the fountain basins. Sculptures of fire above water ... Why not?

The functional-psychological goal of jets of water over expanses of water is to bring a general coolness or at the least a sensation of coolness. For countries with less favorable climates, where cold can be severe and winter lasts quite long, it is a luxury to present jets of water, while it is also functional as well as esthetical and psychological to present plays of water over a mirroring spatial and aquatic base, which forms also an insurmountable and invisible barrier. It is gentleness. Fire

> is gentleness and torture. It is cookery and it is
> apocalypse. It is a pleasure for the *good* child sit-
> ting prudently by the hearth; yet it punishes any
> disobedience when the child wishes to play too close
> to its flames. It is well-being and it is respect. It
> is a tutelary and a terrible divinity, both good and
> bad. It can contradict itself; thus it is one of the
> principles of universal explanation.[54]

On the other hand, one can, I believe, discuss the quality of fire from the point of view of aesthetic perfection. Fire is beautiful in itself, regardless.

It may not, if you will, be very well understood how these walls of fire presently will adapt to the architecture of air.

54 G. Bachelard, *The Psychology of Fire*, p. 7.

In regard to the proposition to construct walls of water apposed to the walls of fire, it is also necessary to speak of water in and of itself in order to understand the spirit of water. It seems that it should be necessary, at first, to understand silence for our soul, which needs to see something to become quiet.

> "And as in ancient times, you could sleep in the sea,"
> says Paul Eluard in *Necessities of Life*.
> [...] The hymn [...] by Saintyves continues:
> "Ambrosia is in the waters, medicinal herbs are in
> the waters ... Oh Waters, bring all our remedies
> for disease to perfection so that my body may
> benefit from your good offices and that I may for
> a long time see the sun."[55]

And then one should not forget the spirit floating upon the waters. This is the fluid element, the essential feminine element whose balance we need to establish, a balance between justice and violence.

Hence the return to Eden, since the Fall of Man, is proceeding well; we have passed through a long evolution in history to accede to the heights of perspective and the routing out of the psychological vision of life that is the Renaissance.

Evolution reascends to the present, passing through dematerialization towards immaterialization, and we direct ourselves through happiness towards an authentic and dynamically cosmic well-being. It is certainly not enough to say or to write or to proclaim, "I have overcome the problematics of art!" It must actualy be done, as I think I have done. I even desire to engage myself, for an instant, in the overcoming of the barrier of the craft, and it is a method that always comes out of that same personal ethics of which I have already spoken, and which made it possible for me to establish myself, me, a painter, in realms foreign to me with no difficulties other than the usual technical problems encountered anyhow by the most experienced technicians.

For thousands of years the Orientals have cultivated a kind of hierarchic ritual that allows, for example, for one corporation to bestow to a member of another corporation an honorary rank of

55 Gaston Bachelard, *Water and Dreams*, pp. 115, 118.

equivalent quality. I observed this in Japan during an eighteen-month apprenticeship at the Imperial School of Ancient Martial Arts. In judo, the council of high grades often spontaneously awards a brilliant "scientist," for example, who hardly did any judo at the university in his youth, with a superior ranking. Honorable, of course, this honor is respected by all practitioners in the field without the least reticence.

We in the West should transform this hierarchic ritual into an effective dynamic reality. Thus I make a point in giving you an example of my potential to pass into the field of music, for example.

Several years after that I created a monotone symphony of which here is a selection: [*plays excerpt*]. And now a scream by François Dufrêne, a monotone scream [*scream, applause*]. And now a scream, pay attention to this, a scream by Charles Estienne [*scream, laughter*], and now a very beautiful scream by Antonin Artaud [*scream*].

I quite regret that I cannot provide a selection from the symphony by Pierre Henry, the well-known composer of phonic and concrete music, but my tape recorder does not function at the required speed for this – oh, yes, but at the moment it is too difficult to mount. But this is precisely the same symphony that I had composed several years ago, from which, if I am not mistaken, you heard a selection initially, of course, that has been reconstituted by Pierre Henry in a much more, ahem, competent manner. [*Laughter*]

The selection from my monotone symphony you heard at the beginning is an electronic sound. The symphony originally lasted for forty minutes. [*Laughter*] It was precisely that long to demonstrate the desire to conquer time. The opening and the ending of this sound was cut, which provoked a variety of strange sonorous phenomena that exhaled sensibility. Effectively having neither a beginning nor an end that is in the least perceptible, this symphony was freed from the phenomenology of time, becoming something outside of the past, present, and future, since in all it knew neither birth nor death, meanwhile existing in sonorous physical reality.

Now, to return to the concept of overcoming the craft, I am now preparing a grand concert in this monotone spirit, but this time no longer electronic, which is too cold for me. I wish to conduct in

person a great classical orchestra of one hundred and forty musicians. [*Applause*]

It would take too long at present to expand upon the details of this enterprise. The idea that emanates from this, and which has bearing on today's topic, is this potential, which the Western artist needs to investigate in the spirit of a pure classical fugue to leave melody and rhythm behind, make the subject the sole theme, and dissolve the counterpoint, which thus would never again appear. There is then no more exhibition, episode, or development; it is the canon of the future of the classical fugue transposed into an immediate theme.

I make a point of astonishing myself before you in stating that Europeans have a very poor notion of what Japanese calligraphy is. The poor persons of gesture and sign have understood only its exotic and superficial aspects. One is ignorant or seems to be ignorant about how Japanese calligraphy has in reality evolved. [*Applause*] Be careful! What I am saying here is a serious, it is not a joke. [*Laughter*] It is like that. And besides, it is too much! I want to scream at these artists, at these painters, at these *Action Painters*, stop gesticulating already; moving around like fools does not mean that you're active! [*Laughter*] Can you go back, because of those terrific machines of which I earlier spoke, just as in their own day the Impressionists returned from the cruel reality of the objective realism of Courbet, owing to the invention of photography, to the astonishment of life and to life itself? Can you be set free from what in my opinion are the torments that torture you in the inferno of composition and the velocity of lines and forms that lead you nowhere?

In my opinion, art is neither a language nor a potential means of communication for the artist. If this were the case, the work of art would be only a means and not an end, not a real creation. Man creates art to not be alone, for there may be only one man on the face of the earth, yet there may be several works of art. The artists of the twentieth century owe it to themselves to integrate themselves into society and cease to be strange beings. And, in order to entertain myself for one more moment before I conclude, I wish to attempt again to establish my ethics one more time, for one mo-

ment, in light of the economic and social problems, in the social structure, in such a manner as it may relate directly to immaterial architecture and immaterial urbanism.

How do I get there, while still drawing from the pictorial norms that I have constructed? For painting, I have long searched for a fixative medium to expressly fix each grain of pigment that make up the radiant and dazzling mass found in the bins of the merchants of color. It is quite dismaying to see this same pigment, when milled in oil, for example, lose all its brilliance, all its essential vitality. It seems as if mummified; nevertheless, one cannot leave it on the ground, held by the fixative medium of the invisible force of terrestrial attraction, for man naturally stands upright and his gaze naturally fixes on the horizon. The painting should be presented at his eye level in a position perpendicular to the earth, like a screen. It thus becomes necessary to make the pigment adhere to the supporting surface in some manner. I have searched for a fixative medium that is capable of fixing each grain of pigment to the other and then to the supporting surface without the alteration of any of them and without depriving any of them of their autonomous potential of radiation, while forming a unit with the others and the support, thus creating the mass of color, the pictorial surface.

Thus by applying these rules of pictorial research to an entire people of whatever country, with the idea of presenting one day a painting that will radiate in the gallery of the world to the eyes of the universe, one realizes that the monetary principle, money, is the fixative for all individuals in a society, [*Laughter*]. It mummifies them and takes away their authority with respect to themselves, and directs them all straight towards quantitative surplus production instead of forming groups, while they abandon the imaginative and free responsibility that would compel them to find well-being in qualitative production.

Thus, a draft of the manifest for the transformation of collectivity can be summarized as follows: to transform the manner of thinking and of action of a people in the direction of individual duty through quality vis-à-vis national collectivity and national duty, always through quality, vis-à-vis the collectivity of nations. Thus

can one elevate an entire people to aristocratic pride in its morality on an individual scale that is truly integrated in society. And it is then that a draft of an economic system can be summarized in the following manner: economy being the domain of choice of vain illusions and of constructions, which a priori denote the insufficiencies of preliminary acolysis – uh, yes, of preliminary analysis [*Laughter*] – certain schools believed to perceive a good number of realities. But this approach to the economic phenomenon has too often remained only an approximation. Such commonplace physiocrats did not know, in extenuating the matrix of the sensuous universe, to discharge the materiality of the cosmos to finally reach the definition of knowledge, by the conscious grasping of the marginal utility of space. A new effort arose in the 1930s with the Keynesian School and the so-called theory of full employment. But if the vocation of employment could lead to a completely worthy therapeutic sum, the complete misapprehension of a conscious collective of spatial intensity could once again lead only to a quantitative approximation. One then sees that everything is analyzed in terms of bankruptcy and the balance of compounded economies shows today only a substantial deficit.

A new era should thus appear in which a qualitative perception of the energetic field of economy would finally be able to orient the fundamental inertia of the living in line with a dynamic conception of the created thing.

This conception finds in me its foundation, in the wealth of spatial patrimony more elaborated every day. Also, a great fresco stretches out, which awaits it monetary label. I challenge, in effect, the reserves and currencies, the riches accumulated from past splendors but perilous mortgaging the structures of the present. No need henceforth for these expensive intermediaries whose facticity empties a past between intellectual apprehension and the very quality of the values seized. Let us turn more simply towards the intrinsic value of matter, essentially residing in the idea of quality. Based on this structurally quality, each corporation would be obligated to deposit in the vaults of the Central Bank, disencumbered beforehand from all deposits of metals, the masterpiece of the profession.

The specified masterpieces, thus gathered, would materialize the basic spiritual directions of the country, clearing the way for all subsequent evolutionary potential, the sole source of progress.

This permanent example, catalyst of latent powers, in maintaining for the spirit a stable but not closed sampling, would at last permit the establishment of a system of barter that would be fundamentally healthy and sheltered from quantitative business cycles. Finally, the suppression of the fiduciary circulation would be able, at the same time, to suppress the least possibility of cyclical evolution leading to the classic inflationary spiral. Overproduction, instead of presenting the characteristics of useless growth of quantitatively uncountable wealth, would no longer be a pure and simple destruction of energies but a general emulation whose constructive quest would contribute to the splendors of the future. On the international level, the creation of a standard representing a spiritual value would forestall any commercial development and allow for the end of customs wars, the idea of quality becoming the multiplier of formerly antagonistic national economies.

These brief overtures on what could be the economy of tomorrow, should we so wish it, allows us a glimpse into the enormous possibilities of a system that at last reconciles universal intellectual and moral aspirations with the strictest economic imperatives. In such a system, the wealthy man would necessarily be an authentic genius within his specialty. This would only be just, at long last.

But let us return – and forget these excessively serious and severe propositions – to the possibility of applying one more time this kind of ethics to the theater, for example. Gradually, one arrives at a spectacle without actors, without decor, without stage, without spectators, with nothing more than the solitary creator who is seen by no one, with the exception of the presence of no one, and the spectacle begins. [*Applause*] The author lives his spectacle, his creation, he is his own public and his own triumph, or flop, and little by little even the author himself is no longer present, and yet the spectacle continues. [*Laughter*] To live in a constant spectacle, in a constant manifestation, to be there, everywhere, and elsewhere, inside as well as outside, is to play life in the first material state, a

kind of sublimation of desire, a matter imbibed and impregnated into "everywhere" and the spectacle continues, a mono-spectacle that is ultimately outside of the psychological realm. The spectacle of the future is an empty room. [*Applause*]

Thus, here is how, across all these pursuits of an art on its way towards immaterialization, Werner Ruhnau and I have met in the architecture of air. He, embarrassed, troubled by the last obstacle that a Mies van der Rohe knew not how to overcome: the roof, the screen that separates us from the sky, from the blue of the sky. And I, troubled by the screen that constitutes the tangible blue on the canvas and deprives man of a constant vision of the horizon.

I had dreamt of this conception of the architecture of air in my monochrome élan for several years already, but without understanding its full importance and its considerable reach. Werner Ruhnau had known to validate this idea, vague as I admit, and make it a reality. Man in the Biblical Eden doubtless found himself in a static trance, like in a dream. The man of the future, in his integration in total space, in his participation in the life of the universe that will offer the first step already taken in this direction, which is the architecture of air, will doubtless find himself in a dynamic state of awakened dream, in a crystal lucidity vis-à-vis the tangible, visible, and material nature that he will control on the earthly plane for his own physical comfort. Liberated from a false interpretation of psychological intimacy, he will live in a state of absolute concord with a nature that is invisible and imperceptible by the senses, that is to say, with life itself that becomes concrete through a reversal of roles ... abstraction effected through psychological nature – excuse me.

And here now, the end of the exact text of our first manifest on the architecture of air. First, to the void, blue light corresponds as material of construction: in the stratosphere, this is the energy that must be employed; in the atmosphere, one will build with heavy air or any other gas that is heavier and more dense than air, while playing with optical fires, magnetism, light, and sound. Sound will be used to neutralize sound. It is also possible to use odors.

In the earth, it is evidently necessary to build with mortar, concrete, stone, clay, and iron.

The architectures of air are only presented as example. It is the spiritual principal itself to use new materials for an architecture that is ultimately dynamic, which is important. Air, gasses, fire, sound, odors, magnetic forces, electricity, and electronics are materials. They should have two principle functions, specifically: to protect against the elements – rain, wind, and atmospheric conditions in general – and the function of thermal conditioning (heating and cooling). It is possible to envision the separation of the two functions. It has been shown that to each original state of nature such as earth, air, and water correspond certain elements of construction. These elements of construction should always be more dense and heavier than the original state to which they are applied.

The architectures of air should adapt themselves to the given circumstances and natural conditions, to mountains, valleys, monsoons, etc., if possible without necessitating the operation of substantial artificial modifications. For example, where the wind changes direction every six months, the roof of air can be created with a minimal artificial support. In the end, it is the old dream of men and of the imagination to play with the elements of nature, to direct and control its phenomena and manifestations.

I was to arrive in my evolution at an architecture of air because only there can I at last produce and stabilize the pictorial sensibility in the first material state. Until now, in the architectonic space, still very precise, I compose monochrome paintings in the most enlightened manner possible. The sensibility of highly material color must be reduced to a more pneumatic pictorial sensibility.

Werner Ruhnau, for his part, is sure that contemporary architecture is on its way towards the immaterialization of the cities of the future.

The suspended roofs and tent constructions of Frei Otto and others are important steps taken in this direction. In using air, gasses, and sound as elements of architecture, this development can be advanced further. My walls of fire and my walls of water are, together with my roofs of air, the materials for the construc-

tion of a new architecture. With the three classic elements of fire, air, and water, tomorrow's city will be built and will at last be flexible, spiritual, and immaterial. The idea of making use of pure energy in space to built for mankind does not at all appear to be outlandish. In such a conception of architecture, it seems easy to understand that the disappearance of the pictorial and of painted dreams is inevitable, and happily so, for it is the pictorial that has killed all real the powers in man.

I wish to conclude by rendering homage to Werner Ruhnau through the following poem [56] by the great German poet Christian Morgenstern, for whose poor translation I beg your pardon:

> There was once a fence made of lattice
> With spaces in-between to peer through them.
> An architect who saw this, appeared suddenly
> one evening,
> And removed the spaces between the lattice
> And build from them a large house.
> The fence remained there afterward, looking silly
> With its lattice, without anything around.
> A sight abominable and basely.
> It is for that reason that the authorities took
> it down
> The architect however took off
> To Afri-or-America.

These are the terms of the poet. [*Applause*]

Werner Ruhnau, no doubt, will not be obliged to take off, at least I should hope not, for I think that the European West will understand the value of our project of immaterialization in time, to live without delay in the new, the alive, the beautiful today. [57] [*Applause*]

56 "Der Lattenzaun," in Christian Morgenstern, *Alle Galgenlieder* [1905] (Wiesbaden: Marix Verlag, 2004), p. 64.

57 Klein is quoting here the first line of Mallarmé's sonnet "Le vierge, le vivace et le bel aujourd'hui" (Will new and alive the beautiful today). See Stéphane Mallarmé, *Selected Poetry and Prose*, ed. Mary Ann Caws (New York: New Directions, 1982), p. 45f.

XVII. SELECTIONS FROM "DIMANCHE"

Yves Klein presents: *Dimanche*, 27 November 1960 [58]
The Newspaper of a Single Day
The Blue Revolution Continues

Announcement

As part of the theatrical presentations of the Festival of Avant-garde Art in November-December 1960, I have decided to present the ultimate form of collective theater: a Sunday for everybody.

I did not wish to limit myself to an afternoon or evening performance.

On Sunday, 27 November 1960, from midnight to midnight, I thus present a full day of festival, a true spectacle of the Void, as a culminating point of my theories. However, any other day of the week could have been used.

I wish that on this day joy and wonder will reign, that no one will get stage fright, and that everyone, conscious as well as unconscious actors-spectators of this gigantic presentation, shall have a good day.

That everyone will come and go, move about, or remain still.

Everything I write in this paper today precedes the presentation of this historic day for the theater.

The theater shall become, or at least rapidly attempt to become, the pleasure of being, of living, of spending marvelous moments, and with each passing day of better understanding the beauty of each moment.

58 Published by Klein in the format of the *Journal du Dimanche,* the Sunday edition of the Paris daily *France-Soir,* in an edition of several thousand copies and distributed on numerous newsstands in Paris on that day.

YVES KLEIN PRÉSENTE :
LE DIMANCHE 27 NOVEMBRE
1960

NUMÉRO
UNIQUE

FESTIVAL D'ART
D'AVANT-GARDE
NOVEMBRE - DÉCEMBRE 1960

La Révolution
bleue
continue

SEANCE DE 0 HEURE A 24 HEURES

Dimanche

27 NOVEMBRE

0,35 NF (35 fr.)

Le journal
d'un
seul jour

THEATRE DU VIDE

UN HOMME DANS L'ESPACE !

ACTUALITÉ

Yves KLEIN

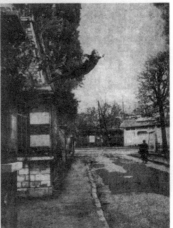

(Photo: Shunk-Kender)

Le peintre de l'espace se jette dans le vide !

L'ESPACE, LUI-MÊME.

Sensibilité pure

● SUITE EN PAGE 2

● SUITE EN PAGE 2

Dimanche 27 November 1960 (The Newspaper of a Single Day)
Letterpress on four pages (55 x 38 cm)

Everything I write in this paper represents my own steps towards this glorious day of realism and truth: the field of operations of my proposed conception of theater is not only the city, Paris, but also the countryside, the desert, the mountains, even the sky, and even the entire universe. Why not?

I know that everything inevitably is going to work out very well for everyone, spectators, actors, stagehands, directors, et. al.

I would like to thank Mr. Jacques Polieri, the director of the Festival of Avant-garde, for his enthusiasm and for proposing to me that I present to you *Dimanche, 27 November.*

Yves KLEIN

The Theater of the Void

The theater is forever searching; it searches for its lost beginnings.

The great theater is, in fact, Eden; the important thing is to establish once for good our static positions individually within the universe. For a long time already I have been announcing everywhere that I am the painter ... I know no others today! I make point of also saying, "I am the actor, I am the composer, the architect, the sculptor." I make a point of saying, "I am." One will no doubt object that this has already been howled out in all sort of ways; this is certainly true. I am perhaps repeating others, but I do so consciously, well aware of having earned the right to say it: and there it is, for me just as for everyone, there is nothing more to do; today the official theater is "to be" and "I am," so in fact all that anyone wishes me "to be" and even all that anyone wishes me not "to be"! I shall even accomplish "to be" no longer at all one day! ... But, one should not be mistaken about this: it is not a matter of "me" when I say, "I, me, my, etc."

This is because the spirit in which I live is a spirit of wonder, stabilized and continuous, a classical spirit, because I have no avant-garde traits, no traits of that avant-garde which ages so quickly, from generation to generation.

My art will not belong to one age, no more so than the art of all the great classics ever belonged to the ages in which they lived,

because like them I seek, above all, to realize in my own creations that "transparence," that immeasurable "void" in which lives the permanent and absolute spirit freed of all dimensions!

No, I do not let myself be beaten at my own game in speaking today of a theater of the Void with such a vainglorious and egocentric foreword: my theater will even assume a universal value insofar as my companions will know my thinking better than I know it myself, for if they number in the thousands, they will reflect on it thousands of times more than I alone.

I am well aware that I may present myself by writing these lines on my own with what seems to be a kind of superiority complex. I point out to those who would be blind and clumsy enough to give me the advantage of attacking my exasperation with myself that it would be quite easy to lead me to defeat, but a defeat that would be on the eve of great and definitive triumphs for those who engage in the great game and know to expose themselves.

I have fought against being regarded a "painter" by leaving for Japan to live the adventure of judo and the ancient martial arts there. In the same way I fought against being regarded as a "man of the theater"; but it was judo,[59] the physical and spiritual practice of the *katas*, that accounts, in spite of myself and unexpectedly, for my formation in that artistic discipline we call theater. All of it is just as beneficial and profound as any other, if not more so. In presenting what follows, I comply with a profound necessity, and I am acting as a realist, full of common sense. I love Molière and Shakespeare because one can find in their works this transparence of the void that so fascinates me.

For me "theater" is not at all a synonym for "Representation" or "Spectacle."

Important intellectuals, themselves members of the avant-garde like [Alexander] Tairov, for example, even wanted to theatricalize the theater.

[Nicolas] Evreinoff dreamt of the monodrama, of the theatricality in daily life, thought-gesture-speech.

59 See Yves Klein, *Les Fondements du Judo* [1954] (Paris: Éditions Dilecta, 2006).

[Konstantin] Stanislavsky, an extreme realist, would have liked the effective and definitive death of any actor who had to play his death on the stage. A precursor of Dada, [Yevgeny] Vakhtangov, locked up the public in an auditorium for two hours with no other goal than to lock them up in a gesture of mere cynicism. This event was part of his "theater of revolt" and titled *The Strange Evening.*

The Czech [Emil František] Burian created a synthetic theater; the characters of his play, *Romeo and Juliet,* were fantastic infernal machines that performed on stage while the actors read the texts off-stage. Amfitheatrof showed laconic mini-dramas of ten minutes duration, interrupted by discussions that were evidently part of the program. He would announce to his public, which commissioned his presentations from him in advance, that he was ready to endure tomatoes and rotten eggs but not cobblestones.

The "phonographs" in Jean Cocteau's play *The Eiffel Tower Wedding Party* are also fine examples.

It takes too long to cite here all the attempts that have been made since the beginning of the century to leave the conventional, learned, academic for the realm of the spectacle. I believe that almost everything has been done already, right up to Jacques Polieri in his recent production of Tardieu's play,[60] in which off-stage voices and three screen-panels are the only scenery and the only presence! (His idea is moreover to bring the stage sets to life and make them speak.)

Bravo! – How fortunate that all this exists, but careful! I must warn the reader that my theatrical work has nothing, absolutely nothing to do whatsoever with any of these experimentations and researches, perhaps with the exception of those by Antonin Artaud, who sensed the coming of what I am here proposing today. Artaud, however, like a good many other "greats" of the true theater, loses himself in the false, artificial, and intellectual conception of the "word" that has rerouted so many for so long. For

60 Stage set for *Une voix sans personne,* by Jean Tardieu (Théâtre de la Huchette, Paris, 1956). According to a note by Polieri in the Yves Klein Archives, Klein himself participated in one of the performances in February 1956.

my part, I know that "in the beginning was the word, and the word was God"; two times "was" for two times "word" plus "God" – in all five words which, if one reflects upon them a little, clearly say what they wish to express: that "Word," in this nonform, is neither articulated nor even disarticulated "Speech."

What I wish for: no more rhythm, above all, let there never again be rhythm!

And further, my work is not "research"; it is my slipstream, my wake. It is the very matter of the static vertiginous speed, which propels me, standing still, into the immaterial! Again, listen to what I am not saying when I speak of my work: "It is clearly more beautiful because it is useless!" No, I say, "It is like this, and like this it will be, and no one will ever be able to make it into something else!" Why? Precisely because it is "classical"!

Thus, very quickly, one arrives from this at a theater without actors, without sets, without stage, without spectators ... to nothing other than the creator himself who is seen by no one, and the theater-spectacle begins!

The author lives his creation: he is his own public, and his own triumph or disaster. Rapidly, even the author himself is no longer there, and nevertheless everything continues ...

To live a perpetual manifestation, to experience the permanence of being: to be present everywhere, elsewhere, inside like outside, a kind of sublimation of desire, a matter imbibed, impregnated "throughout" ... and everything continues, monotheater, beyond the psychological domain at last ... The future of the theater is an empty hall: it is no longer a hall at all!

This 1954 manifesto has since inspired mediatory propositions such as those which follow:

To create a kind of private theater to be (effectively) frequented by subscription.

Each members is to receive, in exchange for their subscription, a seat in their name in the empty auditorium of the theater where a continual performance without actors, spectators, etc. is given. This constant nonrepresentation, in this auditorium, which no one enters after the initial installation must have moments more

intense than others, communicated, at the beginning, to subscribers by a program that they receive by mail or ... otherwise! On these special moments, preferably in the evening, or early morning, at the rising of the sun, the interior of the theater should be brilliantly illuminated in such manner that it can be seen well from the outside (the ideal location of such a theater, for the moment, would be Paris, the theater of Marigny, for example).

I repeat: the theater will be closed; no one will be able to get inside, only the ticket office at the entrance will be open, so that late arrivals will be able to, at the last moment, subscribe before each performance. The director of such a theater ought to search the city, the countryside, or during long trips undertaken for that purposes, for suitable actors and thus constantly renew the theater troupe. The actors will be chosen by him in the streets, everywhere, and have to be given immediately a signed contract and an advance on their fee.

The new actors thus chosen will have nothing to do but to know that they are actors and to stop by to cash their vouchers after each performance or "at the moment of hyperintensity" indicated in the subscribers' program.

Thereafter, as part of their new and grave responsibility, the actors will flee the theater and vanish into the crowd to visit the enormous museum of the past that the modern world of today has become!

A Man in Space!

The painter of space leaps into the void!

The monochrome man who is also a champion of judo, black belt 4th dan, practices regularly dynamic levitation! (with or without a net, at the risk of his life).

He claims to be able to join up with his preferred work in space soon: an aerostatic sculpture, composed of one thousand and one blue balloons, which will take off from his exhibition in 1957 into the sky of Saint-Germain-des-Prés never again to return!

To liberate sculpture from plinths has long been his concern. "Today the painter of space must, in fact, go into space to paint, but he must go there without trickery or deception, and not in an airplane, nor by parachute, nor in a rocket: he must go there on his own strength, using an autonomous individual force; in short, he must be capable of levitation."

Yves: "I am the painter of space. I am not an abstract painter but, on the contrary, a figurative artist, and a realist. Let us be honest, to paint space, I must be in position. I must be in space."

Pure Sensibility

A small auditorium.

The spectators, after having duly paid their rather pricey admission fee, enter the auditorium, and take their seats.

The curtain is lowered. The auditorium illuminated.

When the auditorium is filled, a man gets on stage, in front of the still lowered curtain, and announces:

"Ladies and Gentlemen, due to circumstances, this evening we are forced to chain you to your seats (and, in addition, to gag you) for the duration of the presentation. This measure of security is necessary in order to protect you from yourselves in the presence of this particularly dangerous performance, from a purely emotional point of view!

"We express in advance our regrets to those of you who are not unable to be chained and gagged before the raising of the curtain and we kindly ask that you leave the auditorium and request a refund at the exit. No one will be permitted to stay in the auditorium unless firmly chained to their seats during the performance. Thank you."

... At once a group of "chainers" and "gaggers" enter the auditorium and systematically and rapidly, row after row, immobilizing all the spectators.

When it is done ... the room darkens ... the curtain rises accompanied by a continuous fizzing sound, similar to that made by freshly opened carbonated water, but prodigiously amplified.

It is an acoustic, monotonous inundation, impregnating space in a volumetric way, perceptible to the sensitive hearing of each spectator.

The stage is a white empty space, very white, with curved corners… Everything is empty, absolutely empty with fizz! (If the spectators were not gagged, the acoustics would need to be to cutoff).

Beautiful young girls, nude or at most wearing bikinis, mingle like hostesses with the male spectators in the auditorium and comfort them, adjusting their chains and gags, telling them the time and how much longer they have to endure the spectacle (extremely handsome young men, also nude or at most wearing bikinis, attend to the female spectators).

After the first half hour, the fizzing sound fades away, little by little, until it is completely dissolved. Another half hour passes in absolute silence, during which the spectators continue to face the empty, white, and brilliantly illuminated stage.

The curtain lowers. The light return in the auditorium. The groups of "chainers" return to free the spectators from their chains and gags.

Capture of the Void

An entire city, indeed even a capital or, better yet, an entire country will serve as stage and scenery. The State itself will announces the date of the presentation throughout the land. On the designated day, at the designated hour, everyone will return home, lock the door with two turns of the key, and the outside world will be devoid of humans for two hours.

There is no one in the streets, no one in the administrative offices or in any other public places, no one in the countryside; everything is closed; everyone is at home and no one moves.

The earth will appear from outer space, for two hours, entirely devoid of living subjects!

… Then my faithful associates who are with me will throw me out of my home against my will, for I shall be afraid and it will be necessary that I should be literally expelled outside, into the emp-

tiness of the streets and the countryside, facing nature and every-thing else alone. To speak frankly, this will be but one step on the road to the "capture of the real void," which will be accomplished after my definitive disappearance, during of one of these solemn national seances. This "capture of the void" will be realized by those who will have understood its concept or, rather, its principle and who will experience it, at last, as pure and static action in a completely natural manner.

The Thieves of Ideas

After the urbanism of air, and above all, after the total and defini-tive immaterialism of architecture will have been achieved, which is to say, when we will have regained the lost Eden and live again in an climate-controlled nature, nude, without any artificial bar-riers, then our current conception of intimacy will have changed significantly. We will know, at all times, each other's previously concealed secrets, down to the smallest details of our daily life. At that stage, our sensibility will be developed to such a degree that it will become possible to envisage each other's deepest thoughts; these thoughts will not be read or perceived intellectually; they will be "grasped" through a process of impregnation with "sensi-bility" rather than through psychic penetration since, by then, psy-chology will have disappeared almost completely.

Even if one ever arrives at this possibility of "dreaming the dream of others" – as some today steal ideas, ideas called "in the air" (that some capture more rapidly than others and that others realize more rapidly than some) – there will always be the "poet" who, beyond the dream itself, will know the illuminated trance of contact with the affective center of all things, with "joy" in the first material state, which, both profound and exalted, is extradimen-sional and lies at the origin of life itself.

This play is an anticipation of such a state. It takes into account many of the conditions of the psychological atmosphere in which we are still living today to show precisely that that idea that "one day there will be no more ideas" will some day have true func-

tion and value. It will be the "silence" that generates everything in each of us.

The stage is either triangular, composed of two white, transparent screens onto which the scenery/film is rear-projected, or semicircular, with one single, panoramic projection screen.

Everything is immaculate white, even the floors and the ceiling. After the curtain rises, thirty seconds pass, showing this empty, violently illuminated stage, Then, accompanied by a continuous tone, the lights are lowered in intensity until the moment when the film is rear-projected onto the two screens (or onto the single panoramic screen).

In the orchestra, two actors, seated far from each other among the spectators, suddenly rise and acknowledging each other with friendly gestures.

They head for the stage through the rows of spectators.

On stage, the film has begun to be projected. It is a delightful landscape with trees, hills, and a river, bathed in sunlight à la Renoir, with a marvelous view of a distant and indefinable horizon.

The continuous sound changes into a very sweet pastoral music. The actor to the left arrives first on the stage and contemplates the landscape with intense joy.

The actor to the right arrives, contemplates the same landscape for a second as well, and greets his friend by exclaiming: "It is beautiful today!"

The actor to the left quivers at his words as the wind rises in the landscape next to him. In the gust of the wind, a voice which is his own: "Yet I thought of it first!"

The actor to the right: "What a marvelous landscape!"

The actor to the left receives these works like a punch to the stomach and turns, convulsed, towards the public, showing a defeated face ... In the landscape next to him clouds amass and the wind doubles its force. The voice in the wind says: "I had noticed that before he did! ... It is him ... He is the thief of ideas!" And so, from one idea to the next, and from one useless, common observation to the next, with no added merit and without ownership, the actor on the left experiences all the torments of feeling everything

first but hearing the other, the actor to the right, announce everything first. The play is almost a monologue since the actor to the right speaks all the time, standing facing the screens, with his back turned to the audience or observing, from time to time, his friend who becomes more and more contorted by despair next to him, performing a series of mimes, at times facing the spectators, and at other times facing the scenery/film.

The film of always already stolen ideas may project all kinds of events thought by the actor to the left, beginning with the first statement about the sunlit landscape, while the background sound is clearly linked to the sequence of these events.

Thus, from one fatuous comment to the next, the one from whom everything is always stolen becomes a derelict. Collapsed on the floor, he thinks always first, although being bogged down by all kinds of more and more important ideas, and thus finds himself effectively more and more robbed. (All kinds of violent colors reflecting his emotional disarray may be cast on him by a combination of projectors.)

The actor on the right always stays in his section, with the sun and the landscape unchanged; he is happy.

In the auditorium, a young woman gets up from among the spectators in the orchestra and makes her way towards the stage.

The actor on the left is the first to notice this.

Yet the actor on the right is the first to speak: "How beautiful she is!" The young girl smiles and joins him on the stage where they look at each other, walk around each other, holding hands ...

Suddenly, the young girl sees the living derelict, next to them, on the floor in the section of the stage where everything is deplorably dark and disastrous.

Naturally attracted to those who suffer, she brusquely lets go of the hand of the actor on the right and goes straight over to the actor on the left who is contorted with pain on the ground as he devours her with his eyes. She gently lifts him up.

A mental barrier is erected; the actor on the left has in his head the image of the young woman who has come instinctively to his

aid. Love prevents the other actor from seeing his thoughts. The marvelous landscape returns to his section as he takes the young woman into his arms.

At that moment, a sudden darkness falls over the section of the actor on the left and he disappears!

(The dialogues are in preparation.)

Proposal for a National Theatrical Institution

The spectators are received by a psychiatrist who submits them to a general aptitude exam. Afterwards they proceed to a swimming pool in which they are washed and thoroughly cleansed by splendid young female specimens of the human race.

Then they spend twenty minutes in the sauna, and next are hosed off in an oxygen chamber while they are able to admire, by the sense of touch only, hypersensitive tactile sculptures on the other side of the walls: gorgeous live models, in the nude, men and women, exposed within reach of the hands of the spectators (who pass their arms through cylindrical openings in the walls to feel them without seeing them).

Following ozonization, the spectators are induced into an artificial sleep state for twenty-four hours and then awakened, massaged, showered, dressed, and violently expelled.

The Contract

Act I

The curtain rises; the actor and the spectator sit opposite each other at the extreme ends of the stage. In the center, a little to the back, is the author. They discuss the theater of Yves Klein and other theatrical possibilities.

Act II

The curtain rises to reveal an auditorium with orchestra, balconies, etc.; actors occupy all the seats; the theater is packed. The auditorium on the stage is identical in every detail to that in which the real spectators are situated; in the center, between the two auditoriums,

several authors are standing in front of small tables and preside in turn over the discussion.

From Vertigo to Prestige (1957–1959)

For years I have been training for levitation and I know well the means to accomplish it effectively (the judo falling-techniques).

On the one hand, there is the legendary and traditional vampirism during the night with absolute physical immobility during the day (this is a matter of diastole and systole); on the other hand, the effective liberation of the personality in every aspect in the individual by the exasperation of the Ego, practiced to the point of a kind of absolute purifying sublimation.

I recently declared, during a talk in Germany in January 1959, that, once liberated from the psychological world, the artist of tomorrow will continuously recreate himself by being able to levitate in total physical and spiritual freedom. I have already made the first steps towards works of this type, such as the flying aerostatic sculptures of 1957, made of one thousand and one blue balloons; and the experience with the Obelisk of the Place de la Concorde, illuminated by blue light during the night with its plinth remaining in darkness; and also the fumes of the inauguration of the Blue Period in 1957. It is what I have already called the passage from vertigo to prestige [du vertige au prestige] (in sculptural terms, it is the liberation from the enslavement to plinths).

Thus I would like to present myself on the stage of a theater stretched out in space several meters above the floor without any trickery or deception for at least five to ten minutes and without commentary.

"Come With Me Into the Void"

I have been painting already for several years from models and even with the effective collaboration of models. Indeed, for a long time I have wondered why figurative painters or even sometimes abstract painters such as Fautrier, for example, feel the need to paint

nudes. To simply seek out a living human form to draw and to copy after nature was not a good enough reason for me; I felt that there must be something else. The nude model brings sensuality into the atmosphere. Careful: not sexuality!

Models create a sensual climate inside the studio, just as they do possibly outside, which permits the stabilization of the pictorial matter. In the true sense of the Christian faith, which says: "I believe in the incarnation of the word; I believe in the resurrection of the body," the body is the true sense of the theater of the word: the word is flesh!

And so I engaged models and I tried it; it was very beautiful. I was fascinated by the flesh, the delicacy of living skin, its extraordinary color and, paradoxically, at the same time, its colorlessness.

My models laughed at me as they watched me execute, with themselves as subjects, splendid and uniformly blue monochromes! They laughed but, more and more, felt themselves drawn to the blue.

One day, I understood that my hands, the tools by which I manipulated color, were no longer sufficient. I needed to paint monochrome canvases with the models themselves … No, this was no erotic folly!

It was even more beautiful. I threw a large white canvas on the ground. I poured some twenty kilos of blue paint in the middle of it and the model literally jumped into it. She painted the painting by rolling her body over the surface of the canvas in every direction.

I directed the operation standing up, moving quickly around the entire perimeter of that fantastic surface on the ground, guiding the model's every movement, and repositioning her. The young woman, so inebriated by the action and by the close contact of her flesh with the blue, ended up no longer hearing me shouting at her: "Again a little more to the right, there, come back by rolling on that side, the other corner is not yet covered, come over here and apply your right breast, etc."

There was never anything at all erotic or pornographic about these fantastic sessions, nothing amoral; when the painting was finished, my model took a bath. I never touched any of them; it

is for this reason that they trust me and that they love to collaborate with their entire bodies on my painting. It was the solution to the problem of distance in painting: my living brushes were commanded by remote control.

With me, they understood; they were doing something; they were acting. Before, with the figurative artists who sketched them, they recognized themselves afterwards in the paintings. Then came the abstract artists and it became disquieting, psychological, and unhealthy. They, in fact, no longer understood what purpose they were serving.

With me, they first thought that I was insane; but soon they would not pass up any chance to come and pose for me or rather to come and work with me!

This is what I wish to present on the stage accompanied by, as musical background, the song "Come With Me Into the Void," with music by Hans-Martin Majewski:

> When I think of you,
> The same dream always returns
> We are walking arm in arm
> On the wild path of our holidays
> When, little by little,
> Everything seems to disappear around us
> The trees, the flowers, the sea
> Along the sides of the path
> Suddenly there is no longer anything
> We are at our end of the world
> Well ... Should we turn back?
> No ... you say no
> Come with me into the Void!
> If you return one day
> You who also dreams
> Of this marvelous void
> Of this absolute love
> I know that together,
> Without saying a word,
> We will leap
> Into the reality of this void
> Which awaits our love

As I wait for you every day:
Come with me into the void!

 (1957)

Conclusion

... If evil there be; "... I did not wish for it!"
See *The Naturometry of the Blue Period* for the pictorial develop-
ment of that proposition.[61]

Monochrome Stupefaction

The convened spectators enter an empty room whose floor is cov-
ered with rich, white, woolly carpet. There they receive blue pills
to be consumed on the spot.

Two or three minutes later, they collapse under the effect of the
drug: that is to say, they fall into an agreeable dynamic torpor in
which an immense interior space appears, like the blue of the sky,
a uniform monochrome blue.

(Even so, within this blue, two other colors seem quite distinct
and separate from each other: gold and pink, but in the final analy-
sis everything is a uniform I.K.B. blue.)

It is the beatitude of artificial paradises in blue.

Everyone indulges in it.

Five Rooms

The link between spirit and matter is energy. The combined mecha-
nism of these three elements generates our tangible world, claimed
to be real but ephemeral. It is for this reason that, for such a long
time, theater has been a spectacle, and we shall emerge from this
disaster only if we decide to disregard energy. It is at that moment
that extraordinary and extradimensional illumination will be

61 *Naturemétrie de l'époque bleue.* A text published under the
title *Le vrai devient réalité* in *ZERO* 3 (Düsseldorf, 1961). See also
pp. 183-92 below.

accomplished and that one will be directly within spirit and matter, without any intermediaries!

Five Rooms is a proposal to that effect. Spectators pass through the rooms pulling along balls chained to their feet. They enter in the following sequence:

A room of nine monochrome blue paintings of identical format and color (I.K.B.) (1)

An empty, entirely and immaculately white room (including the floor) (I.K.I.) (2)

A room of nine monogolds of identical .999 fine gold (I.K.G.) (3), all formatted identically to the preceding blue monochromes in the first room.

An empty, dark, almost black room (I.K.N.) (4)

A room of nine monopinks formatted identically to the blue and gold monochromes in the preceding rooms. Exact color: rose madder lacquer I.K.P. (5) ...

Exit.

In the same spirit of a nonidea, this presentation was anticipated in 1958 in collaboration with Jacques Duchemin.

The essential intention was to pay homage to His Holiness the Pope John XXIII.

A large square room: on one of the walls, an immense blue monochrome I.K.B.; on the facing wall, an identically formatted immense white monochrome that slowly turns blue within thirty minutes.

On the two other walls: two identically formatted paintings, one red, the other green, that when exposed to the ambient air of the room dissolve in the same span of time of barely thirty minutes.

The theme of the presentation: "Evil and War Disappearing before John XXIII."

The public is invited and even urged to intone a *Te Deum* during the thirty minutes of the demonstration.

(1) - I.K.B. = International Klein Blue
(2) - I.K.I. = International Klein Immaterial (Void)
(3) - I.K.G. = International Klein Gold
(4) - I.K.N. = International Klein Nothingness
(5) - I.K.P. = International Klein Pink

War

A brief personal mythology of monochromy, dating from 1954, adaptable to film or ballet.

(Disclaimer: I have determined to leave this text intact, as it was written in 1954, although I find it today a bit naive and would without doubt no longer employ the same terms.)

*

Two principle abstract protagonists: line and color, which combine, multiply, and interpenetrate thereafter. The only scenery is an immense transparent hemispheric screen (for he rear or front projection).

*

First painting: Projection of an intense and immaculate whiteness onto the screen for four seconds.

*

Second painting: Dissolve from white to gold (color of .999 fine gold). Four seconds of monochrome gold accompanied by a continuous monotone sound (the wavelength of gold).

*

Third painting: Dissolve from gold to pink (rose madder and carmine pink lacquer). Dissolve from the continuous sound of gold to the continuous sound of pink. Four seconds of monochrome pink accompanied by four seconds of monotone pink.

*

Fourth painting: Dissolve from pink to blue (I.K.B. blue). Dissolve from the continuous sound of pink to the continuous sound of blue. Four seconds of monochrome blue, accompanied by four seconds of monotone blue.

*

Fifth painting: Upon the image of uniform blue suddenly appears a gigantic hand (the prehistoric handprints at Castillo, Spain, Abbé Breuil).[62] The continuous sound comes to a sudden and dramatic halt.

*

Commentary: Profiting from a need felt by the first man to make a mark beyond himself, the line (that since the beginning of time is, in fact, found nowhere in the immeasurable space but, nevertheless, is there, waiting) manages to insinuate itself into the kingdom of color and of space that has been inviolate until then .

*

Here begins the composition of concrete music.
 Also the possible beginning of the ballet.

*

The dancers, lying prone on the stage, invisible until now, rise slowly in front of the screen and begin the dance around the outlines of a gigantic hand projected on the screen. Slowly, the hand begins to move, then it gradually disappears, three fingers, then only two are sketching linear traces in bare clay ... Then appear the traces made by prehistoric hands at Ornos de la Peña and Altamira in Spain, recovered by Abbé Breuil.
 The dancers follow the traces on the screen.
 At the same time, a linear concrete music follows the traces.
 In this part of the ballet, man discovers all shapes of nature, the shapes of the tangible and sensual world on which he has just come to set his eyes. He discovers the female shapes, just as he discovers

62 Klein saw reproductions of the prehistoric handprints discovered by the French archaeologist and anthropologist Henri Édouard Prosper [Abbé] Breuil at Castillo in René Huyge's *Dialogue avec le visible* (Paris: Flammarion, 1955).

the shapes of a rock, a lion, a plant, and (here a slightly suggestive, indeed, even erotic dance may be added) the affective sensual emotion between man and woman.

Then comes the period of murder (Abel and Cain), the final transition from dream to reality.

<div align="center">*</div>

FROM THIS MOMENT ON, IT IS UP TO THE CHOREOGRAPHER TO CUT THE FOLLOWING SCENES.

<div align="center">*</div>

Increasingly harnessed, pure color, the universal soul in which the soul of man bathes in the state of terrestrial paradise, is imprisoned, compartmentalized, cut apart, and reduced to slavery. On the screen, projections of red line drawings from Ornos de la Peña or Pech-Merle; Australian line drawings by members of the Worora tribe, Port George; also decorated feet.

The concrete music continues, adapted to the images projected on the screen.

<div align="center">*</div>

In the joy and delirium of its triumph by ruse, the line subjugates man and imprints upon him its intellectual, material, and emotional abstract rhythm. Realism will soon appear.

<div align="center">*</div>

When the first moment of stupefaction passes, prehistoric man realizes that he has just lost his vision.

He recovers by finding figurative form.

Realism and abstraction combine in a horrible Machiavellian mixture that becomes human life on earth and is living death. "The horrible cage" [63] of which Van Gogh will speak millennia later. Color is subjugated to the line, which becomes writing ...

63 See p. 19n11 above.

On the screen, projection of images of Nuestra Señora del Castil-
lo, Almadén, Abbé Breuil, hordes of warriors from Cueva del Val del
Charco del Agua Amarga, Teruel.[64] Concrete music embellished
with negro rhythms.

This scripture of a false, elaborated reality, the figurative physi-
cal reality, makes it possible for the line to organize itself almost for
certain in the conquered terrain.

Its goal: to open the eyes of man to the exterior world of mat-
ter that surrounds him and to enable his advance towards realism.
Man is drawn far away from his lost interior vision of color with-
out, however, being able to leave it completely behind. In it's place,
a kind of void is created, atrocious for some, for others earthshak-
ing or wondrously romantic, which becomes the interior life, the
soul torn apart by the reality of the line.

Meanwhile, color – tainted, humiliated, and defeated – prepares
its revenge over the prolonged course of centuries, an uprising that
will prove stronger. On the screen, images of running figures from
Bassonto in South Africa; bison from Lascaux, with large spots of
red and green color; horses from Lascaux; then spots of color inde-
pendent of the drawings; abstract drawings engraved on Neolithic
artifacts; engraved bones; deer reduced to symbols from Southern
Andalusia, recovered by Abbé Breuil.

*

Musical accompaniment of the *Mass for the Poor* by Erik Satie.

Thus the history of the very long war between line and color
begins with the history of the world, of man, and of civilization.

*

Heroic color beckons from deep inside man, from beyond his soul,
every time he feel the need to paint (it is a sign of the attempts
made by the affective body for liberation in space) ...

Color winks an eye at man, who is imprisoned by the forms of
drawing. Thousands of years pass until man understands these

64 Reproduced in R. Huyghe, *Dialogue avec le visible*, p. 183.

desperate cries and suddenly, feverishly, and takes action to liber-
ate color and himself. Paradise is lost, the entanglement of lines
have become prison bars, which, more and more, define human
psychological life. The drama of the inevitable death of "mortals,"
into which they are dragged by the stormy coexistence of line and
color in a state of war with each other, provokes the birth of art.

<center>*</center>

This struggle for eternal and, above all, immortal creation – in
order to transmute objects, forms, sound, and images, to fashion
them from this universal soul of color, which is the conquest of life
itself – was invaded by the line, by the magical, deathly power of
evil and darkness.

Writing is born out of figurative forms and the enchantment
that man feels in separating drawing from color, which leaves
him always with a vague impression of remorse when he has not
done so. On the screen, a parade of masterpieces illustrating the
first signs of the birth of writing; the true and unique undertaking
worthy of the line and of drawing: hieroglyphs. Appeased, color
breathes again and regains purity, although it is still cautiously
compartmentalized in ancient Egypt. Each cast has its own color
(ritual of colors). America: Aztec, Toltec, and Mayan civilizations.

<center>*</center>

In China, color seems to free itself by means of an intermediary, a
ruse (rather still, here, the ritual nature of color, which is substi-
tuted by graphic symbolism, the ideogram).

Color invades images and surfaces with delicacy and drawing
seems to be subjected to it for a time; but it is not by deception that
color seeks to free itself; it feels genuine.

It is, indeed, in the monochrome that the Chinese painting ex-
cels, notably during the Song Dynasty. The artists sometimes add
a tiny stipple of ink to the flat tones, which allows them to obtain
plays of light. The most ancient monochrome paintings are severe
in style: one example is the famous Admonitions hand scroll pre-

served in the British Museum in London (by the painter Gu Kaizhi, 4th century). It is only in the 13th century that violent tones, reds and purples, make their appearance. Meanwhile, color realizes that this chiaroscuro, this delicate painting of atmosphere, those clouds of tone and halftone blended one into the other without violence, although barely striated by drawing, is not a true victory! It is merely a truce and, at most, a compromise. Color does not desire a false liberation. It wants a true victory beyond any weakness.

Soon, thanks to such attempts at coexistence, the line manages to make itself appealing, or at least respectable, to color (reign of the concept form + color, logical categories of vision and understanding). Color and drawing adapt to each other and a morbid but livable life establishes itself and takes shape. Deceived by the illusion of peace between the two antagonists, civilizations devote themselves to the pictorial arts (the great myths are born). Color, like line, is more or less valued according to the period. On the screen, reflections on colors and lines from each of these civilizations. Parade of masterpieces, showing at one time the superiority of the line, at another that of color (psychological deductions). Line and color confront each other in all the following civilizations.

Reflections and images are compared on the screen:

*

India, the Etruscans, Japan, the civilization of Asia Minor, the Middle East, Greece, Rome. Religion, which often forbids figurative representation in art. Color among the Negroes; clearly showing its "ritual" character.

*

The pictorial Christian world: oriental and occidental.

*

The abstract Irish illuminated manuscript, the Middle Ages in Europe.

*

The Italian primitives, the Renaissance, up to our own day, that is to say, by way of the precursors of Impressionism.

*

Last outburst and attempt to defense the line in the debate between Ingres and Delacroix: "Color," said Ingres, "adds ornaments to painting, but it is only the lady-in-waiting."[65]

But Delacroix jotted down some observations in his journal that had struck him: "Colors are music for the eyes ... Certain harmonies of colors produce sensations that music by itself cannot achieve."[66]

*

Very important: the concept of lyricism is regained.

*

Opposition between the essentially affective ritual power of color and the rationalizing symbolism of graphic art.

*

The history of art is the soul of the history of nations. Happy nations have no history: therefore happy nations are those among whom peace reigns. For a history of art to exist, just as for a history of peoples, it is quite simply necessary that there be war! War is

65 "The color adds ornaments to painting, but it is only the lady-in-waiting [*dame d'atour*], since it does nothing but render the true perfections of art more pleasant." Henri Delaborde, "Notes et pensées de J.-A. D. Ingres sur les beaux-arts, in *Gazette des beaux-arts*, Paris 1869, série 2, tome 3, pp. 112-13.

66 *Journal de Eugène Delacroix*, ed. André Joubin (Paris: 1950), vol. 3, p. 391 (Supplement). Delacroix is here citing the French art critic Jean-Baptiste Alphonse Karr.

necessary, and is necessarily followed by peace, and peace by war again, and war again by peace – Duality – Duel – Contrast – Opposition – Progression, and evolution by comparison and analogy.

It is what one can reproach art for: that, with some exceptions, there really has been only one history of art, a kind of constant expression of the time. Certainly, there have been geniuses all the same, genuine artists, who more or less unconsciously transcended their own times through their art, sometimes well in advance of several centuries, often also reaching equally far back into the past.

Yet, art is this invisible link, this glue, that holds the entire universe together through time, eternally. Genuine artists should be prophets of a peace that is deep and violent in intensity and stronger than a destructive war. Today the line is pursued even into more decidedly retrenched manifestations by this necessity to regain the absolute. The very rapid evolution of these past years in Japanese calligraphy is the proof of this; the line disappears and transforms itself instead into shapes without contours, or almost so, filling the entire surface again almost uniformly.

<div align="center">*</div>

The line, being jealous of color as the authentic inhabitant of space, is trying to free itself from being only a visitor in space: it dissolves and invades the pictorial surface. Evolution allows this initiation, which will put everything back in order again. Everywhere everyone desires genuine peace; not the false and dishonest "Peace of Nations" but that ineffable peace, which prevailed in nature and in man before the line intruded on color.

<div align="center">*</div>

Today, Japanese calligraphy would almost be able to fill, in an equal and unified manner, a given surface with its spatial presence; as a result it would be a dominant feature impregnated everywhere by itself through it choice and its creative quality. There would be no more linear psychological prison bars. Standing in front of a

colored surface, one would find oneself directly face to face with the matter of the soul.

A drawing is in inscription on a picture. Drawing a tree is the same as painting a color and writing next to it the word "tree." In fact, the true painter of the future will be a mute poet who will write nothing but express himself, without articulation and in silence, with an immense and limitless painting.

*

In Egypt, the line, feeling the danger of continuous insurrection of the conquered and occupied color, tries to win a psychological victory over color by imitating nature, "all senses," leading to the false enlightenment of pleasure, a pleasure that is almost always sensory, particularly as to the sense of sight. In consequence, artists become aesthetes, abstract or realist. Passing through an entire range of styles of figuration, color is on the brink of death, then regains its strength. There are pacts and treaties between the two adversaries during the rise of this or that civilization. Often color succeeds in dominating without ever completely defeating the line.

*

Throughout the long history of art, as incomprehensible and incredible as it seems, there have always been artists who chose as their emotive theme that which is ephemeral and unreal.

Nevertheless, the power of the image is such that one sees entire civilizations by turns, in distraught, prohibiting either figuration or abstraction.

Arriving at the lowest point of materialism in the 20th century, the veil of the temple of art is finally torn, everyone is initiated and able to appreciate and deeply understand art, which, at other times, had been reserved for the privileged few. In the first chapters of his treatise,[67] Leonardo da Vinci does his utmost to demonstrate the superiority of painting over poetry, music, and sculpture.

67 *Il Libro di Pittura,* first published in Paris in 1651 with illustrations by Poussin.

Painting and art in all its manifestations makes the masses anxious. One recognizes in images the possibilities of the unconscious mind, pursuits to consciously or unconsciously recover that which has been forgotten but can still be sensed by everyone.

> The knowledge of the real furnished by our senses is at the foundation of our experience of space; analogous to the construction of concepts by our intelligence. Bergson has affirmed this. The comprehension of the physical world, just as that of words or of clear ideas, fails when one passes from what defines form to what manifests itself by intensity or quality alone. Clear or distinct ideas only exist through analogy with the separations of space. Pure sensibility is confused; it is only duration; therefore, communicability.[68]

> The child has been put to bed. The room is dark. She closes her eyes; she presses her fingers against her eyelids. And she sees great flames. She sees them; they are in her eyes, deep inside her head. But there is nothing else, neither within nor without, no objects, no eyes. Quite simply, the child sees an intense color. She now removes her hands from her eyes and there appears a marvelous assemblage of diamond-shaped forms, floating side by side as if on water, as soft almost as liquid velvet, spilling phosphorescent light like a flowering shrub at night.
> But this astonishing light is neither day nor night. It is immutable and yet trembles softly. It is always there in her head. Will it always be there? And the color is more beautiful than all the colors on earth, as sumptuous as the intense color of garden pansies, but without that appearance of old, moldy fabric. The child calls her mother and asks: "What is it that one sees when one closes ones eyes?" But the mother does not understand at first; she explains it to her, and her mother replies: You mustn't do that ... you will become blind!"[69]

68 René Huyghe, *Dialogue avec le visible* (Paris: Flammarion, 1955), p. 204.

69 The source for this quotation could not be identified.

*

Delacroix and romantic realism. On February 20, 1824, although determined to trace nature, so to speak, he cried out:

> Ah, cursed realist, would you wish by chance to pro-
> duce an illusion for me such as I imagine that I am
> present in reality at the spectacle that you claim
> to offer to me? It is the cruel reality of objects
> that I flee when I take refuge in the creative sphere
> of art.[70]
>
> Woe to the picture which shows to a man gifted with
> imagination nothing more than finish. The merit of the
> picture is the indefinable: it is just the thing which
> goes beyond precision.[71]

What then is it?

> It is what the soul has added to the colors and to
> the lines.[72]

Delacroix was seeking total expression in and by color.

But in this he is misled; there is confusion in the meaning of the word soul when he says that in drawings the soul tells part of its essential being. It is no longer a matter of the soul when one speaks of drawing and of this the 20th century makes a point. It is a matter of the subconscious, which is altogether different. And when he says, "It is within yourself that you must look and not around you,"[73] he is exactly right, but careful: in ourselves is found an essential part that is the only true life and even vitality that we posses, which is the soul; the rest is merely realism, that which everyone understands as such and which is merely ephemeral. The subconscious, the intellect, sensuality, etc., etc.

70 Delacroix, *Écrits I: Études Esthetiques*, p. 67. The date given by Klein does not correspond to an entry in Delacroix's journal.

71 *The Journal of Eugène Delacroix* (Supplement), p. 711.

72 Ibid.

73 Delacroix, *Écrits I*, p. 83.

*

It is immediately after the period called "realism" that the pictorial revolution occurs that ultimately leads to the great tearing of the veil of the temple of art: impressionism.

Impressionism is a technical revolution. There is no need to exaggerate at the outset, as has been done, the importance of the theories of Rood[74] and Chevreul[75] on color vision. For the most part, the Impressionists are highly incapable of adhering to these theories; the idea is in the air, as they say … Still, these painters are struck by the resources that are opened up by the prismatic decomposition of light into the elementary colors of the spectrum. They realize that two juxtaposed complementary colors will blend together within the eye by reciprocal exaltation, while their mixture yields a heavy, earthy quality. They advocate thenceforth the use of pure and generally light color. Some among them even claim to have altogether banned black and all its gradations of gray, which anyway don't exist in nature.

*

Thus the vast plan for the liberation of color in the 19th century is plotted. Manet, Renoir, Monet, Degas.

Interior light is all color.

*

If it is true that the physical world is the reflection or even the direct projection of the spiritual world, then, in this case, we are quite emancipated from these two aspects or states. But, in any case, the decadent periods in all the great civilizations have always been those in which sensibility – essentially the emotional

74 Ogden N. Rood, *Modern Chromatics with Applications to Art and Industry* (London: C. Kegan Paul & Co., 1879)

75 Michel Eugène Chevreul, *The Principles of Harmony and Contrast of Colors and their Applications to the Arts* [1839] (London: Henry G. Bohn, 1860). Seurat credited his thorough understanding of color to a variety of sources, including Delacroix, Chevreul, and Rood.

and exclusively human domain – has been brought to its highest point of refinement and exactitude.

<div align="center">*</div>

What could be more delectable today for the New World, which is experiencing its powerful, active, dominating ice age, than to observe Old Europe, which is dying immensely rich of sensibility, ridden of any materiality and spirituality?

What an immense human body it represents. Europe is all "flesh," pure, satiated with the blood of past civilizations and silenced of inner joy. We are rapidly becoming cannibals.

"The painter of the future will be *a colorist as such as has never yet existed.*"[76] This will come in a later generation. Van Gogh foresaw monochromy.

In the works of Van Gogh, color possesses sculptural quality that reveals a new vision of space; this color, as is commonly known, was for the Dutch genius the very language and symbol of his sensibility.

<div align="center">*</div>

Standing in front of paintings that certainly have live and speak, I have felt a sensation of being imprisoned, looking through prison bars (the lines in the paintings) at the free and true world of color.

This is what I believe Van Gogh meant to express through his alchemy of painting: "I long to be freed from I know not what horrible cage."[77] What makes our human physical existence bearable is to live in a house with no barred windows; only then is life sustainable.

All this has inspired ridicule in those who believe that the solution is to be found in balance. Balance is a tour de force that demands constant attention to avoid falling at the slightest error. It is a false and horrible solution that makes people blind because

76 *The Complete Letters of Vincent van Gogh,* vol. 2, p. 559 (Letter to Theo 482).

77 Ibid., p. 126. See p. 19n11 above.

while they commit themselves with endless precautions to carefully weigh the pros and cons about everything, they see nothing and fail to live a true life.

<center>*</center>

And so a new flood will soon again devastate the human species in its quest for balance that it will never find because it is not to be found: the destiny of man is his flesh, his life.

<center>*</center>

It should be noted, in regard to art, that as soon as events become dark, there is always an invasion of lines in painting. The difficult years in the life of any civilization, or even simply in the collective and individual span of human life, are promptly striated and obscured by lines in their pictorial arts. It is pointless to return to a position of balance; one must seek life and peace in ones essence, in ones race, and in ones dominant traits: the human dominant trait is color; an entire and immense evolution leading up to the discovery of the mystery of color through the ages is proof of that.

<center>*</center>

Van Gogh, 1885: "*Color expresses something in itself,* one cannot do without this, one must use it; what is beautiful, really beautiful."[78] There is an organic predisposition deep inside ourselves that today urges us all to rediscover color, which is our life.

Drawing in painting is like writing circles around the soul! This writing explains and describes the absurdities and the superficial, worthless ephemera surrounding the flaming heart of being.

78 *The Complete Letters of Vincent van Gogh,* vol. 2, p. 428 (Letter to Theo 429)

Van Gogh to Theo (letter 459): [79]

> Paintings have their own lives that arise entirely
> from the soul of the painter. In short, a painter is a
> man who, consciously or not, tears open his very soul
> by extirpating, with or without pain, or with joy, for
> each painting, the scraps in order to transform them
> through the alchemy of painting (the creative genius)
> into the matter of the ephemeral, perishable, and
> physical soul.

<center>*</center>

Like Christ, the painter says Mass by painting and gives the body of his soul as nourishment to others; he brings about, on a miniature scale, the miracle of the Holy Communion in each painting.

John 6:53: "I tell you the truth, unless you eat the flesh of the Son of Man and drink his blood, you have no life in you."

Throughout the entire ballet ... possible application of great gusts of wind, hot, cold, or temperate – odors.

The Statue

When I shall finally have become like a statue by the practice of exasperating my ego, which will have led me to that ultimate sclerosis ...

Then, and only then, I shall be able to set this statue in its place and leave my home and join the crowd to see the world at last. No one will notice, because they will all be looking at the statue while I shall be able to walk about, free at last ...

It is then that I shall be able to realize what has always been my dream: to become a journalist/reporter!

79 This quotation does not correspond with the reference given by Klein. It is not included in the *Complete Letters* and, most likely, was erroneously attributed by Klein to Van Gogh. Its source could not be identified.

The Mark of the Immediate

In 1953, I proposed to a movie producer in Tokyo to shoot a short movie in color about a mystical-realistic voyage – highly contemplative, yet as dynamic as possible. It would be showing simultaneously the surfaces of different substances in nature as well as showing the depths of their live plunged into an apparent sleep but, in fact, well awake.

I wanted to show man in nature by the traces and the marks that he leaves behind, traces and marks that are always of a marvelous greatness, artificial, ephemeral and yet forever indestructible.

The camera would become the eyes of a *promeneur*[80] who seats himself for a moment alongside a beach in the company of a very beautiful, young, vibrantly voluptuous girl, who undresses herself to stretch out in the sand at his feet under a torrid summer sun.

The *promeneur* then lifts his eyes up and contemplates the pure blue cloudless sky.

Then, his eyes slowly moves downward to the horizon, scanning across the volumetric, transparent, and uniformly blue surface, to finally rest his gaze upon the line of the horizon between the two elements of air and blue water.

Surveying the surface of the sea from the horizon to the shore, his gaze rests upon the waves breaking onto the beach. Then he looks towards the beach to greet at his feet the body of the beautiful girl lazily stretched out in the sand at his feet.

He scrutinizes the body of the girl.

Next the camera cuts to the skin; it is shown at very close range as if under a microscope with its small hairs and pores ejecting sweat like mysterious little volcanoes, then the trembling of the skin, its panting, all of this is observed in extreme close-up.

The nervous tension mounts and quickly becomes a sensual tension; it is very hot.

His eye then seeks relief and wanders off to leafy trees. The leaves are shown up-close with their veins, and one senses the sap flowing beneath the quiet green.

80 One who promenades; a walker or stroller.

The camera moves downward to the trunk of the tree, focuses closely on the bark, the microscopic insects, and then on the ground, the stones, and the grass.

Now the camera focuses on the area next to the feet of the *promeneur*. There, the ground is seen, the tiny pebbles, the earth, the extinguishing butt of his cigarette.

Microscopic inspection of this ground: it is covered with a kind of dew, like the trees and the trunks of the trees nearby. Everything seems to perspire, and yet the air is dry; it is still very hot.

Suddenly, the wind rises.

His eyes turn to the sky, concerned; there are several clouds.

His gaze returns to the stretched-out body of the nude girl.

The wind then redoubles and raises a cloud of dust. The dust sticks to the sweaty body of the beautiful young girl and mixes with her perspiration.

He then draws a large white handkerchief from his pocket and delicately applies it to the skin of the young girl to wipe off the fine mud that has formed in an instant on the surface of her skin.

When he takes away the large white handkerchief, it has left an imprint: the imprint of flesh!

The girl is nervous and takes a towel to wipe away more. There are imprints across her white towel.

The *promeneur* looks at his dirtied handkerchief and then throws it to the ground.

The girl looks at her dirtied towel and also throws it to the ground.

The intrigued *promeneur* takes out a large handkerchief and cautiously takes the imprint of the ground at his feet, for there, too, dust has settled. He then studies this imprint and continuous to collect imprints of the bark of a tree and of one leaf. Each time he looks with a marveling gaze at the resulting imprint on his white handkerchief. He throws away the handkerchief, which is caught on the tips of branches of a small bush.

The girl feels ill at ease; she rises and plunges into the sea to swim.

The *promeneur* then notices the beautiful body's imprint in the sand.

Sensual tension mounts again.

His eyes once again move up to the sky in an effort to distract himself. He faces the dazzling sun.

For a moment, the *promeneur* endures this terrible light; then he again turns his gaze down to the beach, to the sea, the tree, and the lines of the shadows cast across the ground.

Again a gust of wind. The wild landscape is shown as a negative, with light and shade in reverse, the result of the dazzling direct sunlight; the handkerchiefs and the towel lie scattered around the ground, artifacts within that grand nature; they are carried off by the wind on a crazy, unbalanced course towards nowhere.

The girl emerges from the water, dripping wet and beautiful; she approaches the *promeneur.*

They embrace and stretch out together in the sand.

There, in a flash of amorous passion and confusion, the two bodies struggle.

The girl dominates and finds herself on top of the *promeneur* who is lying on his back to see the sky; this time, however, the camera shows a bit of cloud and a bit of sun at the edge of the screen.

For a long time he gazes up, marveling at the sky, which is blemished with a single cloud and illumined by a small piece of sun.

Then, the camera moves to the horizon, for the *promeneur* and the young girl are now standing upright and readying themselves to leave. The camera looks behind the *promeneur* at the sand; at the imprint of their entwines bodies and their sensual struggle.

The camera moves up to the sky and the sky is again a pure blue, cloudless as it was at the beginning of the promenade, at the beginning of the film.

The Sleep

The curtain is raised onto a scene: a room, a large bed, and in this bed a man sleeping. The actor who plays this role each evening must wear himself out during the day to the point of exhaustion so that he is soundly asleep in his bed on stage when the curtain goes up. Everyone watches him sleep for ten minutes, then the curtain is lowered.

Everything occurs in silence and, above all, there will be no applause whatsoever for fear of waking up the actor who is very tired and needs to sleep.

The Reversal

It would be interesting to present a theatrical play upside-down.

The entire play would be performed by actors with their feet on the ceiling and their heads facing the floor; this should be possible today with the help of certain contraptions. All the furniture would also be on the ceiling, which would be, in practical terms, the floor of the stage. All the ceiling decor would be located on the floor, i.e., for example: a solidly hung chandelier, which would levitate statically in space.

—◇—

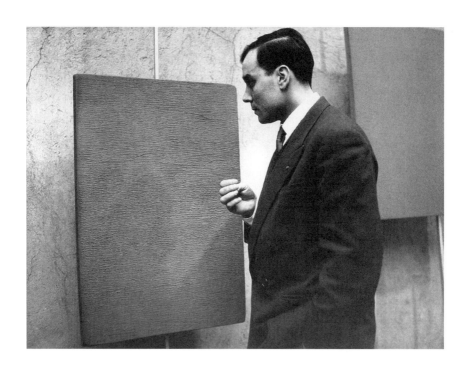

Yves Klein at his exhibition *Proposte monocrome, epoca blu*
at Galleria Apollinaire, Milan, Italy, January 1957.

XVIII. THE MONOCHROME ADVENTURE
THE MONOCHROME EPIC

Foreword

I am aware that in writing this book I may commit an error of diplomacy in the traditional art world, in the formal or even in the so-called informal world of contemporary art. I realize that all these notes and thoughts are confused, highly confused, poorly expressed, emphatic, primitive, certainly often naive, for they have been written day by day.

I know that many will regard this as blah-blah in bad taste. But that is all the same to me; I am neither a literary man, nor am I a man of sophistication. I am an artist and I love my freedom, which is touched neither by vanity nor by stupid candor, even if I have, from time to time, a brush with idiocy.

One more thing, my manner of writing may sometimes appear to be aggressive and can even suggest that I entertain a certain acrimony vis-à-vis antagonists or quite simply vis-à-vis the difficulties that I have encountered with my monochrome propositions and anything else for more than fifteen years. I feel nothing of the kind, neither sorrow nor bitterness; on the contrary, I am very happy with everything that has occurred. To this very day it has been a marvelous fight filled with Life and the Fantastic. And I can declare without exaggeration that I truly and deeply love all my enemies.

My fundamental self is at war with my multiple psychological personalities. I love in myself everything that does not belong to me, which is to say my life, and I despise all that belongs to me: my education, my psychological heredity, my learned, traditional perspective, my vices, my faults, my attributes, my obsessions; in short, anything that each day unrelentingly leads to physical, sentimental, and emotional death.

Part 1
Truth Becomes Reality or Why Not![81]

> He who does not believe in miracles is not
> a realist.
> David Ben-Gurion

Through color I feel the sentiment of complete identification with space; I am truly liberated.

When color is no longer pure, the drama can take on frightening proportions.

Total freedom represents a great danger for those who do not know what it is.

Novices keep asking me: "But what does it represent?" I could answer, and I did so in the beginnings, that it simply represents blue, by itself, or red, by itself, or that it is the landscape of the world of the color yellow, for example. This is not inaccurate; it is, in my opinion, of the greatest importance. In painting a single color by itself, I leave behind the phenomenological "spectacle" of ordinary, conventional, classical easel painting.

One could say to me, "agreed," no more lines, no more drawing, but why not two colors? In response, I believe, it would be amusing to recount my rejection from the *Salon des Réalités Nouvelles* in 1955, which does not lack savor and has a strong bearing on that point.

In 1955, I registered in accordance with the established deadlines after having precisely indicated to the Secretariat that I was not in the least a figurative artist (since the regulations governing the Salon prohibited to exhibit any figurative works) and showed some "photos" (of which it was noted that they might not reproduce well in the catalogue). My enrollment fee was accepted and I was registered. Several months later, I received notice to deliver my submission for the installation at the Palais des beaux-arts de la Ville de Paris.

There, in the presence of my canvas, the various members of the Committee speedily agreed, after a moment's hesitation, that

81 See p. 45n29 above.

my submission was acceptable, with various utterances of "Yes, evidently." I was then given a receipt in exchange and my painting, which I had titled "Expression of the World of Color, Orange Pencil [*Expression du Monde de la Couleur, Mine Orange*]," was taken into storage. It was quite orange. (This was not yet the period in which I claimed orange was blue and vice-versa.)

I returned home, excited about the idea that my work would be hung for the first time in a Parisian Grand Salon, but this illusion, alas, did not last long! In the afternoon of the following day I received a curt letter announcing to me that my submission had been rejected and demanding that I present myself as soon as possible to pick up my canvas: "There are no facilities for the storage of rejected submissions." Such was the letter's brutal tone.

Stupefied, I replied by pneumatic tube (there were only two days left before the opening reception to lodge a protest that I was in complete accordance with their regulations, that they cannot refuse nonfigurative painters and that I did not understand their attitude. In short, I assured them of the sincerity and seriousness of my intentions in the presentation of my submission to their Salon, fearing perhaps that they may have thought my submission to be a provocative joke in bad taste on my part against the spirit of the Salon, which has always been very avant-garde and often sharply criticized by the Press for that very reason.

My mother, well known to all the members of the Salon committee, who were her colleagues, then received an extraordinary telephone call from one of its members, whose name I cannot reveal here, of course, and the ensuing conversation can be summarized as follows: "You understand, it really isn't sufficient; if Yves at least accepted to add a little line, or a point, or even simply a spot in another color, we would be able to hang it, but one single, uniform color, no, no, truly that is not enough, that is impossible!"

As I categorically refused to add anything whatsoever, I received a second letter the following morning, very polite and courteous this time, but still very firm, from which I shall quote only the last paragraph, absolutely incredible in its totalitarian spirit: "We shall be pleased, if some other year, you should decide to show with us

to the extent to which, having seen our salon, you will harmonize your effort with our own."

In short, total dictatorship, in a Salon that prides itself on being largely open to the most advanced attempts, concepts, and explorations.

This little story has come back to me in connection with the question: "Why not two colors together?"

Well, because I refuse to present a spectacle in my painting. I refuse to make comparisons and to draw attention, to put some stronger element in relation to some weaker ones.

Even the most civilized representation is based upon the idea of a "struggle" between different forces, and the "reader"[82] attends in a painting a morbid drama, be it a matter of love or hate.

The canvas is like an individual; I desire to consider it as it what it is and not to judge it, above all, not to judge it!

When there are two colors in a painting, a struggle is engaged; the viewer may extract a refined pleasure from the permanent spectacle of this struggle between two colors in the psychological and emotional realm and perhaps extract a refined pleasure, but it is one that is no less morbid from a pure philosophical and human vantage point.

I absolutely do not wish to favor one candidate over another, according to the traditional and learned criteria of which I am absolutely not certain, and to reject the other one while still keeping it around to clearly show that I have selected the best one!

I know, this cruel regime has existed and still exists; for me it signifies living death, oozing morbidity, obscurantism, and, above all, the ferocious condemnation of freedom.

Just as the Impressionists of whom I consider myself a descendent, just as, more directly, DELACROIX of whom I consider myself a disciple, I stroll about and encounter sympathetic states, a real or an imaginary landscape, an object, a person, or quite simply a cloud of unknown sensibility through which by chance I suddenly traverse, an ambience ...

82 See p. XXI n33 above.

From the voiceless conversation that ensues between these state of things and myself, an impalpable affinity is born, "indefinable,"[83] as DELACROIX would say. It is this "indefinable," this inexpressible poetic moment, that I desire to fix on my canvas since my mode of being (notice, I am not saying *expression*) is to make paintings. And so I paint the pictorial moment that is born of an illumination by impregnation in life itself.

"... To feel the soul without explanation, without vocabulary, and to represent that feeling ... This is, I believe, foremost among the reasons that led me to the monochrome!"

For me, the art of painting is to produce, to create freedom in the first material state.

The lines, bars of a psychological prison, as I see it, are certainly in ourselves and in nature, but they are our chains; they are the concretization of our mortal state, our sentimentality, our intellect, limiting our spiritual realm. They are our heredity, our education, our skeleton, our vices, our aspirations, our qualities, our gimmicks ... In short, they are our psychological world in its entirety, down to its most subtle crannies.

Color, on the contrary, on a human and natural scale, is that which is most immersed in cosmic sensibility. Sensibility has no crannies; it is like humidity in the air. Color, for me, is the "materialization" of sensibility.

Color permeates everything just as indefinable sensibility permeates without form and without limit. It is spatial matter that is at once abstract and real.

The line may be infinite, just as the spiritual is, but the line does not have the capacity to fill the all-encompassing immeasurability; it does not possess the capacity of color to impregnate everything.

"The mind is capable of many things, Sir," DELACROIX wrote, "it is an adroit and intelligent being that profits from the perceived weakness of its neighbor and lies low when the storm of passions is too strong. But worth is a vigorous, ribald young man whom noth-

83 *The Journal of Eugène Delacroix* (Supplement), p. 711.

ing can resist, come hell or high water, and who gets straight to the point"[84]

In taking up these words, I would like to say: "The line is capable of many things, Sir, it is an adroit and intelligent being that profits from the perceived weakness of its neighbor and lies low when the storm of passions is too strong. But color is a vigorous, ribald young man whom nothing can resist, come hell or high water, and who gets straight to the point."

The line perforates space; it is always in transit; it inscribes itself; it is a tourist.

Color finds itself impregnated in space; it inhabits it ...

There are vibrant colors, colors that are majestic, vulgar, sweet, violent, or sad.

Such colors are human, even when there are outside of us, while forming an integral part of our personalities and of our interior lives; they are in this regard charged with all of our sentimental affectivity. What is so extraordinary about this is that, as we realize this, we are free, for color is itself free! It is instantaneously dissolved into space. When we contemplate a terribly sad color, for example, we feel ourselves immersed, dissolved in a space that is immeasurably and extradimensionally sad; this is the sorrowful freedom that is more vast than the infinite!

The line runs, goes out to infinity, while color itself "is" in infinite.

For me, colors are living beings, highly evolved individuals that integrate themselves with us, as with everything. Colors are the true inhabitants of space. The line merely travels across, passes through space ... Each nuance originates from the base color but clearly possesses it own autonomous existence, which immediately signals that the fact of painting a unique color is not limited; there are myriad nuances for all colors, each of which possesses its individual and particular worth.

A painting is merely a witness, the sensory surface that records what occurs. Color, in its chemical state, which all artists employ,

84 The source for this quotation could not be identified.

is the medium most capable of being impressed by this "event." I think, then, that I can say: my paintings represent poetic events or rather immobile witnesses, silent and static witnesses of the very essence of movement and of free life, which is the flame of poetry during the pictorial moment!

My paintings are the "ashes" of my art. It is the monochrome that make me the most intoxicated. I have tried I don't know how many styles. I have been as much of a painter as it is permitted; I have advanced and become avant-garde; I have passed through all the periods; I have been insatiable and drawn from wells of pleasures and consolations, which have already left me jaded. In any case I do believe that it is only in the monochrome that I truly live pictorial life, the painterly life of which I have dreamed. This was precisely what I have hoped for in painting! I find myself within it, in the special matter, the pictorial matter, and I have blossomed. It is true, I am for the first time inebriated and fully satisfied in painting monochromes. The life of color! And it is this that brings to mind for me COLOMBO and its merchants of precious gems who empty before you their pouches filled with sapphires, aquamarines, rubies, making little piles on a table covered with soiled, uncolored velvet. What a spill! What infinite scintillation!

This is what I seek to find again in colored matter, this unique and living spill, filled at once both with luxury and serenity.

I say this quite emphatically, and yet I am, in fact, quite a bit inebriated. Intoxicated painting is well known; VAN GOGH devoured his colors by the tube; it is a drug. One does not become a painter; one suddenly discovers that one has always been one!

For several years I have thus pursued this adventure, this pictorial experiment based upon the sensorial, sensuous, and the sculptural resources of pure color, which is to say, of color presented as such, offered in and for itself to the "readers."

These monochrome propositions, so named by Pierre RESTANY because their material presentation makes them true supports of color (before I simply called them "paintings"), have preserved the objective aspect of traditional painting.

They are panels of wood or hardboard in varying formats (format and chromatic value being in general unconnected) whose surface

has been covered with a very fine and tightly-stretched canvas. It is this canvas that is destined to receive the "color," after meticulous preparation. A color whose tone, once fixed after diverse pigments are mixed together, is uniform. I speak of a kind of alchemy practiced by today's painters, "created" in the tension of each moment of the pictorial matter, suggestive of a bath in a space more vast than infinity. On the occasion of my second Paris exhibition, at Galerie Colette ALLENDY in 1956, I presented a selection of these propositions in various colors and formats. What I sought to inspire in the public was that "moment of truth,"[85] of which Pierre RESTANY spoke in his introduction to my exhibition, allowing for a blank slate devoid of all exterior contamination and attaining a degree of contemplation that turns color into full and pure sensibility.

Unfortunately, it became apparent from the responses to that occasion, and especially during a debate organized at Galerie Colette ALLENDY, that many of the spectators were prisoners of a conditioned way of seeing and remained sensitive to the relationships between the different propositions (relationships of colors, of intensities, of dimensions and architectural integration), recombined them into decorative polychromy. It is this that led me to push my attempt further still, this time in Italy at Galleria Apollinaire in Milan, in an exhibition dedicated to what I dared to call my Blue Period. (In fact, I had already dedicated myself for more than a year to the search for the most perfect expression of "Blue.")

This exhibition was comprised of ten[86] paintings in dark ultramarine blue, all of them rigorously similar in tone, intensity, proportions, and dimensions. The rather passionate controversy that arose from this manifestation proved to me the value of the phenomenon and the real profundity of the upheaval that comes in its wake to those unwilling to submit passively to the sclerosis of accepted ideas and set rules.

I am happy, despite all my errors and all my naiveté, and despite the utopias in which I dwell, to find myself researching so current a problem.

85 See p. 20n12 above.
86 See p. 20n13 above.

In fact, in the atomic age, where all matter can suddenly vanish to leave behind nothing but what can be imagined as the most abstract, I may be permitted to recount the following tale from ancient Persia.

A flute player one day began to play only a single and unique continuous sound.

Having done so for more than twenty years, his wife finally pointed out to him that other flute players have produced many harmonic and melodic sounds, etc., and that this was perhaps more interesting and varied.

To this the "monotone" flute player replied that it was not his fault that "he" had found the note for which the others were still in the process of searching!

Each of these blue propositions, all similar in appearance, were perceived by the public as clearly distinct from each other. The nonprofessionals passed from one to the next, as was fitting, penetrating in an instant state of contemplation the worlds of blue.

But each painting's blue world, although of the same blue and treated in the same way, revealed itself to be of entirely different essence and atmosphere; none resembled the other anymore than pictorial moments and poetic moments resemble each other. Though all are alike in nature, superior and subtle (detection of the immaterial).

The most sensational observation was that of the "buyers." Each selected from among the displayed paintings the one that pleased them the most and paid its price. The prices, of course, were all different. This fact demonstrated that, on the one hand, the pictorial quality of each painting was perceptible by something other than the material and physical appearance and, on the other, that those who made their choice recognized that state to which I refer as "Pictorial Sensibility."

To those who keep telling me after all this was done that I could go no further, I am going to continue in this spirit, having thus detected the existence of pictorial sensibility. I repeat it here once again, my master DELACROIX had, well before me, announced it under the name of the "INDEFINABLE," but it has been imperative

to me that I rediscover it myself in order to make the Blue Period into an initiation for both for the public and for myself.

It is during this period that I decided to penetrate still further into this new conquered landscape; in sum, the physical painting owes its right to exist to one single fact, that one believes only in the visible while quite obscurely sensing the essential presence of something else, clearly otherwise more important, at times almost invisible!

Again, DELACROIX:

> Ah, cursed realist, would you wish by chance to pro-
> duce an illusion for me such as I imagine that I am
> present in reality at the spectacle that you claim to
> offer to me? It is the cruel reality of objects that
> I flee when I take refuge in the creative sphere of
> art.[87]

In art that today is regarded as abstract, reality is represented by psychological objects of the domains of the subconscious as well as of the unconscious.

Once again, Delacroix:

> Woe to the picture which shows to a man gifted with
> imagination nothing more than finish. The merit of the
> picture is the indefinable: it is just the thing which
> goes beyond precision. What then is it? It is what the
> soul has added to the colors and to the lines.[88]

In the period of DELACROIX, the word soul was doubtless not yet as outworn and exhausted as it has become today. This is why I have avoided using it until now ... I am thinking of replacing it to advantage with words much less compromised such as human or cosmic "sensibility" or, better yet, "pure energy."

Therefore, I am seeking the real value of a canvas. Take two paintings, rigorously identical in every visible and readable aspect such as lines, colors, drawing, forms, format, thickness of the paint, and technique in general; yet, one is painted by a "painter," the other

87 Delacroix, *Écrits I: Études Esthetiques*, p. 67.
88 *The Journal of Eugène Delacroix* (Supplement), p. 711.

by a competent "technician," an "artisan," and although both are officially recognized as "painters" by the collective public, this real yet invisible value makes certain that one of the two is a "painting" and the other is not.

The painter is the one who knows how to specify that real value, that sensibility that is born out of the belief and the knowledge that there is poetry if matter consists of concentrated energy, as science has concluded in its latest analysis.

There is, therefore, the possibility of no longer concentrating energy and merely awaiting, by this apparent inaction, the decontraction of energy.

The canvas consists of concentrated poetic energy, contracted more precisely from the psychological point of view; in color, initially, which is the medium that charges itself and saturates itself best with this state of subtle things, and then, afterwards, the lines, the drawing, the form, and the composition prepare the discourse to almost excuse the intrusion of solidified freedom into the imprisonment of tradition.

I thought, then, that the next step, following the Blue Period, would be the public presentation of this pictorial sensibility, this "poetic energy," this impalpable, free matter in a nonconcentrated, noncontracted state.

It would be a truly informal painting, such as it is and should be. Thus I presented, in my last double exhibition in Paris, at Iris CLERT and Colette ALLENDY in 1957, in one room on the first floor of Iris CLERT's gallery a series of surfaces of pictorial sensibility, invisible, of course, to the naked eye and yet very much present.

Truth be told, what I am after, my future development, the solution for my problem, is to no longer do anything at all as quickly as possible, but consciously, with care and caution. I want to "be," plain and simple. I will be a "painter." People will say of me: that's the "painter." And I will feel myself to be a "painter," a true one, precisely because I won't paint, or at least not in appearance. The fact that I "exist" as a painter will be the most "formidable" pictorial work of the present age; like the fact that a poet who does not write poems is much more within poetry than a poet who winds

up with all his "laid eggs" black on white. It is indecent and obscene to materialize or to intellectualize. It is sufficiently sensual in the abstract to live poetry or painting or simply art!

Painters are not creators in the primary sense that one sometimes wants us to admit. They are not pregnant with paintings. Artistic creation is in my opinion something quite different than animal or human procreation. Can paintings in fact create? Are they capable of creating other paintings by their relationships between them? Do they have gender? Are they hermaphrodites?

Paintings are living, autonomous presences; this is the crucial point of the entire discussion. It proves that artistic creation is more delicate, much more delicate than one thinks, even while being very real. This idea reminds me of the Catharist fervor of the Middle Ages.

Paintings create ambiences, sensitive climates, phenomenal states, and particular natures that are perceptible yet intangible, at once mobile and static, balanced beyond the phenomenology of time!

Truth be told, all objects and all states of matter originate things in this manner to a greater or lesser degree. Let's just say that paintings, in their ways, are nearer to perfection!

Painters should resemble their paintings, which end up becoming stand-ins for them, in a sense, for they create, they procreate art, or rather not: it is life that they create, the first life, life itself. True paintings create something that overcomes the problematics of art! They originate from this phenomenal substance that may be said to be pictorial sensibility, freedom in the first material state, or simply life refined and made comestible for our higher senses – the perception of things abstract and pure.

This is why I so often repeat, despite the contempt and the mocking smiles of my colleagues, that every painter one has an obligation to bring out the best of oneself solely and uniquely in the refinement of space that defines painting!

Thus, paintings set an example for the painters who produce them, for they do not paint paintings; they no longer have the need to assure themselves in this way of their existence and that they, in

turn, are capable of creating. Freed from the psychological world, they understand and, quite simply yet also quite surprisingly, they themselves are paintings.

At this degree of sensibility (not to be confused with sentimentality) one may experience that by removing a canvas, a "truth," from where it was hanging long enough to refine the atmosphere around it, one will very quickly perceive its absence, for its presence had been very strong because of the psychological effect of the material support that it represents, allowing one to lean oneself safely into the full void of pictorial sensibility. But after having become accustomed to its absence, one will perceive a new presence emanated from and created by its past physical presence; this [new] presence will be a "presence-presence" of some sort and will exist in itself, autonomous and distinct from everything else in the space from which the painting is missing. And it will well be a matter of creating art that is pure and true, that is no longer suggestive of this or that, no longer picturesque, no longer the crystallization of desires, of psychological states, etc., etc.

The role of the painter in the society of the future will be to live "externally," to live *in* a collectivity in which he will refine, through his presence, the best, the purest, and the most delicate states of sensibility and its atmosphere so that these, quite simply, may be healthful, gay, and good!

And one will be able to say that painting, like poetry, is the "art of creating souls to keep company with souls."

A painter collaborating with an architect in a new construction, for example, will no longer paint figurative, abstract, or monochrome murals but, quite simply, bestow upon the construction of the structure, through his presence in this collaboration, a certain sensibility, a sensuous life, a warmth that would take the structure itself a much longer time to create with its inhabitants – and certainly not under the same gentle, kind, fantastic, formidable, extraordinary, and marvelous conditions as the painter of the future will be able to do it, ever so often, through his effective presence during the construction.

The structure will be decorated with material "pictorial sensibility." The modern architect will therefore finally be able, in his own way, to concern himself with strictly utilitarian issues and leave the creation of a vertiginous climate of poetic pictorial expression in the new atmosphere of the construction as a whole to the artist-painter.

This will be a "marvelous realism," the imagination of the twentieth century, the art-science of "the blending of fire and water."[89] DELACROIX, with whom I decidedly feel more and more in agreement, copied into his journal the content of a conversation that he had with Chopin:

> I asked him what established logic in music. He made me feel what counterpoint and harmony are; how the fugue is like pure logic in music, and that to know the fugue deeply is to be acquainted with the element of all reason and all consistency in music. I thought how happy I should have been to learn about all this – which is the despair of the common run of musicians. That feeling gave me an idea of the pleasure in science that is experienced by philosophers worthy of the name. The thing is that true science is not what is ordinarily understood under that name, that is to say, a department of knowledge which differs from art. No, science, looked upon in the way I mean, demonstrated by a man like Chopin, is art itself, and, obversely, art is no longer what the vulgar think it to be, that is, some sort of inspiration which comes from nowhere, which proceeds by chance, and presents no more than the picturesque externals of things. It is reason itself, adorned by genius, but following a necessary course and encompassed by higher laws. This brings me back to the difference between Mozart and Beethoven. As he said to me, "Where the latter is obscure and seems lacking in unity, the cause is not to be sought in what people look upon as a rather wild originality, the thing they honor him for; the reason is that he turns his back on eternal principles; Mozart never. Each of the parts has its own movement which,

89 See p. 171n104 below.

while still according with others, keeps on with its
own song and follows it perfectly; there is no coun-
terpoint, 'punto contrapunto.'" He told me that the
custom was to learn the harmonies before coming to
counterpoint, that is to say, the succession of the
notes which leads to the harmonies. The harmonies in
the music of Berlioz are laid on as a veneer; he fills
in the intervals as best he can.
 These men so vehemently in love with style, who would
rather be stupid than lacking in an air of gravity.[90]

This is a beautiful conversation, worthy of true artists who are truly searching – and not merely assuming an air of gravity and mysteriousness to conceal their incompetence and their lack of understanding. What can I say? I respect DELACROIX more for his realist conscience of a true man of art and less for his paintings, which, while significant, are not, in my opinion, the most important.

On account of the sensient and spiritual attitude revealed in his journal, DELACROIX is to me one of the great men with the status of "painter."

Here again is what he says of all those poor individuals who think that to speak of art is impossible, taboo, indecent, and unseemly for a truly inspired painter: "[In music, as] in all the other arts doubtless, as soon as style, character, the serious things, in a word, appear, everything else is forgotten."[91]

I detest artists who empty themselves into their paintings, as is often the case today. The morbidity! Instead of contemplating beauty, goodness, truth, they throw up, they ejaculate, they spit all their horrible, rotten, and infectious complexity into their painting as if to relieve themselves by burdening "others," the "readers" of their works, with the artist's remorse for their failures.

I execute my paintings very quickly, in very little time.

When I am not inspired I find myself void and demoralized, morbid and mentally feeble. It is then that I work a lot on a canvas; I begin over and over, endlessly: I fail, I return to the same old ideas.

90 *The Journal of Eugène Delacroix* (7 April 1849).
91 Ibid. (11 April 1849).

On the other hand, when all goes well, when I am in top form, I execute good paintings very quickly, straight, without hesitation or stopping, and I am content. It is tiring, but it is a good tiredness.

It was in 1947 that the "idea," the conscious "monochrome" vision first came to me. I must say that it came to me rather intellectually; it was the result of all my passionate searching then.

Judo (1946); Rosicrucian cosmogony (1947), as interpreted by Max Heindel of Oceanside, California;[92] jazz; playing the piano and dreaming of having a large orchestra; composing music consisting of a single tone: "a great monotone symphony" (not necessarily, however, in the spirit or rhythm of jazz) with a unique musical mass impregnating itself with space, a melody melted into one single and unique continuous note from the beginning to the end (I did create this great symphony two years later in 1949). This continuous "sound" was deprived of its initial attack and of its ending by an electronic process and, thus, emerged from space even while remaining in it, penetrated it anew, then returned to silence – duration: twenty minutes (originally forty minutes long, but that was of no importance since the drawn-out, continuous sound, deprived of its attack and of its conclusion, created a sensation of vertigo, an aspiration of sensibility, outside of time – this symphony did not exist even as it was there, emerging from the phenomenology of time because it was not born and had not died after existing in the world of our possibilities of conscious perception. It was silence – an audible presence!).

During this period (1946–47) I also painted and sketched, but only a little; the fact that my father and my mother were painters irritated me and distanced me from painting. Yet, thanks to them I was being kept up-to-date with the most extreme avant-garde ideas in painting and, moreover, in some ways it made, unconsciously, want to go always further.

It was under these circumstances that, I no longer really quite know how, my research led me to daub gouache on surfaces composed of monochrome spots in a pointillist manner of sorts, but

92 See p. 34n21 above.

with only one color; then, thanks to my youthful audacity, I suppose, I decided to dispatch with it all and fill the entire surface with a single, rigorously monochrome and uniform color.

However, I did not yet become consciously aware of the value of my discovery until two years later in London in 1949.

It was really there that this was brought to light for me. All my ideas had already matured some extent, especially this one.

I left for England suddenly with my friend from Nice, Claude PASCAL. We had decided to study two languages together, English and Spanish, by spending time in the respective countries. Then we intended to leave Spain on horseback, ultimately for Japan (to study judo) by way of Morocco, a place where it was then possible to procure horses for a good price.

The plan was so firmly anchored in our minds that we would have carried it through in its entirety had Claude not fallen seriously ill upon returning to London at the end of 1950.

We had even undergone a long and very serious training in horseback riding to that end in Ireland on the Curragh [racecourse] near Dublin for six months, on horseback almost constantly from dawn to dusk.

In London I worked secretively for about a year to earn my living in the Old Brompton Road framing shop of one of my father's friends, Robert Savage. It was there that in assisting in the preparation of glues, colors, varnishes, and gildings that I first came near raw materials and handling them in bulk. In applying coat after coat on the frames between sanding, taking great pains to avoid any undesired imperfections or irregularities, I first glimpsed a beautiful white distemper, clean and dry. Then, after the second coat, it was a very pale reddish gray or a translucent pink. It was necessary to constantly examine the surface closely, from about five to six centimeters away, to inspect it in detail (my vision was perfectly normal), and to see if it was consistently silken, smooth, or deliberately rough.

And then, the gold! Those leaves literally fly away with the slightest movement of air and have to be caught in flight with a knife in one hand and the gilders cushion in the other. The leaves

are delicately placed on the surface to be gilded, prepared with a base and moistened with gelatinous water beforehand. What material! What better training with respect to pictorial matter! At last, the burnishing with the agatha stone, etc.

It was during this year at the "SAVAGE" studio that I perceived the illumination of matter as a profoundly physical quality. When I returned home to my room in the evenings I did monochrome gouaches on pieces of white cardboard and also increasingly used a lot of pastels. I was very fond of pastel tones! It seemed to me that, in pastel, each grain of pigment remained free and individual without being killed by the fixative medium, and I made some very large works, but, alas, when sprayed with a fixative, it lost all their brilliance and its tone darkened, and without fixative it unfailingly deteriorated and, little by little, turned to dust; the beauty of the color remained, but without pictorial strength.

I had no affection for oil paint. The colors seemed dead to me. What pleased me, above all, were pure pigments in powder form, such as I often saw at the wholesale paint suppliers. They had a brilliance and an extraordinary, autonomous life of their own. This was truly color in itself. The living and tangible matter of color.

What saddened me was to see that this incandescent powder, once mixed with glue or whatever medium intended as a fixative, lost all its value, became tarnished, its tone darkened. One might obtain the effects of impasto, but after it dried, it was no longer the same; the effective magic of color had vanished.

Each grain of powder appeared to have been individually killed by the glue or whatever fixative used to binding them to each other, as well as to the support.

Irresistibly attracted by this new monochrome manner, I decided to undertake the technical research required to find a medium capable of affixing pure pigment without altering it. The color value would then be represented in a pictorial manner. The possibility of leaving the grains of pigment entirely free, such as they are in powder form, mixed perhaps yet still independent in appearance, seemed sufficiently auspicious to me. "Art is total freedom; it is life; when there is imprisonment in whatever manner,

liberty is restrained and life is diminished in relation to the degree of imprisonment."

To leave the powdered pigment as free as I had it seen at the paint suppliers, when presenting it as a painting, it would simply be necessary to spread it on the ground. The invisible force of gravity would keep it down to the surface of the ground without altering it. At the time, I did not consider this to be a possible solution, especially one that would be acceptable to the plastic arts community, even the most informal among them. Also, I had already begun working in the classical pictorial format, which is to say that I had begun to compose monochrome paintings!

The technique was, and still is (at a much more advanced stage, of course), the following: I decided to retain the classical rectangular format in order to not psychologically shock the viewer who, thus, would see a color surface and not a flat color form. What I desired, at the time, was to present, in a perhaps somewhat artificial style, an opening onto the world of represented color, a window opened onto the freedom to become impregnated with the immeasurable state of color in a limitless, infinite manner. My goal was to present to the public the potential for the pictorial matter of color itself to be illuminated, for all things physical – stone, rock, bottles, clouds – to become an object for the journey of the viewer's sensibility into the limitless cosmic sensibility of everything in order to be impregnated.

Such an ideal viewer of my color surfaces would then become, only in regard to sensibility of course, "extradimensional" to such degree that he would be "all in all"– impregnated with the sensibility of the universe.

Alchemy

All good businessmen are alchemists in their line of work to the same degree as artists are in theirs. All they approach and touch, all they take interest in, becomes related to silver or gold. It is a philosophical stone of sorts that they unconsciously nurture within themselves and that sometimes accords them extraordinary power.

The gold of the alchemists of ancient times could effectively be extracted from anything. But what is difficult is discovering this gift of the philosophical stone in each of us.

This applies equally to the greatest and most classical of painters, such as REMBRANDT, for example: he knew that he was supposed to, in the eyes of everyone, paint and represent those personalities, objects, landscapes that he knew the people of his time would recognized in order to gain himself admission into society; but, in actuality, his painting was alchemical and ahistorical. It did not represent reality; it was a pictorial presence created by a painter who knew how to refine a surface to make it into a sort of highly sensitive photographic plate whose purpose was not to take photographs like a machine but, rather, to capture the poetic, pictorial moment; the artist's inspiration, the communion and illumination in the presence of everything.

The canvas beholds, in an instant, the "indefinable," which stands between a truly and poetically free person and itself, and it has become, for the perishable eternity of centuries, witness to the "pictorial moment."

Similarly, the alchemists no more sought the formula for the transmutation of metals into gold than painters seek in their portraits resemblance or the precise perspective of the landscapes that they depict in their paintings. In the Middle Ages, the alchemists had to have valid reasons, in the eyes of the general public, to manipulate their retorts, ovens, and other strange and wondrous instruments; otherwise they risked being considered sorcerers, something unforgivable at the time.

The philosophical stone is this personal gift that allows us to convert or transmute into gold or into whatever natural state, well-defined, exterior to itself but made precisely for itself. The discovery of the philosophical stone is in itself a second birth in the life of a man; it is a realistic sense of the state of things, a choice, a harmonious accord between nature, the universe, and humanity.

My vision has nothing whatsoever to do with that of MALEVICH or even MONDRIAN.

Color for itself is what I wish to create as a presence. Then there is the following dilemma: I did not quite know until now whether I should call myself "painter" or not. And clearly, yes, I am painter because painting, in my opinion, is painting only if the artist can transmute it precisely by virtue of his quality as creator, this impalpable matter, this living pictorial matter that impregnates the canvas and gives it eternal life, at least for the duration of its perishable existence.

The rest, all those lines, forms, and colors put together in a certain order, is not part of the domain of art. It is certainly good, but it is not essential to painting.

The essence of painting is this "something," this ethereal glue, this intermediary product that the artist secretes from his entire creative being and has the power to place, to incrust upon, to infuse into the pictorial matter of the canvas.

This phenomenon applies to all true artists, even to those who are not strictly painters, but to all artists who understand how to impregnate their works with radiant life, with pure poetry or, in other words, who know how to embed a soul in their creation; that is authentic creation!

Reflections on the Color Blue [93]

> The blue of the sky, if we were to examine its many image values would require a long study in which we would see all the types of material imagination being determined according to the basic elements of water, fire, earth, and air. In other words, we could divide poets into four classifications by their response to the single theme of celestial blue:
> Those who see in an immobile sky a flowing liquid that comes to life with the smallest cloud.
> Those who experience the blue sky as though it were an enormous flame - "searing" blue, as the Comtesse de Noailles describes it.

93 Excerpts from G. Bachelard, *Air and Dreams*, pp. 161-70 (chapter 6: "The Blue Sky").

Those who contemplate the sky as if it were a solidified blue, a painted vault – "compact and hard azure," as the Comtesse de Noailles again says.

Finally those who can truly participate in the aerial nature of celestial blue.

... The word blue designates but it does not render.

... First, a document taken from Mallarmé in which the poet, living in the "dear ennui" of the "Lethean ponds" suffers from "the irony" of the azure. He perceives an azure that is too offensive and that wants

To stop with untiring hand
The great blue holes that naughty birds make.

... It is through this activity of the image that the human psyche receives future causality through a kind of immediate finality.

Moreover, if we are truly willing to live, with Eluard, by imagination and for imagination, these hours of pure vision in front of the tender and delicate blue of a sky from which all objects have been banished, we will be able to understand that the aerial kind of imagination offers a domain in which the values of the dream and of the representation are interchangeable on the most basic level. Other matters harden objects. Also, in the realm of blue air more than elsewhere, we feel that the world may be permeated by the most indeterminate reverie. This is when reverie really has depth. The blue sky opens up in depth beneath the dream. Then dreams are not limited to one-dimensional images. Paradoxically, the aerial dream soon has only a depth dimension. The other two dimensions, in which picturesque, colored reverie plays its games, lose all their oneiric interest. The world is then truly on the other side of the unsilvered mirror. There is an imaginary beyond, a pure beyond, one without a within. First is nothing, then there is a deep nothing, then there is a blue depth.

... A. Claudel, for example, seeks an immediate and passionate adherence. He will seize a blue sky in its raw material. For him, before this enormous mass where nothing stirs, this mass that is the blue sky

or rather a sky overflowing with azure, the first ques-
tion will be "What is blue?" The Claudelian hymn will
answer: "Blue is obscurity become visible." To feel
this image, I will take the liberty of changing the
past participle, for, in the realm of the imagination,
there are no past participles. I will say, then, "Blue
is obscurity becoming visible." This is precisely why
Claudel can write: "Azure, between day and night,
shows a balance, as is proved by the subtle moment
when, in the Eastern sky, a navigator sees the stars
disappear all at once."

Blue has no dimensions. "It is" beyond dimensions, while the
other colors have some.

Those are the psychological spaces. Red, for example, presup-
poses a hearth giving off heat. All colors bring forth associations
of concrete, material, and tangible ideas, while blue evokes all the
more the sea and the sky, which are what is most abstract in tan-
gible and visible nature.

To point out: fire is blue and not red or yellow. One only has to
visually observe its flame to have the proof of this.

The impoverished possibilities of perspective in painting, the
"trompe-l'œil," as it is so befittingly called, are the prerogative of
the powerless who regard themselves failed sculptors. The true
painter lives only in his color; he mixes it, applies it upon his entire
canvas as if to interweave it anew with all the science of the innate
surface tension.

"In the work there is a gravity which is not in the man."[94] It is
when man is grave and serious that he is incapable of work. The
painters who are followers of the line, form, and contour are infe-
rior to sculptors. Painting is, before all, color in and of itself.

Observe, you have an idea, a plan, a line to follow in thought
and in action, you act as a son of Cain,[95] as a designer, as a realist,
not as a creator – while if you love as a true lover of everything,
which is to say if you love fully, you are in a state suffused with love
and you impregnate everything that you desire, by abandoning the

94 *The Journal of Eugène Delacroix* (23 October 1852).
95 See p. 171n104 below.

eternal, grave life there. The line enables you to go anywhere, it cuts through the most secret layers of the mysteries of your unconscious, but without revealing to you the sensuous life. Sensuality will be its only victory.

In the final analysis, the line can only suggest; whereas color "is."

It is a presence already in itself that can be charged by the artist with a particular life, bringing its presence within reach of the human sensibility.

The scenes of the life of Jesus described in the Gospels vividly strike our senses and touch us almost physically; more than a narrative account, more than a representation, they are a presence. Although no color is named and neither face nor landscape described, we are constantly face to face and one on one with them.

I want to create works of nature and spirit.

Colors, in the ensuing blue period, were for me the pinnacle of freedom in the art of painting and I now realize that this freedom is only an interlude, a frontier. I return at present into another country, another realm that is completely unknown to me but that clearly exists.

Art is the inner secret. The barrier is the line that, like Lucifer, is ever present.

Color is always experienced as impregnated with faith and profound love. One identifies with it – while, on the other hand, a drawing can only be read, interpreted.

I have in front of me, on the wall, what one refers to as a figurative painting.

What I see, at first, on the canvas ought to be, according to what I believe is imaginable, the manner in which someone would see effectively who is stripped of all poetic sensibility, of all capacity to illuminate matter, of all the dynamics of the liberated mind. The subject of the painting is mountains. What has killed the painting, when it entered into this academic phase of the cult of perspective, is precisely that true perspective, the extradimensional perspective of the human sensibility and of nature. That perspective does not see with the naked eye.

Art is not magic, nor is it occultism, as certain persons want to believe. From the standpoint of art, magic, like occultism, is an illicit diversion, unhealthy, in bad taste, and unwelcome (Surrealism, Dada).

Just as the religions of Moses and Christ opposed magic because it was an illicit diversion from the power of God. In fact, in the Bible, a miracle is hardly different from the wonder of magic. One is realized by the will and with the help of Jehovah, while the other takes place with the assistance of Evil.

Likewise in art, the phenomenon, the work of art, is hardly different from a magical realization. One is realized with the will and with the help of poetry (poetic, material sensibility extracted from space), while the other takes place with the assistance of traditional wisdom (academicism deprived of inspiration).

The presence of the indefinable between man and nature is as evident for me as the color between light and darkness.

Religion has spoken of God.

Science said (through the voice of Einstein): "The most beautiful experience we can have is the mysterious."[96]

Art said (through Delacroix in the pictorial domain): "Woe to the picture which shows to a man gifted with imagination nothing more than finish. The merit of the picture is the indefinable: it is just the thing which goes beyond precision: in a word, it is what the soul has added to the colors and to the lines."[97]

Today 1957

I want everything to be wondrous, in myself and everywhere, all my gestures and actions, and anything else, to create a constant state of happiness, of rediscovered total freedom and profound joy, joyous living.

To make realist, trompe-l'œil paintings representing banknotes, for me, would have multiple meanings and symbols that are of no

96 Albert Einstein, *Ideas and Opinions*, trans. Sonja Bargmann (New York: Crown Publishers, 1954), p. 11.

97 *The Journal of Eugène Delacroix* (Supplement), p. 711.

interest to me except to the extent to which they would be compre-
hended exactly by each possible viewer.

I am a painter, so well, I shall make something that will be paint-
ing in everyone's eyes and also filled with humor, why not? If there
is no humor, so much the worse for those who do not see it. As
for myself, I wish to be happy; I don't even wish for more, I am
so already, so long as I shall live as an artist in the domain of art,
for sure.

The Earth Is Flat and Square

> Sensibility, it is pure enthusiasm,
> of profound joy, at once gay and solemn.

Indeed, how absurd to believe that the earth is a globe in space.
This is a another grave consequence of the learned way of seeing of
men tortured by their psychological purview and by tradition.

Tradition would have it that the earth is round. Scientifically,
our period would have it thus. The Ancients who believed, before
Galileo, that the earth was flat, were not deceived, although only
priests and initiates had this information and, at the time, were
hardly willing to explain themselves to the people. For their part,
they received all of their scientific knowledge only through intu-
ition and in an almost mystical manner.

If the earth really was a rotating, solid mass, as we are taught
today, all of us and all that is not affixed to the surface of the earth
would long since have been projected out into space. In fact, try
to place an ant or some other insect on a pinwheel and spin it; the
insect will not remain on the surface for one second, unless it is
placed very close to the axis, which would mean that to remain on
the surface of the earth, if it really were a rotating globe, we, all of
humanity, would have to be content to live prudently on either the
North Pole or the South Pole.

No, the earth is not round; it is flat, but not in the primary and
naive sense in which ancient peoples believed it to be.

Spin a coin quickly; it will visually appear to be a globe. This
globe is the optical illusion of a round earth, for the earth is flat

like a coin and we live upon the surface constituted by the edges of the coin, which due to its rotation has become internal, created by the rotation of the coin on its own axis, not on the outside of this optical globe.

Just as the Ancients believed it (except for, undoubtedly, the initiated who knew about it, as we shall see later).

This thin and narrow surface of the coin is thus the terrestrial surface, for the flat earth, turning on its axis at a terrifying speed that surpasses our vibratory potential of sensation, would effectively give the visual appearance of a round surface, but it is also a quite tangible surface upon which we walk and support our entire weight, held down by the force of gravity, which is finally explained in a manner that is logical, clear, and simple: by turning on its axis, the flat earth creates a void in the interior of its rotation that causes the force of gravity to rule upon the surface of the edges, which are almost continuously everywhere at once.

Thus one can observe, to my knowledge, in numerous ancient civilizations, notably among the Egyptians, the Aztecs, and the Mayas, in many of their frescoes and initiation paintings of the schools of life, the so-called "penetration of the nine minor mysteries," represented somewhat naively by an adept, hands joined in front, head lowered, plunging towards the hard ground! The initiate, having arrived at a certain degree of perception of the hyper-rapid and extrahuman vibrations, could see the infinitely brief moment of the passage of earth's borders and penetrate the internal surface, the true face of earth in the interior void, in order to emerge from the other side.

Evidently, this will raise any number of objections, and one in particular: why is it that one finds mountains, valleys, oceans, and deserts irregularly scattered on this illusory surface of the earth? Why, if it is really flat and turns on its axis, and we, in fact, live on a surface created by the thin edges of the flat earth, passing at each instant under our feet at some point on the illusory surface in the form of a globe on which we find ourselves, why then are not the mountains all the same, and on the same line of thinking, also the valleys, the oceans, etc.? Because, in my opinion, the cosmic dust

of the atmosphere, attracted by the void created by the rotation on its axis of the flat earth, have not been able to pass through the barrier created by the terrible speed of its rotation and are held, like us (like all that is material, in our degree of concentration of vibration) and have formed an irregular terrestrial crust, which is perfectly adjusted to the surface of the illusory globe.

Finally, the earth, which is to say, the flat surface turning on its own axis in order to constitute our globe, is not round but square. It is difficult for me to further advance this proposition, for I am not a mathematician. All that I can say is that we re-encounter herein the famous problem of the squaring of the circle; and that nothing in nature is a circle; everything is square. The square is the sign of man as the sign of pure and total divinity.

On the Monochrome

Never using the line, one has been able to create in painting a fourth, fifth, or whatever other dimension – only color can attempt to succeed in this exploit. The monochrome is the only physical way of painting – permitting us to attain the spiritual absolute. If we imagine that cinema always existed, that one only knew moving pictures, then the creator of a fixed image would today have been considered a genius!

Young painters, BURRI, TAPIÈS, MACK, DAWING, IONESCO, PIENE, MANZONI, MUBIN, and others still that I do not know, have now come to paint in an almost monochrome manner. But this is not a grave matter for me, quite to the contrary. It is not important "who first composed a monochrome painting."

MALEVICH, by a path different from my own, which is that of "the exasperation of form," arrived at the monochrome almost forty years before me, although that may never have been his intention (his white square on white background hangs in a New York museum).[98]

98 *Suprematist Composition: White on White*, 1918. It is in the collection of The Museum of Modern Art in New York.

A Polish painter,[99] a disciple of MALEVICH, has painted mono-
chromes with compositions of forms in relief in the style referred
to as "unist." All of that is unimportant. It is the fundamental idea
that counts, through the centuries. I consider GIOTTO as the real
precursor of the monochrome painting that I practice, for his blue
monochromes in Assisi[100] (called decoupages of the sky by art his-
torians, but they are clearly unified monochrome frescoes) and the
prehistoric men who entirely painted the interiors of their caves
in cobalt blue. And then there are the writings of monochrome
thoughts by painters such as VAN GOGH and DELACROIX. I con-
sider myself on the lyrical side of painting.

These exasperated with form, the Polish "unists," the suprema-
tists and the neoplasticians still live in the visual, in the academic
side of painting. I will expand somewhat on this, for it seems im-
portant to me to take stock (provisionally anyway):

In June 1957 I exhibited in LONDON and had occasion to meet
with an attaché of the Soviet Embassy and speak with him at length
about the case of MALEVICH.

He related to me how, some time after the October Revolution,
MALEVICH and several of his students or followers organized a
large exhibition in Moscow; certain among his disciples even ex-
hibited, it appears, completely unified rectangular or square sur-
faces, white, black, color, but all clearly with the intention to re-
duce painting to form-phenomena and noncolors. In a manifesto,
apparently out of print or lost, MALEVICH and his colleagues
declared on that occasion that they thought to have reached the
limits of painting and that, in consequence, they returned now to
the collective.

They went, in effect, their separate ways, work in factories or in
the fields of collective farms after the close of the exhibition.

This story, true or false, is distressing for it shows whereto honest
men are lead by academic obscurantism, which is to say, fear ...

The line and its consequences – contours, forms, composition,
etc. – had diverted these impassioned seekers into an impasse

99 Wladyslaw Strzeminski.
100 At the Basilica of San Francesco d'Assisi.

through the power of suggestion of an ephemeral reality: dialectic materialism. They abandoned poetry and sensibility at the junction of eternal life and fate, where they should have turned, had they been true painters, towards the absolute affective pictorial power of color. Thus reaching the exasperation with form without the immaterial and spiritual hope that color gives, it was entirely natural for them to give up art and to join their comrades of the great communist social experiment, which is also entirely in the same spirit: "the exasperation with dialectical materialism and commonplace solidly tangible realism." Soviet Communism is also clearly an exasperation with form in regard to the social structure in opposition to Christian societies and the illuminated civilizations of the Middle Ages. Hence communism unifies and monochromizes, but it does so by killing the individual, the soul, while the Christian democracy tries to stimulate the individual, albeit by precisely defining the personality and leading it to a concept of collective unity through its emotional foundation and not through its material heritage.

I allow myself here to call to mind that, in my paintings, I have always sought to preserve each grain of powder pigment that dazzled me in the radiance of its natural state from any alteration whatsoever by mixing it with a fixative. Oil kills the brilliance of the pure pigment; my fixative does not kill it or anyway much less so.

I see its origin in the dispute between INGRES and DELACROIX. On the side of INGRES: a line of academics terrorized by space who take refuge in the false and temporal vanity of the line, the traditional symbol of the inhuman (Ingres said: "Color is only the lady-in-waiting"[101]), which culminates, after passing through realism (Courbet), in the cubists (in a theoretical sense, excluding the exceptional cases of painters who are painters in spite of themselves, in spite of their attachment to working in accordance with a theory), in Dada, the neoplasticians, the unists and all the so-called cold or geometric abstract artists. MALEVICH arrived from there, the pinnacle of the exasperation with form.

While, following DELACROIX, one arrives at our own time by way of lyricism, the impressionists, the pointillis ts, the fauves, by

101 See p. 123n65 above.

way of a certain affective surrealism, lyric abstraction, right up to the monochrome that I practice and which is not at all monoform, but which is, through the color, the pursuit of every sensibility for the immaterial in art.

I shall here cite the following passage from *Air and Dreams* by G. BACHELARD:

> Some will no doubt object that I am making too much of a very restricted image. They may also claim that my desire to think through images could easily be satisfied by the flight of a bird which is also completely carried away by its élan and which is also master of its own flight path. But are these winged lines in the blue sky really anything more to us than a chalk line on a blackboard whose abstraction is so often criticized? From my particular point of view, they bear the mark of their own inadequacy: they are visual, they are drawn, simply drawn. They are not lived as acts of will. No matter where we look, there is really nothing but oneiric flight that allows us to define ourselves, in our whole being, as mobile, as a mobility that is conscious of its unity, experiencing complete and total mobility from within. [102]

At the Biennial Exhibition in Venice in September 1958 I questioned a Soviet art critic on MALEVICH to verify what the Russian diplomat had one year earlier told me in London. His story was somewhat different. He told me that MALEVICH, after that famous group exhibition, had begun to paint in a realist-trompe-l'œil manner (and had continued to do so until his death, around ten years later), becoming stylish, etc., and that is where the visual and the exasperation with form leads to when one strays from the real value of painting: color. It leads to the miserable "trompe-l'œil."

The integrity of MALEVICH is above reproach. One cannot presume upon such a man, whom I deeply respect for his absolute commitment (because, for me, he is a painter despite himself, as I have already said) and it is herein that it becomes dramatic: that he was constrained by the regime to go there. KANDINSKY left

102 G. Bachelard, *Air and Dreams*, p. 258.

Russia after the October Revolution to work freely. MALEVICH, too, would certainly have been a man to leave Russia if he had felt ill at ease to continue to paint and evolve in his own way. In fact, he had affectively attained not the limits of painting but the limits of his art, the limits of his own art, which, already, was no longer (in reality) painting after he abandoned the illumination of total freedom through color.

The Human Attribute: "Quality"

I am partisan to a certain depersonalization in art.

The artist who creates must no longer do so in order to then sign his works but, as an honest citizen of the immeasurable space of sensibility, to constantly create by virtue of the fact that he is conscious of his life and profoundly illuminated, as is the entire universe, which we neither see nor feel, enclosed in the psychological world of our learned ways of seeing.

I am, therefore, for both an extreme individualism and for a total depersonalization, which may seem paradoxical but, in the final analysis, is not so if one tries hard to think in terms of sensibility, in terms of the static character of absolute movement in space. This means, and I shall come back to this, "life itself." Looking back upon the great biblical myth of Genesis, It is quite certain that if had Eve offered Adam the fruit of the tree of life rather than that of the tree of knowledge (of good and of evil), we would have never, in a sense, left Paradise where we had lived in a state sufficiently similar to that in which today we find the mineral kingdom, "the state of trance."

The mineral kingdom is the only authentic and pure reflection of the spirit, if it is true that the reflection of spirit is matter.

Eve was mistaken as to the order of evolution foreseen by God, for it is quite clear that those two trees had been placed there, in Paradise, without reason.

It should be noted that God had ordained not to eat the fruit from the tree of knowledge, but had said nothing with regard to the tree of life.

It is quite regrettable that Eve did not share the fruit from the tree of life with Adam initially, for then it might undoubtedly have been quite possible for them to also eat the fruit from the tree of knowledge without any danger.

It should be remembered that God expelled Adam and Eve from Eden by pronouncing these words: "Let us drive out them for fear that they will eat fruit from the tree of life and that they will have eternal life then and be our equal."

Through absolute art, that is to say, through the living illumination that I become by enclosing myself within the spheres of artistic creation and immersing myself in the limitless eternal sensibility of space, I am returning to Eden. I am certain of it, and it is because of this that I desire more and more, in my art, to reject the illusion of my personality, the ephemera of the linear, the composed and structured psychological. I wish to be a sane man, solid, normal, quite normal within the tangible nature, and to live in complete sensibility, in complete confidence, constantly within the immense joy of being life itself, eternal life, just like the impressionist figurative painters and all those who have loved the simple life filled with true and honest poetry – easel, colors, and canvas tucked under the arm. Evidently, I continue on my way towards my subject, which is space, pure spirit, but then, it is of the same nature as the countryside or the marvelous seaside beloved by our true painters of the past; there I will then create an immense immaterial painting of incomparable stable, static quality and radiant with real movement; and I will not burst into space like that poor and yet great MALEVICH, with all his ponderous personality burdened with academicism with the best intentions of an amazed tourist: "The blue colour of the sky has been defeated by the Suprematist system, has been broken through, and entered white, as the true real conception of infinity," wrote MALEVICH, "... I have overcome the lining of the coloured sky, torn it down and into the bag thus formed, put colour, tying it up with a knot. Swim in the free abyss, infinity is before you."[103]

103 "Non-Objective Art and Suprematism" (1919), In *Art in Theory, 1900-2000: An Anthology of Changing Ideas,* eds. Charles Harrison and

And this is why I can say, at the age of thirty, in 1958, that when MALEVICH burst into space as a tourist, around 1915 or 1916, I was there already to welcome him and he visited me, for I was the proprietor, the inhabitant or, rather, the co-proprietor and co-inhabitant, already and always. The position of MALEVICH in relation to me makes it possible to leave by the static speed of the immeasurable spirit of the phenomenology of time and allows me to say honestly and calmly that MALEVICH painted a still life based one of my monochrome paintings.

In effect, MALEVICH had infinity before him, while I am within it . One does not represent the infinite, nor does one produce it ...

Water and Fire

For some time now, the sculptor Norbert KRICKE has been attacking the problem of the creation of art in "water." As he himself says, he had to "become" water in order to fully comprehend all of its fluidic possibilities and thus to create a new hydraulic interpretation of art. His "hydrodynamic" conception corresponding to my own "pneumatic" conception of art, we have decided to collaborate and, as the first step, create fountains of water and fire. As creators, we have divided and shared the domains and kingdoms of the elements as follows:

KRICKE = *water and light*

YVES = *air* (plus *wind:* the anger of sensibility) and *fire.*

With his fountains of water, KRICKE represents the element of coolness in countries with hot climates (a psychological rather than actual effect, for water in the public places of those countries provides very little real coolness; it is mostly just the suggestion of coolness that is produced).

Thanks to air, I can provide real coolness in my collaboration with him: by creating air-conditioned currents that strike the water from every direction as well as in one main direction, continuously shaping them as living, glittering matter and creating a true coolness in the desired space. The fountains of water and fire represent

Paul Wood (Oxford: Blackwell, 2003), p. 293.

for me, if we succeed in realizing them, the same type of phenom-
ena as the biblical "molten sea," which failed in the presence of the
Queen of Sheba, because that age was not ready for such an event:
"the blending of water and fire." [104]

104 The Molten Sea, the laver made by Solomon for the use of the
priests is mentioned in 1 Kings 7:23-26; 2 Chr. 4:2-5. Yves Klein refers
here, however, to the Masonic Legend of the Molten Sea, as recounted
in Max Heindel's Rosicrucian tractate *Freemasonry and Catholicism*
(1931), which Klein knew well. According to the legend, "the Sons of
Cain, descended from the fiery Lucifer Spirits, were naturally profi-
cient in the use of FIRE. By it the metals hoarded by Solomon and his
ancestors were melted into altars, lavers and vessels of various kinds.
Pillars were fashioned by workmen under the direction of Hiram Abiff,
and arches to rest upon them. The great edifice was nearing comple-
tion when he made ready to cast the "molten sea," which was to be the
crowning effort, his masterpiece. It was in the construction of this
great work that the treachery of the Sons of Seth became manifest and
frustrated the divine plan of reconciliation. They tried to quench the
fire used by Hiram Abiff with their natural weapon, WATER, and almost
succeeded ... The events which led up to the conspiracy against the
Grand Master, Hiram Abiff, mentioned in our last chapter, and which
culminated in his murder, commenced with the arrival of the Queen of
Sheba who had been attracted to the court of Solomon by tales of his
wonderful wisdom and of the splendor of the temple he was engaged in
building. She is said to have come laden with gorgeous gifts and it is
stated that at first she was much impressed with the wisdom of Solomon
... There the two Initiatory Orders met for the consummation of a defi-
nite work of amalgamation symbolically called THE MOLTEN SEA, a work
which was then attempted for the first time. It could not have been
wrought at any earlier period, for man was not sufficiently advanced.
At that time, however, it seemed as if the united efforts of the two
schools might accomplish the task, and had it not been for the desire
of each to oust the other from the affections of the symbolic Queen
of Sheba, the soul of humanity, they might have succeeded ... Masonic
traditions tell us that Hiram's preparations were so perfect that suc-
cess would have been assured, had not treachery triumphed. But the
incompetent craftsmen whom Hiram had been unable to initiate into the
higher degrees, conspired to pour WATER into the vessel cast to receive
the Molten Sea; for they knew that the Son of Fire was unskilled in
the manipulation of the watery element, and could not combine it with
his wonderful alloy. Thus, by frustrating Hiram's cherished plan and

Subtler still will be the fountains of light and fire, and those of air and water (gusts of wind against the cascade).

KRICKE may also work alone: water, plain and simple, suffices; so does water and light. I myself may also work alone, preferably in the Nordic countries, to reheat an entire public square with forests of immense flames, swept by a wind that, while, for example, making these flames undulate gently, will distribute the heat anywhere, even to adjacent and neighboring streets.

KRICKE and I are studying numerous projects based upon these above mentioned elements, and the results from these studies will soon, I hope, be realized.

Immaterial Habitat

I now would like to speak about a great architectural project that has always been close to my heart, the realization of a habitat that is truly "immaterial" but emotionally, technically, and functionally practical.

This house must be constructed with the aide of a new material: "air," blown into walls, partitions, roofs, and furnishings. It must, of course, provide air conditioning in such a way that the construc-

spoiling his Masterpiece, they aimed to revenge themselves upon the Master... When Hiram confidently PULLED THE PLUGS, the liquid fire rushed out, was met by the water, and there was a roar that seemed to shake heaven and earth, while the elements boiled and battled. All but Hiram hid their faces at the awful havoc; then from the center of the rafing fire he heard the call of Tubal Cain, bidding him jump into the Molten Sea. Full of faith in his ancestor, who had gone before him upon the path of fire, Hiram obeyed and plunged fearlessly into the flames. Sinking through the disintegrated bottom of the vessel, he was conducted successfully through NINE-ARCH-LIKE layers of the earth to the Center, where he found himself in the presence of Cain, the founder of his family, who gave him instructions relative to blending Water and Fire, and who furnished him with a NEW HAMMER AND A NEW WORD, which would enable him to produce these results. Cain looked into the future and uttered a prophecy which has been partially fulfilled; what remains is in process of realization day by day, and as surely as time goes on all will come to pass."

tion material itself provides specific and ambient heat and cooling functions for the entire house. All foundations (underground) of this house will, at most, reach ground level. These foundations will be built with "solid" materials.

Any sheds, kitchens, bathrooms, closets, etc. will be fitted with locks. As for the remaining parts of the house, it will not be necessary to provide locks, for there will be nothing tangible to steal or take away.

In the garden or surrounding yard, the pit for the machinery should be located at a sufficient distance, between fifty and one hundred meters away, to avoid mechanical noise from reaching the habitat, thus preserving its intimacy.

Above ground, one constructs with air – with immaterial materials.

Below the ground, with soil – with material materials, denser and heavier than earth.

For an entire city, the possibilities are vaster still and more interesting.

One single and unique air roof will blow air out on one end and take air in on the other end to refresh the air, while sections of air perpendicular to the ground will delimit the spaces beneath this immense roof.

—◇—

XIX. PROJECT FOR AN ARCHITECTURE OF AIR
BY YVES KLEIN AND WERNER RUHNAU [105]

The architecture of air has in our minds always been just a transitional stage, but today we present it as a means for the climatization of geographical spaces. The illustration shows a proposition for the protection of a city by means of a floating roof of air. An central expressway leading to the airport divides the city into a residential zone and an industrial and mechanical support zone.

The air roof regulates the temperature and, at the same time, protects that privileged area.

Ground surface of transparent glass.

Subterranean service zone (kitchens, bathrooms, storage and utility rooms).

The principle of privacy, still present in our world, has vanished in this city, which is bathed in light and completely open to the outside.

A new atmosphere of human intimacy prevails.

The inhabitants live in the nude.

The primitive patriarchal structure of the family no longer exists.

The community is perfect, free, individualistic, impersonal.

The principal activity of the inhabitants: leisure.

Obstacles formerly considered in architecture as tiresome necessities have become luxuries:

Fireproof walls

Waterproof walls

Airborne forms

Fountains of fire

105 The German architect Werner Ruhnau was introduced to Yves Klein by Iris Clert in Paris in March 1957. He subsequently invited Klein to submit a proposal for the decoration of the lobby of the new Gelsenkirchen Opera House, which Ruhnau was designing, followed by various collaborative projects between Klein and Ruhnau, such as the "architecture of air."

Fountains of water

Swimming pools

Air mattresses, inflatable seats ...

The true goal of immaterial architecture: air conditioning of vast geographic residential areas.

Rather than being accomplished by miracles of technology, this temperature control will become reality when human sensibility has merged with the cosmos. The theory of immaterialization denies the spirit of science fiction.

The newly developed sensibility, "a new human dimension, guided by the soul," will in the future transform the spiritual and climatic conditions on the surface of our earth.

To want means to envision ... Associated with this desire is the determination to experience what one envisions, and the miracle occurs in all realms of nature.

> He who does not believe in miracles is not
> a realist.
> Ben-Gurion

—◇—

XX. THE TRUTH ABOUT NEW REALISM [106]

"History of a collective dream of absolute realism and of the discovery of a sentimental and romantic realism" ... Alas!

"Today's Realism," as it was proposed by me, was born during the great work in GELSENKIRCHEN, 1958.

There I created gigantic monochromes and sponge-reliefs in the entrance hall of the new opera house then in construction. The idea (on the one hand, collaboration in art, and on the other, creating a center of sensibility) came to me undoubtedly through the constant contact with all the different entities that, like me, worked on this vast project.

It was in March 1959 that I first delivered to the public the declaration on collaboration in art, on the occasion of JEAN TINGUELY's exhibition at Galerie SCHMELA in Düsseldorf.

Thereafter I gave a seminar at the Sorbonne in which I denounced this new realism of today and published OVERCOMING

106 This uncommonly harsh text of Klein's was written in response to Restany's manifesto of New Realism, *A 40° au-dessus de Dada* (At Forty Degrees Above Dada), published on the occasion of an exhibition he had organized at Galerie J (run by Restany's second wife, Jeannine de Goldschmidt-Rothschild) in Paris in May 1961. Klein strongly objected to the title and the "abusive filiation" [*filiation abusive*] of the New Realism to Dada. In an undated note with the heading "What is the role of Pierre Restany?" Klein writes, "[Restany] took it upon himself to peg us in relation to the Dada revolution, without consulting with me, I should add, without consulting with all the members of the group, i.e., Arman, César, Tinguely." (Yves Klein Archives). Consequencently, on October 8, 1961, after a "day of neutral observers" [*journée des observateurs neutres*], Klein, together with Raymond Hains and Martial Raysse, dissolved the movement of New Realism, which was witnessed by three critics: Alain Jouffroy, Pierre Descargues, and John Ashbery.

THE PROBLEMATICS OF ART in Belgium:[107] a theoretical essay of several manifestos, notably among which was one on the center of sensibility.

I proclaimed, in collaboration with the architect RUHNAU, the manifesto on the center of sensibility, even though the origin of new realism was too Germanic, too much Bauhaus, because of Ruhnau; and even though I would have always resisted that spirit, the manifesto was written in German and published in Belgium. What is interesting today is to see how my immoderate intentions at that time could lead to this "new realism of today."

I certainly had no doubts whatsoever writing OVERCOMING THE PROBLEMATICS OF ART: it is the exaggerations within this little book that today are bothering even me!

In 1959, I published an article that was more general, but also more focused in its intentions and more explosive in spirit.

In this article, I literally announced that "Today's Realism" had been born.

This article responded for the first time in a new and different manner to the ridiculous campaign mounted by the journal *Arts* and other publications, then headlined: ARE WE RETURNING TO FIGURATIVE REALISM? IS THIS THE END OF ABSTRACT ART?

"The end of abstract art? Possibly, I responded, but a return to easel painting, to the portrait, to the landscape, to the still-life? It would be quite naive to believe that; what is clear is that we are heading towards an implacable and true new realism of today."

During that time, RESTANY starting to arrive at the position that I had taken. As always, he was a little slow in catching up, but he did eventually.

In the course of extensive discussions, he recognized that I was right and that the title of my book, TRUTH BECOMES REALITY, begun in 1956 (and still in preparation), was not so stupid after all.

107 The book, which constitutes chapter XVI in this volume, was first published as *Le Dépassement de la problématique de l'art* in December of 1959 by the Belgian sculptor Pol Bury, who, under the pseudonym of Achille Campenaire, was a bookseller and worked for the publisher Éditions Montbliard at La Louvière, Belgium.

I claimed during this period that in art "stupidity" was essential; it is necessary to be completely stupid to be true.

One coup followed another in the momentous year of 1959: there was the inauguration of GELSENKIRCHEN and the official triumph of the monochrome; then, in March 1960, the anthropometries of the blue period; and then I left IRIS CLERT. (She had made RESTANY considerably uneasy: "Two monsters loathing each other.")

RESTANY then sets himself into motion and brings about what I still refer to as the "restoration." He comes to see me and proposes to create a very restricted group of "new realists."

I reply to him that this is impossible, first of all because no one exists, in my view, yet in the atmosphere and the absolutely pure climate that this position demands.

He demonstrates to me that my ideas are too exclusive and too tyrannical and that in wanting too much greatness, too much truth, and too much purity, in the end nothing is gained – and I become persuaded.

1960 passes by peacefully, during which time Restany perfects the "new realism" movement in his head.

I did not like the prefix "new" at all. I would have preferred to retain the original title, "Today's Realism," for "today" is, in fact, more permanent than "new."

Today remains everyday for centuries.

New becomes old right away.

But RESTANY is taken with this; he is excited, fidgety: in October 1960 he gathers us all at my home: all those whom we, he and I, had finally decided to invite to join, which is to say: HAINS, ARMAN, TINGUELY. RESTANY himself invites CÉSAR who anyway doesn't show up. HAINS brings along DUFRÊNE and VILLEGLÉ. ARMAN and I invite RAYSSE from our school of Nice. For his part TINGUELY brings SPOERRI along.

Nevertheless, Restany was right to proclaim today that it is the "Pictorial Immaterial" of Yves Klein that created "New Realism." It is in this essential point that "New Realism" is the most important movement in the art of the twentieth century. For invisible art, the

"Immaterial Pictorial Presence," created by Yves Klein, is clearly the new accomplishment that New Realism contributes to the history of art!

It should be noted that Restany is not a critic in the NR movement: he is a committed, militant member of the group!

Within the NR movement, ARMAN represents the "mummification of Quantitativism." The object in itself has no importance whatsoever for Arman. It is the surface of a thousand similar objects that constitute quality as opposed to quantity!

HAINS represent the "promenade" through the city and its "walls" plastered with outrageous advertisements torn and lacerated by an unconsciously exasperated society. It is the synthesis of contemporary collective social Tachism! And, above all, anonymous, as says Yves Klein.

TINGUELY represents the premature agony of the machine that becomes human through its constant breakdowns, which he foresees and organizes.

YVES KLEIN represents the atmosphere for all that through his all-powerful, all-impregnating "immaterial."

XXI. PRAYER TO ST. RITA [108]
FEBRUARY 1961 Y. K.

The BLUE, the GOLD, the PINK, the IMMATERIAL, the VOID, the architecture of air, the urbanism of air, the climatization of vast geographical spaces for a return of human life to the legendary Edenic state. The three bars of fine gold are the proceeds from the sale of the first four ZONES OF IMMATERIAL PICTORIAL Sensibility.

To God the Almighty Father in the name of the Son, Jesus Christ, in the name of the Holy Spirit, and in the name of the Holy Virgin. Through Saint Rita of Cascia under her guardianship and protection, with all my infinite gratitude. Thank you.

Y. K.

Saint Rita of Cascia, I ask you to intercede with God the Almighty Father that He may always grant me, in the name of the Son, Jesus Christ, the Holy Spirit, and the Holy Virgin, the grace of living in my works and that they may always become more beautiful; and that He may also grant me the grace that I may discover continually and regularly new things in art, each time more beautiful, even

108 Saint Rita (1381-1457) spent 40 years as a nun living to the Augustinian Rule in the monastery of Saint Mary Magdalen at Cascia, Italy. Klein, a devout Catholic, traveled to Cascia several times. In September 1958 he gave the monastery a small blue monochrome painting dedicated to Saint Rita. He returned in February 1961 to place an ex-voto in the monastery. The offering consists of a plastic case, 21 x 14 x 3.2 centimeters, divided into several compartments. The upper part has three trays filled with blue pigment (IKB), pink (monopink) and gold leaf (monogold). The lower part contains three gold ingots of different weights resting on a bed of blue pigment. In the central part of the case a wide slot was built so as to hold the folded manuscript of the prayer. See Pierre Restany, *Yves Klein: Fire at the Heart of the Void* (Putnam, Conn.: Spring Publications, 2005).

if, alas, I am not always worthy to be a tool for creating Great Beauty. May all that emerges from me be beautiful. So be it.

 Y. K.

Under the earthly guardianship of Saint Rita of Cascia: pictorial sensibility; the monochromes; the I.K.B.; the sponge sculptures; the immaterial; the static, negative and positive anthropometric prints; the shrouds; the fountains of fire and water; the architecture of air; the regulating of geographic spaces, thus transformed into constant Edens rediscovered on the surface of our globe; the Void.

 The theater of the void; all the particular marginal variations of my work; the Cosmogonies; my blue sky ; all my theories in general. May my enemies become my friends, and if that is impossible, may any attempt against me never harm me. Make me and all my works invulnerable. So be it.

 May my work in Gelsenkirchen always be beautiful, more and more beautiful, and be recognized as such and as soon as possible. May the fountains of fire and walls of fire be executed by me without delay in front of the Gelsenkirchen opera house; may my exhibition in Krefeld be the greatest success of the century and be recognized by all.

 Saint Rita of Cascia, saint of impossible and desperate cases, thank you for all the powerful, decisive, marvelous aide that you have granted me up to now. Thank you infinitely. Even if I am personally unworthy of it, grant me your aide again and always in my art and always protect everything that I have created so that even in spite of myself it should always be of great beauty.

 Y. K.

XXII. RITUAL FOR THE RELINQUISHMENT
OF THE IMMATERIAL PICTORIAL SENSIBILITY ZONES [109]

The immaterial pictorial sensibility zones of Yves KLEIN the Monochrome are relinquished against a certain weight of fine gold. Seven series of these pictorial immaterial zones all numbered exist already. For each zone the exact weight of pure gold which is the material value correspondent to the immaterial acquired.

The zones are transferable by their owner. (See rules on each receipt.)

Every possible buyer of an immaterial pictorial sensibility zone must realize that the fact that he accepts a receipt for the price which he has paid takes away all his possessions.

In order that the fundamental immaterial value of the zone belongs to him and becomes a part of him, he must solemnly burn his receipt, after his first and last name, his address and the date of the purchase have been written on the stub of the receipt book.

In case the buyer wishes this act of integration of the work of art with himself to take place, Yves Klein must, in the presence of an Art Museum Director, or an Art Gallery Expert, or an Art Critic, plus two witnesses, throw half of the gold received in the ocean, into a river or some other place in nature where this gold cannot be retrieved by any one.

From this moment on, the immaterial pictorial sensibility zone belongs to the buyer absolutely and intrinsically.

The zone[s] having been relinquished in this way are not any more transferable by their owner.

Y. K.

—◇—

109 Original written in English. In a handwritten note Klein added: "The gold may be burned instead of being thrown in a river (gold burning makes blue fire) ... If someone should prefer to acquire an immaterial zone of pictorial sensibility ... or void ... anonymously ... he can do so without any ritual ..."

XXIII. TRUTH BECOMES REALITY
YVES THE MONOCHROME 1960

... Leaving my mark beyond myself, I have done it!

When I was a child ...

My hands and my feet dunked in paint, then applied to a surface, and there it was, I was there, face to face with my own psyche. I had proof of having five senses, of knowing how to make myself function!

Then I lost my childhood ... just like everyone else (one must have no illusions about that). Repeating that little game as an adolescent, I very quickly encountered nothingness.

I did not like nothingness, and this is how I came to know the void, the profound void, the blue profundity!

As an adolescent, I wrote my name on the back of the sky in a fantastic realistico-imaginary journey, stretched out on a beach one day in Nice ... I have hated birds ever since for trying to make holes in my greatest and most beautiful work! Away with the birds!

Having arrived in that place, in the monochrome adventure, I no longer had to make myself function; I simply functioned.

I was no longer myself; I, without the "I," became one with life itself. All my gestures, movements, activities, creations were original, essential life in itself. It was during this period that I said: "Painting is no longer for me a function of the eye. My works are only the ashes of my art."

I doggedly turned my canvases into monochromes, then the all-powerful blue emerged and reigns still as it will always.

It is then that I began to doubt myself; I took models into the studio, not to paint them as models but to be in their company.

I was spending too much time in the studio alone; I did not wish to remain by myself in that marvelous blue void.

Here the reader will smile, no doubt. But remember, I was free of the vertigo that all my predecessors had experienced when faced

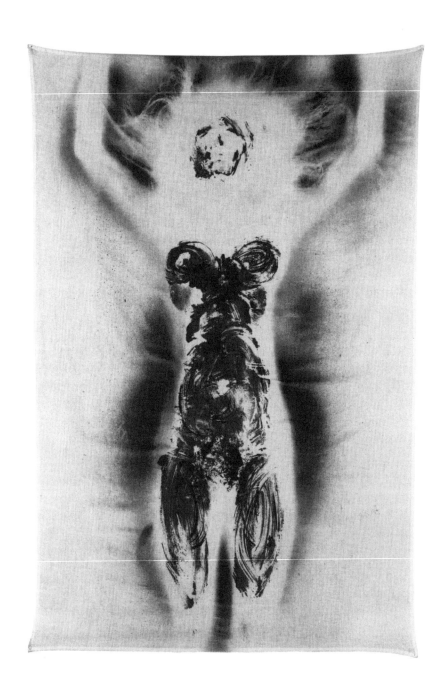

Vampire (ANT SU 20), ca. 1961.

with the absolute void, which must be and is the real pictorial space ... But how much longer would it last?

In the past, the painter used to go to the subject, working outdoors in the countryside, both feet on the ground. It was healthy!

Today, easel painting has become completely academized, so much so that it has imprisoned the painter in his studio face to face with the atrocious mirror of his own canvas ...

... In order not to retreat by shutting myself inside the excessively spiritual regions of artistic creation, using the plain common sense that the presence of flesh in the studio would benefit my incarnate condition, I consequently engaged nude models.

The shape of the human body, its lines, its colors of between life and death are of no interest to me; it is the emotional atmosphere that I value.

The flesh ... !!!!

All the same, from time to time I did look at the models ...

... I very quickly perceived that it was the block of the human body, which is to say, the trunk and a part of the thighs that fascinated me. The hands, the arms, the head, the legs were of no importance. Only the body is alive, all-powerful, and it does not think. The head, the arms, the hands are intellectual articulations around the flesh, which is the body!

The heart beats without thoughts; the mind cannot stop it. Digestion occurs without either our intellectual or emotional intervention; we breath without being aware of it.

Certainly, the entire body consists of flesh, but the essential mass is the trunk and the thighs. It is there that one finds the true universe, hidden by our perception.

The presence of this flesh in the studio has long steadied me during the enlightenment provoked by the execution of my monochromes. It preserved in me the spirit of the cult of "health" that makes of us at once carefree and responsible participants in the universe.

Strong, solid, powerful, yet fragile, like animals in the state of waking dreams in the world of perception, like the vegetal and the mineral entranced in this same world of ephemeral perception ...

... This health that makes us "be," the nature of life itself, all that we are!

As I continued to paint monochromes, I almost automatically reached the immaterial, which made me understand that I was clearly a product of Western civilization, a true Christian who rightly believes in the "resurrection of bodies, in the resurrection of the flesh."

Then a whole phenomenology revealed itself, but a phenomenology without ideas or rather with no systems of official conventions.

What was revealed is separate from form, becomes immediate experience. "The mark of the immediate." This is what I needed!

... One will easily understand the process: at first my models laughed at seeing themselves transposed onto the canvas in monochrome, then they became accustomed to it and loved the values of the color, different for each canvas, even during the blue period where it was more or less the same tone, the same pigment, the same technique. Then while pursuing the adventure of "the immaterial," little by little, I ceased producing tangible art, my studio empty, even the monochromes were gone. At that moment, my models felt that they had to do something for me ... They rolled themselves in color, and with their bodies painted my monochromes. They had become living brushes!

Having had rejected brushes as too excessively psychological already earlier, I painted with rollers, in order to be remain anonymous and at a "distance" between the canvas and myself during the execution, at least intellectually ... Now, what a miracle, the brush returned, but this time it is alive: it was the flesh itself that applied the color to the canvas, under my direction, with a perfect precision, allowing me to remain constantly at an exact distance "x" from my canvas and thus continue to dominate my creation during the entire execution.

That way my hands stayed clean, and I no longer dirtied myself with paint, not even the tips of my fingers. The work completed itself in front of me, with the absolute collaboration of the models, and I was in a position to show myself worthy of it by welcom-

ing the work into the tangible world in a fitting manner wearing a tuxedo.

It is at this time that I noticed "the marks of the body" at each session. They disappeared immediately, for it was required that everything should become monochrome.

These marks, pagans in my religion of absolute monochromy, hypnotized me right away, and I worked on them secretly, always in absolute collaboration with the models, in order to share the responsibilities in case of a spiritual bankruptcy.

The models and I practiced a perfect and irreproachable scientific telekinesis and it is thus that I presented "The Anthropometries of the Blue Period," first privately at Robert Godet's in Paris, in the spring of 1958, and then again, in a much more perfected form, on March 9, 1960 at the Galerie Internationale d'Art Contemporain.

... Hiroshima, the shadows of Hiroshima in the desert of the atomic catastrophe, terrible evidence, without a doubt, but evidence of hope all the same, hope for the survival and permanence, albeit immaterial, of the flesh.

With this rather technical demonstration I wanted to , above all, tear away the veil from the temple of the studio. To keep nothing hidden of my processes and thus perhaps merit the "grace" of later receiving new subjects of amazement through such new technical devices, just as valuable as always, and just as unimportant. These results continue to astonish me just the same. With or without technique, it is always good to conquer! This was my slogan in competing for the judo championships in Japan! I was taught in judo to achieve technical perfection in order to be able to deride it; to be constantly in a position to display it to all my adversaries, and thus, although they know it all, to conquer all the same.

The shreds of this torn veil of the temple/studio provides me even with miraculous shrouds. All is useful to me.

My old Monotone Symphony of 1949, which was performed under my direction, by a small orchestra on March 9, 1960, was destined to create an "after-silence" after all sounds had ended in each of us who were present at that manifestation.

Silence ... This is really my symphony and not the sounds during its performance. This silence is so marvelous because it grants "happenstance" and even sometimes the possibility of true happiness, if only for only a moment, for a moment whose duration is immeasurable.

To conquer silence, to skin it and cover oneself with its hide to never be chilled again spiritually. I feel like a vampire face to face with universal space!

But let us return to the facts; still there in the studio with my models, in 1956, I am reading the journal of DELACROIX and suddenly these lines appear:

> I adore this little vegetable garden ... this gentle
> sunlight over the whole of it infuses me with a secret
> joy, with a well-being comparable with what one feels
> when the body is in perfect health. But all that is
> fugitive; any number of times I have found myself in
> this delightful condition during the twenty days that
> I am spending here. It seems as if one needed a mark,
> a special reminder for each one of these moments.[110]

What an artist needs is the disposition of a reporter, a journalist, but in the wider sense of the words, one perhaps no longer understood today.

I understand now the spiritual mark of these momentary states. I understand it through my monochromes; and the mark of the momentary states of the flesh through in the imprints pulled from the bodies of my models.

... But the mark of the momentary states of nature?

... I leap outside and there I am on the riverbank amidst the bulrush and the reeds. I dust everything with pigments and the wind, which bends the delicate stems, comes to apply it with precision and delicacy upon my canvas that I thus present to the trembling nature: I obtain a vegetal mark. Then it begins to rain, a fine spring shower; I expose my canvas to the rain, and it is done. I have captured the mark of rain! The mark of an atmospheric occurrence ...

110 *The Journal of Eugène Delacroix* (25 October 1853).

An idea comes to me: I have, for a long time, desired to temper nature's climate with the aide of either solar mirrors or other scientific techniques yet to be discovered. The first steps have been made with the architecture of air that I am presently realizing in collaboration with the architect Werner Ruhnau and that will permit us to live nude everywhere at ease in immense regions that we have rendered temperate and transformed into a veritable, regained earthly paradise. It becomes completely natural that the model at last leaves the studio with me and that I take imprints of nature, and that the model should be there suddenly, taking her place in nature, and also mark the canvas there, where she feels good, in the grass, amidst the reeds, at the waterside or beneath a waterfall, naked, in a static pose or in motion, as a true and, ultimately, completely integrated subject of nature.

All phenomena of nature as subject, human, animal, vegetal, mineral, or atmospheric are of interest to me for my naturometrics.

I might even forego colors and work instead with the perspiration of the models mixed with dust, perhaps even with their own blood, the sap of plants, the color of the earth, etc., and time will turn the results obtained into I.K.B. blue monochrome.

Fire is clearly to be included in this. I must have its imprint!

The anthropophagous era is drawing near, frightening in appearance only. It will be the practical realization on a universal scale of these famous words: "Whoever eats my flesh and drinks my blood remains in me, and I in him."[111] Spiritual words, certainly, but these are words that will be effectively practiced during a time prior to the advent of the blue era of peace and glory; total Edenic liberty reconquered by man atop the immaterial sensibility of the universe.

Whatever one may think of this, all of this is in pretty bad taste and, indeed, it is my intention. I shout it out very loudly: "KITSCH, THE CORNY, BAD TASTE." This is a new notion in ART. While we're at it, let's forget ART altogether!

111 John 6:56.

Great beauty is not truly truthful if it contains, intelligently mixed in, "AUTHENTIC BAD TASTE" of "EXASPERATING AND UTTERLY CONSCIOUS ARTIFICIALITY" with just a dash of "DISHONESTY."

One must be like FIRE in NATURE; to understand how to be both gentle and cruel, to know how to CONTRADICT oneself. Then, and only then, does one really belong to the family of UNIVERSAL PRINCIPLES OF ENLIGHTENMENT.

... NO, I am not LITERARY. All my past manifestations have been EVENTS. On the occasion of my first presentation of the "VOID" in 1957 at Colette Allendy's, I already liberated the entire "THEATRI-CAL" theater in a SINGLE blow, freed it from its yoke, the AGE-OLD yoke of PERSPECTIVE!

It is thus, by publishing this text, that I want to make it clear to all artists, young or old, whom I have pulled into my wake these last years a little everywhere in the world, into this path of the "monochrome," and then into the "immaterial "and the "void" (which they are still far from having reached), that I have not in fact changed in any sudden or brusque manner.

... In fact, for some time I have been told repeatedly that the followers of the "monochrome movement" I created in today's international art world are rattled by my most recent works.

... Oh well ... Nothing could be more natural than that I reached this point, and I am sure that they will reach it too. They were also, at first, disconcerted by my monochromes, which they soon after took up with enthusiasm, each in their own style.

Thinking of all that has transpired, I feel today like the proverbial worm in the cheese of the history of science, which eats, and eats and makes holes; it creates a void around itself and moves on ... from time to time, it encounters a hole that it is obliged to bypass in order to advance, in order to live, indeed, in order to eat!

One day, there is no more cheese because the worm has eaten everything; there is nothing more than the void, the great void. The worm is then levitating, free, happy in space, but only for a moment, then it falls quite naturally onto another cheese and continues to eat and continues to create the void around itself, and that

reminds me of a poem that I wrote at the age of eleven, and which my mother has had to wisdom and goodness to save for me. It says what I have always wanted to say:

SILENCE

The soft sound of a dead leaf
dragged by the wind
A stone falling
There, a small hole is dug
The silent space struggles
Suddenly, shadows, steps,
A shepherd, his army of sheep at his side
Their bells ring beautifully
That's it, he has won!
The silence, around him ...
 ... Is behind him ...

 Paris, 1939

... It is not with rockets, Sputniks, or missiles that modern man will achieve the conquest of space. That's the dream of present-day scientists who live in a romantic and sentimental state of mind that belongs to the 19th century.

It is through the terrific yet peaceful force of sensibility that man will inhabit space. It is through the impregnation with human sensibility in space that the ardently desired conquest of this space will be achieved. For human sensibility is capable of anything in immaterial reality; it can even read in nature's memory about the past, the present, and the future.

It is our potential of effective extradimensional action.

Proofs? Precedents?

... In the *Divine Comedy,* Dante describes with absolute precision what no traveler of his time could possibly have discovered, the invisible constellation of the Northern Hemisphere known as the Southern Cross. Jonathan Swift, in the *Voyage to Laputa,*[112] gives the

112 Part 3 of *Gulliver's Travels.*

distances and periods of rotation of two satellites of Mars, though they were unknown at the time.

When the American astronomer Asaph Hall discovered them in 1877, he realized that his measurements were the same as Swift's. Seized by panic, he named them *Phobos* and *Deimos* – Fear and Terror!

May the authentic realism of today and tomorrow live on. I want it to live with the best of me, in total freedom of mind and body.

The universal cannibalism that is approaching, the anthropophagous era through which we are soon to pass, is by nature neither cruel nor fierce nor inhuman; quite to the contrary, it will become the living expression or, rather, the assimilation of a biological synthesis. It will definitively free us from some of the rare tyrannical aspects of ...[113]

—◇—

113 Here the page in each copy of the original publication of this text was literally burned off at Klein's instruction as a gesture of dematerialization.

XXIV. CHELSEA HOTEL MANIFESTO [114]
NEW YORK, 1961

Due to the fact that I have painted monochromes for fifteen years,

Due to the fact that I have created pictorial immaterial states,

Due to the fact that I have manipulated the forces of the void,

Due to the fact that I have sculptured in fire and in water and have painted through fire, and through water,

Due to the fact that I have painted with living brushes – in other words, the nude body of live models smothered in paint. These living brushes are under the constant direction of my commands, such as "a little to the right; over to the left now; to the right again, etc." By maintaining myself at a definite and obligatory distance from the painting, I am able to resolve the problem of detachment,

Due to the fact that I have invented the architecture and the urbanism of air – of course, this new conception transcends the traditional meaning of the terms, "architecture and urbanism" – my original goal being an attempt to reconstruct the legend of the lost Eden. This project has been directed towards the habitable surface of the Earth by the climatization of the great geographical expanses through an absolute control over the thermic and atmospheric situations in their relation to our morphological and psychic conditions,

Due to the fact that I have proposed a new conception of music with my "monotone-silence-symphony,"

Due to the fact that I have also precipitated a theater of the void, among countless other adventures,

I would never have believed fifteen years ago at the time of my earliest efforts that I would feel so suddenly the responsibility to explain myself – to satisfy your desire to know the whys and the wherefores of all that has occurred and the still more dangerous whys and

114 Original written in English.

wherefores for me, in other words – the influence of my art on the young generation of artists throughout the world today.

It disturbs me to hear that a certain number of them think that I represent a danger to the future of art – that I am one of those disastrous and nefarious products of our era who must be crushed and destroyed completely before the propagation of the progress of evil. I am sorry to have to reveal to them that this was not my intention; and to have to declaim with pleasure to those who evince a faith in the multiplicity of new possibilities in the path that I prescribe – Be careful! Nothing has crystallized as yet; and whatever will happen after this, I cannot say. I can only say that I am not anymore afraid today than I was yesterday facing the souvenir of the future.

An artist always feels a little uneasy when called upon to speak of his own works. They should speak for themselves, particularly if they are valid works.

Therefore, what can I do? Stop now?

No, what I call the undefinable pictorial sensibility absolutely forbids this very personal solution.

So ...

I think of those words that I was inspired to write one evening. "Wouldn't the future artist be he who expresses through silence, but eternally, an immense painting lacking any sense of dimension?"

The gallery-goers – always the same, just as the others – would carry this immense painting in their remembrance (a remembrance which does not derive at all from the past but alone is cognizant of the possibility of increasing infinitely the incommensurable within the scope of the undefinable sensibility of man). It is always necessary to create and recreate in a constant physical fluidity in order to receive the grace which permits the positive creativity of the void.

Just as I created a "monotone-silence-symphony" in 1947, composed in two parts – one broad continuous sound followed by an equally broad and extended silence, endowed with a limitless dimension – in the same way, I shall attempt to put before you a written painting of the short history of my art, to be followed naturally at the end of my expose by a pure and *affective* silence.

My expose will close with the creation of a compelling "a posteriori" silence whose existence in our communal space, which is, after all, the space of a single being, is immune to the destructive qualities of physical noise.

Much depends upon the success of my written painting in its initial technical and audible phase. Only then will the extraordinary "a posteriori" silence, in the midst of noise as well as in the cell of physical silence, generate a new and unique zone of pictorial immaterial sensibility.

Having reached this point today in time and knowledge, I propose to gird my loins, then backstep retrospectively along the diving board of my evolution. In the manner of an Olympic diver in the most classic technique of sport, I shall prepare for my leap into the future of today by moving backward prudently, constantly keeping in sight the edge consciously attained today – the immaterialization of art.

What is the purpose of this retrospective journey in time? Simply, neither do I want you nor myself, even for an instant, to fall into the grip of that phenomenon of sentimental and landscaped dreams which would be provoked by an abrupt landing in the past. The latter is precisely the psychological past, the anti-space, which I have been leaving behind in my adventures of the last fifteen years.

At present, I am enthusiastically interested in "the corny." I have the feeling that there exists in the very essence of bad taste a force capable of creating something far beyond what is traditionally termed art. I want to play with human sentimentality and "morbidism" in a cold and ferocious manner. Only very recently I have become a sort of undertaker (oddly enough, I am using the very terms of my enemies). Some of my latest works have been tombs and coffins. Within the same span of time, I have succeeded in painting with fire, using very powerful and searing gas flames, some ten to twelve feet in height, to lick the surface of a painting in order to record the spontaneous trace of fire.

In sum, my goal is twofold: first of all, to register the trace of human sentimentality in present-day civilization; secondly, to register the trace of fire which has engendered this very same civilization. And this because the void has always been my constant preoc-

cupation; and I hold that in the heart of the void as well as in the heart of man, fires are burning.

All facts that are contradictory are genuine principles of universal explanation. Fire is truly one of these genuine principles that are essentially self-contradictory, being at the same time mildness and torture in the heart and origin of our civilization.

What provokes my search for the trace of sentimentality through the fabrication of super-graves and super-coffins, what provokes my search for the trace of fire, why should I search for the Trace itself? Because every work of creation, regardless of its cosmic order, is the representation of a pure phenomenology – all that is phenomena manifests itself. This manifestation is always distinct from form and is the essence of the immediate, the trace of the Immediate.

A few months ago, for example, I felt the urge to register the signs of atmospheric behavior by recording on a canvas the instantaneous traces of spring showers, of south winds, and of lightning (Needless to say, the last-mentioned ended in a catastrophe). For instance, a trip from Paris to Nice might have been a waste of time had I not spent it profitably by recording the wind. I placed a canvas, freshly coated with paint, upon the roof of my white Citroen. As I zoomed down Route Nationale 7 at the speed of 100 kilometers an hour, the heat, the cold, the light, the wind, and the rain all combined to age my canvas prematurely. At least thirty to forty years were condensed into one day. The only annoying thing about this project is that I have to travel with my painting all the time.

My atmospheric imprints of a few months ago had been preluded a year ago by vegetal imprints. After all, my purpose is to extract and conclude the trace of the immediate from any incidence of natural objects – human, animal, vegetable, or atmospheric circumstances.

I would like now, with your permission and attention, to divulge to you possibly the most important and certainly the most secret phase of my art. I don't know whether you will believe it or not, it's cannibalism. After all, wouldn't it be better to be eaten than to be bombed? I can hardly document this idea that has been tormenting

me for some years, so I will leave it up to you to make your own conclusions on what I think will be the future of art.

Taking another step backward along the lines of my evolution, we arrive two years ago at the moment when I devised painting with living brushes. The purpose of this was to attain a definite and constant distance between myself and the painting during the moment of creation.

Many art critics claimed that via this method of painting I was in fact merely reenacting the technique of what has been called "action painting." I would like now to make it clear that this endeavor is opposed to "action painting" in that I am actually completely detached from the physical work during its creation.

Just to cite one example fostered by the misrepresentation of anthropometry by my coverage in the international press – a group of Japanese painters eagerly applied this method in their own very different manner. These painters in fact transformed themselves into living brushes. By drowning themselves in color and then rolling on their canvases, they became ultra-action-painters! Personally, never would I attempt to smear paint over my own body and become a living brush; but on the contrary, I would rather put on my tuxedo and wear white gloves. I would not even think of dirtying my hands with paint. Detached and distant, the work of art must complete itself before my eyes and under my command. Thus, as soon as the work is realized, I stand there – present at the ceremony, spotless, calm, relaxed, worthy of it, and ready to receive it as it is born into the tangible world.

Whatever directed me towards anthropometry? The answer can be found in my work during the years 1956 to 1957, when I was taking part in the adventure of creating the pictorial immaterial sensibility.

I had just removed from my studio all my former works. The result – an empty studio. My only physical action was to remain in my empty studio, and the creation of my pictorial immaterial states proceeded marvelously. However, little by little, I became mistrustful of myself: but never of the immaterial. I therefore hired models, as other painters do. But unlike the others, I merely wanted

to work in their company rather than have them pose for me. I had been spending too much time alone in the empty studio; I no longer wanted to remain alone with the marvelous blue void that was budding. Though seemingly strange, remember that I was aware of not having that vertigo experienced by all my predecessors facing the absolute void which forcibly is the real pictorial space. But how long could my security in this awareness endure?

Years ago, the artist went directly to his subject, worked outdoors in the country, had his feet firmly planted on the ground – it was healthy.

Today, the academicized easel-painters have reached the point of shutting themselves in their studios, confronting the terrifying mirrors of their canvases. Now the reason for my use of nude models becomes quite evident: it was a way of preventing the danger of secluding myself in the overly spiritual spheres of creation, thus rupturing with the most basic common sense, repeatedly affirmed by our incarnate condition.

The shape of the body, its lines, its strange colors hovering between life and death, hold no interest for me. Only the essential, pure affective climate of the flesh is valid.

I was introduced to the void by the rebuffed nothingness. The mining of the pictorial immaterial zones, extracted from the depth of the void which I possessed by that time, was of a very material nature. Finding it unacceptable to sell these immaterial zones for money, I demanded in exchange for the highest quality of the immaterial the highest quality of material payment – a bar of pure gold.

Incredible as it may seem, I have actually sold a number of these pictorial immaterial states.

So much could be said about my adventure in the immaterial and the void that the result would be an overly extended pause while still immersed in the present erection of my written painting.

Painting no longer appeared to me to be functionally related to the eye when in my blue monochrome period of 1957 I became acquainted with what I have termed the pictorial sensibility. This pictorial sensibility exists beyond our being and yet belongs in our

sphere. We hold no right of possession over life itself. It is only by the means of our possession of sensibility that we are able to buy life. Sensibility, which enables us to purchase life at its basic material levels, in the barter price of the universe of space, of the grand totality of nature.

Imagination is the vehicle of sensibility!

Transported by (effective) imagination we attain life, that very life which is absolute art itself.

Absolute art, what mortal men call with a sensation of vertigo the *summum* of art, materializes instantaneously; it makes its appearance in the tangible world, myself remaining at a fixed geometric point, in the track of such volumetric displacements with a static and vertiginous speed.

The answer to the question of how I was introduced to pictorial sensibility may be found in the intrinsic force of the monochromes of my blue period of 1957. This period of blue monochromes was the fruit of my quest for the undefinable in painting which the master Delacroix could already intimate.

From 1956 to 1946, my monochromes experiences in various other colors but blue never let me forget the fundamental truth of our age – that is to say, form no longer is a linear value but rather a value of impregnation.

Just an adolescent in 1946, I went to sign my name on the underside of the sky during a fantastic "realistico-imaginary" journey. That day, as I lay on the beach at Nice, I began to hate the birds which occasionally flew in my pure, unclouded blue sky, because they tried to bore holes in my greatest and more beautiful work.

Birds must be eliminated.

Thus, we humans shall possess the right to levitate in an effective and total physical and spiritual freedom.

Neither missiles nor rockets nor sputniks will render man the "conquistador" of space. These means are only dream world of today's scientists who still live in the romantic and sentimental spirit of the 19th century.

Man will only arrive at inhabiting space through the terrifying though pacifying force of sensibility. The real conquest of space so

much desired by him will only result from the impregnation of man's sensibility in space. Man's sensibility is omnipotent in the immaterial reality. His sensibility can even see into the memory of the nature of the past, of the present, and of the future!

It is our effective extradimensional capacity for action!

If proofs, precedents or predecessors are needed, let me then cite: Dante, in the *Divine Comedy*, described with absolute precision what no traveler of his time could possibly have discovered, the invisible constellation of the Northern Hemisphere known as the Southern Cross; Jonathan Swift, in his "Voyage to Laputa," gave the distances and periods of rotation of two satellites of Mars though they were unknown at the time.

When the American astronomer Asaph Hall, discovered them in 1877, he realized that his measurements were the same as those of Swift. Seized by panic, he named them *Phobos* and *Deimos* – Fear and Terror! With these two words – Fear and Terror – I find myself in front of you in the year 1946, ready to dive into the void.

Long Live the Immaterial!

And now,

I thank you so much for your kind attention.

Collaboration: Yves Klein, Neil Levine, John Archambault

XXV. DIALOGUE WITH MYSELF [115]

But in the process of creating something, by oneself ... the main thing is to know in sum that truth does not exist. Only honesty exists. Honesty is always in bad taste since, after all, honesty is so human; it is only ... a collection of laws, of learned ways of seeing, etc. etc. But honesty does sometimes go beyond a human framework; then it becomes, even in humans, something greater. It becomes life, life itself, a power, that strange life force that belongs neither to you, nor to me, nor to anyone. Life, it is life.

All that I said there, all I just said, is trying to bring myself closer to what I wish to do this evening, but which I have not yet accomplished. All that I have said is feeble; it's a farce. I'm blathering on to myself. No, it is quite difficult to hear oneself dream, to dream while awake. It is quite difficult to pronounce thought. I attempt this experiment, deep down, because I wish to avoid writing. Writing, curiously, is rather precise, deep down; it makes one think better, dream better, and put marks on paper, inscribe, write. But in speech one hears, one articulates, one pronounces. It's quite curious. I don't understand very well what is happening yet.

In writing one can evidently reflect more, concentrate more, to retrieve what truly happens in the act of thinking. Thinking is not exactly the right word. When one thinks, one does not often become illuminated; illumination is thinking with something else

115 The title "Dialogue with myself" [*Dialogue avec moi-même*] was assigned posthumously in 1983 to what was in reality a tape-recorded stream of consciousness made one evening in 1961 by Klein in his apartment in Paris. The recording begins with a short excerpt from the *Monotone Symphony,* then Klein begins to speak: the tone is solemn, the words choppy, often interrupted by silences. The translation follows the transcription made by Marie-Anne Sichère and Didier Semin.

added on; it is more of a spiritual visit, by a strange spirit. Nevertheless, one can't say that it doesn't exist, this spirit, even if one's a materialist. It does exist; it is a propitious moment, perhaps a propitious organic moment: everything suddenly functions very well ...

This is fantastic: because I have this tape recorder, I can attempt this experiment. I was there, having just finished dinner and, there it was, it began right away. Oh ... it was an illuminated dream, quite ordinary, deep down. I had some before that were much more immense, much more fervent, but the vision returned. It was like that, sudden. There I was ... I told myself straightaway: one must try at least once ... try to rise up, continue to rise up while speaking, in order to hear, to capture the spirit. But I didn't succeed. I quickly sent Trotrotte[116] off on an errant, but that didn't work. She didn't understand why I sent her off on an errant; she didn't see the reason why I sent her off on an errant. I gave her one: to go fetch me a girl to take to bed with me. I told myself, deep down, if it'll work, it will be quite pleasant, and if not, it'll set me back to reveries. It is strange but, after having said this, I feel that if I had some element of sensuality around me, an intelligent, healthy, honest, unsentimental sensuality, I could perhaps retrieve it and speak ...

All that is not very realistic. Deep down, what I would like is to expose all that happens inside me, all that I desire, all that I do not desire, all that I am, all that I am not, etc. All that! I truly wish to record how I'm speaking to myself during these reveries. In speaking so to myself about myself, I can now recall some details. Hey! It is starting. I can speak at the same time to myself and to others, hear them answer, judge their responses: if I say something, they will respond accordingly. There it is, that's how it happens. Overall, there are many assumptions. If I do one thing, it will happen; if I do another, that will happen. The consequences for acts are analyzed and conclusions are made. Is it worth the trouble? Is it interesting to even begin or would it be better to do nothing at all? Is it better to interest oneself in something else? To completely change the subject? So, change the subject, do something else, think of something

116 "Trotrotte" was Rotraut Klein's nickname.

else, judge something else, that's what I do. But before dropping a subject, I always review all possibilities.

In regard to the domain of art and the creation of my works, for example, it is amusing because I first have an idea and then I generally see already roughly how it will be carried out. I see details, small things, small details of construction. I picture it volumetrically in the space of my imagination. I construct it, make a prototype of it, and then subject this prototype to an overall comparison with everything that I know to have existed in order to make sure that I am not redoing something that has already been done. Not that it matters; deep down, it is of no importance. But I don't like to do something that someone else has already done or explore something that someone else has already explored. I don't like to go into a territory where someone else has already gone before, someone of my kind anyway, which is to say, a human. If the idea of being quite new and untouched, of never having been visited by a human throughout history, has the virtue, then I again begin to think in a constructive manner: is it worthwhile? Will it be lasting and permanent, once materialized, once created ... yes, once created by me? Will it have value? In sum, am I going to create something that will be an entity, a companion for others as it is for me, which is to say a companion both for all of us and of any one of us, a strange companion of sensibility? And I closely study that in every detail.

But then it is here where it is difficult to speak, for I am studying the matter in terms of quality, as I would say, which means that I am looking for words; I cannot yet express well what I want to say. I am seeking a kind of ... I can't find the words. I see its radiance; I see it visually all over, as if it had been created in comparison with others and then, too, without comparing it to others. I'm telling myself, deep down, why compare that which has no reason to be with that which should be and that which is already? But does it have quality? Is it necessary? Is it true? Is it both beautiful and ugly? Is it both true and false? Is it both good and evil? Is it complete?

It is quite curious because I say all of this to myself while look-
ing at my work, and I feel it makes itself and that a radiance begins
to emanate from it and responds to me and converses with me. This
is rather to explain how creation happens, the creation of an object,
which is to say a canvas, a sculpture, a painting ... Actually, it's all
the same: what I create, and what is most valuable in what I create
is what I do not create. That's what interests me. What I'm doing at
this moment is analyzing myself, analyzing my way of thinking,
stripping myself bare, which I do know is indecent. I shouldn't do
it. It's romantic. It's psychological. I don't like psychology. So why
do I do it? Because I tell myself – beyond that awakened and extra-
lucid affective reverie, visited by the spirit, etc. etc. – that overall
this reverie is vital to humans. It is universal, but it is essentially
human – and indeed, if I strip myself bare, like the people who will
live naked in the architecture of air (for there will be no more inti-
macy; we will know what everyone thinks and does), perhaps an-
other form of intimacy will emerge from further off, from yet fur-
ther away, something that exists but cannot be conceived today).
And what is strange is to think that beyond that there exists still
more, even greater and more immense, and so on and so on. Well,
I no longer know all that much. Must one benefit stupidly from
the simple and silly moments of life, to be simply a normal human
being without forcing oneself, without ... to be simply oneself?
Or must one be intelligent? Must one think? Must one be honest?
Which is to say, must one always go further, always attempt to go
further? That is the logic ... that is what the logic of honesty de-
mands. Or must one then simply do nothing in order to live well, to
live happily, without responsibility? That is the heart of the matter;
it is responsibility that makes us aware that there is always a better
way. Perfectionism.

Deep down, I am a perfectionist. But is that bad? Because one is
never happy. One knows that there is always something better and
that one can do better; the better exists, it exists beyond and one is
never satisfied. And also, to be satisfied is mediocre. When one is sat-
isfied, one no longer knows what to do and one does nothing because
one is no longer satisfied otherwise. There is that philosophy of be-

ing immobilized, stupidly, while knowing that thousands of other possibilities exist. It arises from temperament, I know, which urges you, which pushes people like me to seek further and others to remain where they are. And yet, it is where one is; it is also interesting. One must remain where one is and, at the same time, always go further. Overall, it is the measure; it is the measure that always matters, the eternal measure. Is France truly the country to be measured against? It has been said that but I know nothing of it, but it is also certain that since my return from a three-month-long trip to America that I feel myself again capable of thinking about that measure that is not at all apparent to me, that I have not at all experienced, and that I admire and envy. I would like to understand it. I would like to live this all-powerful measure, at once creative, serene, peaceable, dynamic, and exclusive.

[Myself and Myself] Yves Klein and Co.
Ireland, 1950

XXVI. WITH REGARD TO MY ATTEMPT AT THE IMMATERIAL [117]

In regard to my attempt at the immaterial, which is to say the void ... impossible to give you a photograph. Please publish the photocopy, this page written by my own hand, to clearly show that I am of good faith.

Yves Klein

—◇—

117 Drafted on a loose sheet of paper in the Yves Klein Archives.